Official Autodesk Training Guide

Learning Autodesk® 3ds Max® 2008

Foundation

Autodesk

Focal Press is an imprint of Elsevier
30 Corporate Drive, Suite 400, Burlington, MA 01803, USA
Linacre House, Jordan Hill, Oxford OX2 8DP, UK
Copyright (c) 2008, Elsevier Inc. All rights reserved.

Acknowledgements

Art Direction:
Michiel Schriever

Sr. Graphic Designer:
Luke Pauw

Cover Images:
Images courtesy of Bedlam Games, © 2007 Groove Media Inc.

Images courtesy of Uniform

Copy Editor:
James A. Compton

Technical Editor:
Mark Gerhard

DVD Production:
Roark Andrade, Peter Verboom

Content Marketing Manager:
Carmela Bourassa

Project Manager:
Lenni Rodrigues

Director – Products, Planning and Tools
Michael Stamler

Special thanks go out to:
Sarah Blay, Zandro Chan, Lui Francisco, Julie Fauteux, Marc-André Guindon, Tonya Holder, Georgia Kennedy, Laura Lewin, Robert Lin, Sam O'Hare, Cheryl Roscoe, Chris Ruffo and Mary Ruijs.

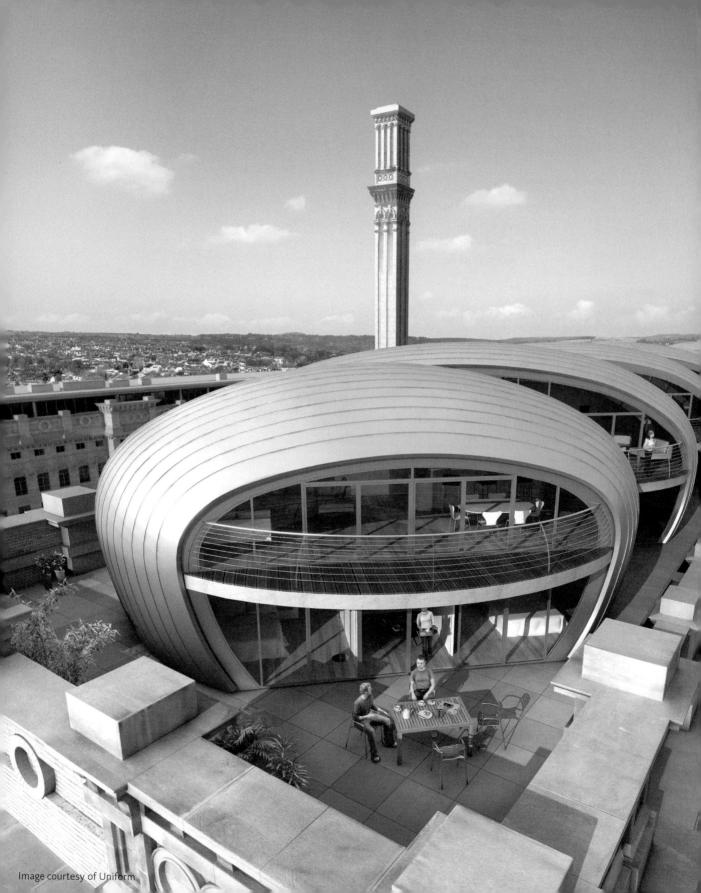

Primary Author

Rémi Breton

Rémi Breton, an advanced user of Autodesk® 3ds Max®, Autodesk® Combustion® and Autodesk® MotionBuilder™, develops solutions to various production problems in CG pipelines for the video game, TV, and film industries.

Rémi has work on several projects with NeoReel, including the feature film *Journey 3D*. He served as technical director for the TV show *Tripping the Rift* and for video games *Yu Yu Hakusho*, *Black & Bruised™*, *Syberia*, and *Road to India*.

www.neoreel.com

Contributing Author

Mark Gerhard

Mark Gerhard is a 3ds Max Guru.

An artist by training, he is an author and instructor who has been focused on 3ds Max for nearly 20 years. He was among the first artists hired to test the product in 1990. He was on the training team that introduced the product to the Autodesk dealer and education channel and was lead writer for the 3ds Max tutorials. He has trained and presented worldwide across many different industries including design visualization, mechanical, film, games, and forensics. He has led countless 3ds Max classes at the corporate, collegiate and high-school levels since 1991, and is expert in teaching 3ds Max and Autodesk® VIZ to novices quickly and intensively. He has freelanced in the architecture, industrial design, simulation and forensics fields, so he brings real-world knowledge into the classroom.

He has been a sculptor, painter, printmaker, presentation graphics specialist and department manager, airbrush artist, graphic designer, newspaper reporter, software tester, corporate instructor, product manager, application engineer, freelance modeler and animator, senior technical writer, freelance technical editor, part-time adjunct community college professor and summertime secondary school 3ds Max instructor.

Bedlam Games

"You can maintain a normal life and still do something enjoyable like this—you don't have to sacrifice one for the other," Art Director, Lui Francisco describes the vision behind Bedlam, a Toronto-based development studio owned by Groove Games. In an industry where employees often work grueling hours, it's refreshing to hear that the team at Bedlam is committed to a standard forty-hour work week. "The concept is that if you try to be organized from the beginning, commit to a plan, you can avoid a lot of the headaches that most development teams have to go through later on."

Their first project was to create *Kung Fu: Deadly Arts*, a fighting game for use on Groove Games' Skillground website. The game was designed by Zandro Chan, Bedlam's Studio Head, who was inspired by classic Kung Fu movies. Chan, a black belt in Yoshinkai Aikido, says that it was important to him that the game mimic actual martial arts, which are closer to dance than brute violence, and still have a touch of cinematic flair.

In this way, the game is more sophisticated than the average martial arts title, as it involves defense skills as well as attack moves. "It's not your typical button mashing fighter game," Francisco explains, "There is a bit of a strategy to it. You can parry attacks and that's one of your weapons as well. It makes it more of a flow back and forth, adding an intuitive rhythm to the combat, something that is inherent to all great Kung Fu films."

The development team spent the first few weeks working on paper, because the studio was still being set up. Francisco says that this time allowed them to iron out problems with the level flow so they were ready when the equipment arrived. "As soon as we got our licenses and computers we were able to start using Autodesk 3ds Max (software) to build the game."

After working out what fighting animation moves they wanted, Bedlam hired FAST Motion, a stunt team to do the motion capture. Francisco notes that the team at FAST Motion was a natural partner because, "They have so much fighting experience in terms of stunt coordination with the film industry that whenever we need any kind of combat, they can help very quickly."

The game was developed using a combination of Autodesk® MotionBuilder™ and Autodesk® 3ds Max® software products. Something that the team found particularly useful was the pelt mapping utility, first introduced in version 8, which allows the user to interactively stretch texture over shapes, and add the placement of seams. "It was one of the best things," Francisco says, "because the team could wrap UVs very quickly, especially the organic shapes that you get instead of sitting there trying to unwrap them all individually."

Kung Fu: Deadly Arts was developed exclusively for use on the Skillground website, which provides a unique online gaming experience. Registered users can play for free or enter score-based tournaments with real cash prizes. "It's an actual community," Francisco explains. "People can go there and chat—even trash talk. It's like a social networking site but with games attached." The site also allows for games to be constantly developing.

Bedlam has a variety of projects in the development pipeline and is eager to find new ways to leverage the possibilities of the Skillground site. "I would love to work on an action adventure game," Francisco admits, "On a platform like Skillground, it could be something that really extends and be almost never-ending."

Uniform

In the 1960s, it took a group of four moptops from Liverpool to cement EMI's reputation as Britain's premier recording company. Forty years later, with the former London headquarters in decay, developers looked to a different group of Liverpudlians to promote the site's redevelopment. They commissioned Uniform, a design studio with a strong VFX background, to produce a film that would generate excitement about the proposed regeneration.

Sam O'Hare, Senior Designer and VFX Supervisor, explains that the creative team knew right away that they wanted a musical style to play up "the musical heritage and make it a bit pop." What resulted is a cinematic tour through the revived space, led by a color trail that interacts with the stylized people in the scene. Nicknamed "Jeff" by the animators, the trail represents "the spirit of regeneration moving through the site."

The environment was completely computer-generated using Autodesk® 3ds Max® software and the dancers were rotoscoped from green screen footage. O'Hare describes how animating "Jeff" around the characters was made easier by a 3ds Max plug-in called "Ghost Trails." "It's a tool that allows you to generate trails by moving a spline shape through a scene," he explains, "Jeff was made of about twelve elements that were all linked together into a hierarchy, so I only had to animate one object and the entire thing would be generated automatically. This made it much faster to animate." A particle system was also attached to the objects to throw out bits of confetti and glittering dust.

The Blyth Road project has not only impressed the design community, but has received coverage in the digital arts press as well. It has been nominated for a Design Visualization Award along with another Uniform project called "Crystal," a promotional film for long-time client, the Beetham Organization.

Beetham wanted to promote their upcoming office scheme in the heart of the city of London, which will feature three glazed buildings with asymmetrical, crystalline structures. Uniform's creative team wanted to reference the architect's vision in their work, but also produce something cinematic. They came up with the concept of tracking three crystals as they explore the city and the features of the building. To achieve their vision, the team filmed over the city using a helicopter equipped with a gyroscopically stabilized HD camera. They also shot high dynamic range images (HDRIs) and used 3ds Max software for modeling the towers.

As the crystals traverse through the cityscape, they both reflect and are reflected in their environment. Achieving the correct reflections and refractions was a challenge for the animation team. "We hadn't done a lot of compositing objects into reflective objects in real footage before," O'Hare admits, "One of the things we found was that the buildings were already reflecting sky in the footage, so we needed to render out separate black and white matte passes, which were then tinted down to a dark blue. We used them to actually cut out holes into which the reflection of where the crystals would sit."

O'Hare acknowledges that the team's VFX work helps to keep Uniform at the forefront of the design industry. "From an architectural visualization point of view, there aren't many companies who are doing this sort of stuff." But he contends that what really sets the company apart is its commitment to quality, "We always work to exceed our clients' expectations."

Table of Contents

Project 03

Project 04

Project 05

Preface

This book will provide you with a working introduction to the tools and techniques of Autodesk® 3ds Max® 2008. In *Learning Autodesk 3ds Max 2008 | Foundation*, you will follow through five projects that will give you a firm foundation in using the software program as you model, rig, animate, texture map, and render. A character animation and visual effects system for professional artists and designers, 3ds Max offers incredible power and flexibility for generating digital images of animated characters and scenes. It is an extremely exciting tool for the artist and designer, and should provide you with many hours of sheer creative delight. It is the goal of this book to acquaint you with the basics of doing 3D with 3ds Max. When you have completed these exercises, you will be well on your way to mastering the methods you need to go further in your learning and training.

Autodesk 3ds Max is used by many different industries for diverse purposes. Design visualization is a prominent use of 3ds Max, as is video game development. You will gain experience in both applications in the course of completing these projects.

As you explore further into 3ds Max, you will discover that there are many ways of doing the same thing, using different tools and techniques to achieve the same end. Often the examples and workflows you will follow are primarily intended to teach you something new, rather than to do it the most efficient, or industry standard method. These will be pointed out throughout the projects as you go along.

Get ready to have fun, the world of Autodesk 3ds Max awaits you!

How to use this book

How you use *Learning Autodesk 3ds Max 2008 | Foundation* will depend on your experience with computer graphics and 3D animation. This book moves at a fast pace and is designed to help you develop your 3D skills. If this is your first experience with 3D software, we suggest that you read through each lesson and watch the accompanying demo files on the DVD, which may help clarify the steps for you before you begin to work through the tutorial projects. If you are already familiar with 3ds Max or another 3D package, you might choose to look through the book's index to focus on those areas you'd like to improve.

Updates to this book

In an effort to ensure your continued success with the lessons in this book, please visit our web site for the latest updates available: *www.autodesk.com/learningtools-updates*.

Learning Autodesk 3ds Max 2008 | Foundation DVD-ROM

The *Learning Autodesk 3ds Max 2008 | Foundation* DVD-ROM contains several resources to accelerate your learning experience, including:

- Link to a 30-day trial of Autodesk® 3ds Max® software
- Bonus short films
- Access to new software feature demos
- Autodesk 3ds Max hotkeys reference guide
- Free models from Turbo Squid

Installing support files

Before beginning the lessons in this book, you will need to install the lesson support files. Copy the project directories found in the *support_files* folder on the DVD disc to the *3dsmax* directory in your *My Documents* folder on your computer. Launch 3ds Max and set the project by going to **File** → **Set Project Folder...** and selecting the appropriate project folder:

C:\Documents and Settings\<username>\My Documents\3dsmax\project1

Understanding 3ds Max

If you are new to Autodesk® 3ds Max® software, you will find that this book has been written with you in mind. The material contained within this volume takes you from a raw beginner to a seasoned professional using 3ds Max confidently in a production environment.

This manual provides complete instructions so that individuals can use the material to learn in a class or on their own. The manual comprises five projects: Getting Started, Modeling, Materials & Mapping, Animation and Rendering.

Each project has a series of lessons that include both theory and an ongoing exercise. The theory part of each lesson introduces you to new functional areas of 3ds Max and explains these features with short simple examples. The exercise shows you a practical application of the theory learned in a particular project. Combining these elements, a project gives you a sound understanding of the functions, features, and principles behind 3ds Max, and shows you how to apply this knowledge to real-world situations.

To understand Autodesk 3ds Max, it helps to understand how it works at a conceptual level. This introduction is designed to give you a quick overview of the key concepts behind 3ds Max, along with the tools that implement those concepts. In other words, the focus of this introduction will be on how different 3ds Max concepts are woven together to create an integrated workspace. You'll work with these concepts and features further throughout the projects, and you will use many of them in virtually every lesson.

Introduction

The 3ds Max user interface

Most of the main user interface is occupied by the viewports, where you view and work with your scene. The remaining areas hold controls and show status information. One of the most important aspects of using 3ds Max is its versatility. Many program functions are available from multiple access points in the user interface.

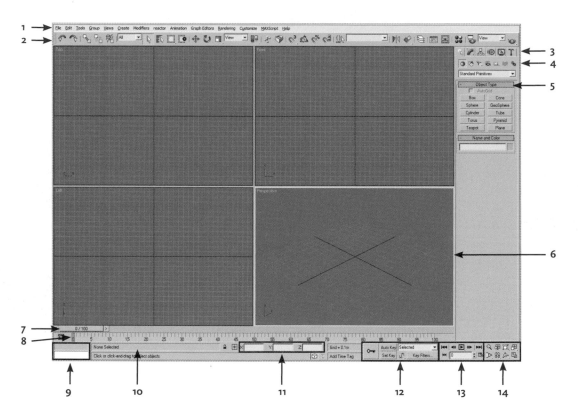

1. Menu bar

2. Main toolbar

3. Command panels

4. Object categories

5. Rollout

6. Active viewport

7. Time slider

8. Trackbar

9. MAXScript Mini-Listener

10. Prompt line and status bar

11. Coordinate display

12. Animation keying controls

13. Animation playback controls

14. Viewport navigation controls

The Command panel

This collection of six panels provides handy access to most of the modeling and animation commands.

The Create command panel

- **Create** holds all object creation tools.
- **Modify** holds modifiers and editing tools.
- **Hierarchy** holds pivot, linking, and inverse kinematics parameters.
- **Motion** holds animation controllers and trajectories.
- **Display** holds object display controls.
- **Utilities** holds miscellaneous utilities.

Using Transform gizmos

The Transform gizmos are viewport icons that let you quickly choose one or two axes when transforming a selection with the mouse. You choose an axis by placing the mouse over any axis of the icon, and then press and drag the mouse to transform the selection along that axis. In addition, when moving or scaling an object, you can use other areas of the gizmo to perform transforms along any two axes simultaneously.

The three transform gizmos

Understanding 3ds Max

Using a gizmo avoids the need to first specify a transform axis or axes on the Axis Constraints toolbar, and also lets you switch quickly and easily between different transform axes and planes. A Transform gizmo appears when one or more objects are selected and one of the transform buttons is active on the toolbar. Each transform type uses a different gizmo. By default, each axis is assigned one of three colors: X is red, Y is green, and Z is blue. The corners of the Move gizmo are assigned the two colors of the related axes. When you position the mouse over any axis, it turns yellow to indicate that it's active.

Right-click menus

3ds Max uses several different types of right-click menus. For object editing and ActiveShade control, you use the quad menu, which can display up to four quadrants of tools.

Commands on the quad menu vary depending on the kind of object you are editing and the mode you are in. Right-clicking a viewport label displays the viewport menu, which lets you change viewport display settings. Also, the command panel and the Material Editor have right-click menus that let you manage rollouts and navigate the panel quickly. And most other windows, including Schematic View and Track View, have right-click menus that provide fast access to commonly used functions.

The basic quad menu

Flyouts

A flyout is similar to a menu, except that its items are buttons. A flyout button is indicated by a small arrow in the lower-right corner. To display the flyout, press and hold the mouse button for a moment; then choose a button by dragging the cursor to it and then releasing the mouse button.

The flyout for using different centers during transform operations

Rollouts

Rollouts are areas in the command panels and dialogs that you can expand (roll out) or collapse (roll up) to manage screen space. In the illustration here, the Keyboard Entry rollout is collapsed, as indicated by the plus sign, and the Parameters rollout is expanded, as indicated by the minus sign.

A collapsed and an expanded rollout

Scrolling panels and toolbars

Sometimes a command panel or dialog is not large enough to display all of its rollouts. In this case, a pan ("hand") cursor appears over the inactive parts of the panel. You can scroll command panels and dialogs vertically, and you can scroll a toolbar along its major axis. To scroll a panel:

- Place the pointer over an empty area of a panel to display the pan cursor.
- When the pointer icon changes to a hand, press and drag the panel up or down.

> **Note:** *A thin scroll bar also appears on the right side of the scrolling panel. You can use the pointer to drag the scroll bar as well.*

Spinners

A spinner is a mouse-based control for numeric fields. You can click or drag the spinner arrows to change the value in the field.

A set of three spinners

To change a value using a spinner, do any of the following

- Click the spinner's up arrow to increment the value; click the down arrow to decrement the value. Press and hold for continuous change.
- **Drag** upward to increase the value, or **drag** downward to decrease it.
- Press **Ctrl** while you drag to increase the rate at which the value changes.
- Press **Alt** while you drag to decrease the rate at which the value changes.
- **Rightclick** a spinner to reset the field to its minimum value.

Introduction

Numerical Expression Evaluator

While a numeric field is active, you can display a calculator called the Numerical Expression Evaluator.

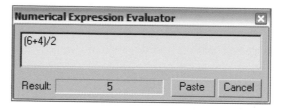

The Numerical Expression Evaluator

- Select a numeric field to make it active.
- Press **Ctrl+n** to display the calculator.

 The expression you enter is evaluated, and its result is displayed in the Result field.

- Click **Paste** to replace the field value with the result of the calculation.
- Click **Cancel** to exit the Numerical Expression Evaluator.

Entering numbers

You can change a numeric value by a relative offset by highlighting the contents of a numeric field (not in the Numerical Expression Evaluator) and typing **R** or **r** followed by the offset amount. For example, a length field shows 70 and you highlight it:

- If you enter **R30**, 30 is added to the length and the value changes to 100.
- If you enter **R−30**, 30 is subtracted from the length and the value changes to 40.

Controls and color

The user interface uses color cues to remind you what state the program is in.

- Red for animation: The Auto Key button, the Time Slider background, and the border of the active viewport turn red when you are in AutoKey (Animation) mode.
- Yellow for modal function buttons: When you choose a button that puts you in a generic creation or editing mode, the button turns yellow.
- Yellow for special action modes: When you choose a button that alters the normal behavior of other functions, the button is highlighted in yellow. Common examples of this behavior include sub-object selection and locking your current selection set.

Note: *You can exit a functional mode by clicking another modal button. Some buttons also allow you to exit by right-clicking in a viewport or clicking the modal button a second time.*

Undoing actions

You can easily undo changes you make to your scene and your viewports. There are separate undo buffers for both the scene objects and each viewport change. Use one of the following solutions to reverse the effects of most scene operations.

- Use the toolbar **Undo** and **Redo** buttons.
- Use the menu **Edit** → **Undo** and **Edit** → **Redo** commands.
- You can also use **Ctrl+z** for undo and **Ctrl+y** for redo.

To reverse the effects of most viewport operations, such as zooming and panning, use the following solution;

- Use the menu **Views** → **Undo** and **Views** → **Redo** commands.
- You can also use **Shift+z** for Undo View Change and **Shift+y** for Redo View Change.

Tip: *In almost any case, each time you are dragging using the left mouse button (**LMB**) or the middle mouse button (**MMB**) to execute an operation, like changing values of a spinner, making a transformation on an object or panning in the viewport, you can click on the right mouse button (**RMB**) while dragging to cancel the current operation.*

Using Auto Backup

You should regularly back up your work. You can automatically save backup files at regular intervals by setting the Auto Backup options on the Preferences dialog. The backup files are named *AutoBackup##.max*, where ## is a number from *01* to *99*, and stored, by default, in the *\autoback* folder. You can load a backup file like any other scene file. Note that Auto Backup doesn't start until you have saved your file for the first time, so be sure to save when you first begin your work.

Viewing and navigating 3D space

Everything you create in 3ds Max is located in a three-dimensional world. You have a variety of options for viewing this enormous stage-like space, from the details of the smallest object to the full extent of your scene. Using the view options, you move from one view to another, as your work and imagination require. You can fill your screen with a single, large viewport, or set multiple viewports to track various aspects of your scene. For exact positioning, flat drawing views are available, as are 3D perspective and axonometric views. You navigate 3D space by adjusting the position, rotation, and magnification of your views. You have full control over how objects are rendered and displayed on the screen.

General viewport concepts

Viewports are openings into the three-dimensional space of your scene, like windows looking into an enclosed garden or atrium. But viewports are more than passive observation points. While creating a scene, you can use them as dynamic and flexible tools to understand the 3D relationships among objects.

At times you may want to look at your scene through a large, undivided viewport, giving you a "picture-window" view of the world you are creating. Often you use multiple viewports, each set to a different orientation.

If you want to move an object horizontally in the world space, you might do this in a top viewport, looking directly down on the object as you move it. At the same time, you could be watching a shaded perspective viewport to see when the object you are moving slides behind another. Using the two viewports at the same time, you can get exactly the position and alignment you want.

You also have pan and zoom features available in either view, as well as grid alignment. With a few mouse clicks or keystrokes, you can reach any level of detail you need for the next step in your work.

In addition to geometry, viewports can display other views such as Track View and Schematic View, which display the structure of the scene and the animation. Viewports can be extended to display other tools such as the MAXScript Listener and the Asset Browser. For interactive rendering, the viewport can display the ActiveShade window.

Viewport layouts

The default 3ds Max layout uses a two-over-two arrangement of viewports. Thirteen other layouts are possible, but the maximum number of viewports on the screen remains four. Using the Layout panel of the Viewport Configuration dialog, you can pick from the different layouts and customize the viewports in each. Your viewport configuration is saved with your work.

The fourteen different viewport layouts available

Resizing the viewport

After choosing a layout you can resize the viewports so they have different proportions, by moving the splitter bars that separate the viewports. This is only available when multiple viewports are displayed.

Active viewport

One viewport, marked with a highlighted border, is always active. The active viewport is where commands and other actions take effect. Only one viewport can be in the active state at a time. If other viewports are visible, they are set for observation only; unless disabled, they simultaneously track actions taken in the active viewport. To activate a viewport you can click on the Viewport Label in the upper left. You can also activate a viewport by right-clicking anywhere in the viewport. This will activate the viewport without changing the selection in the viewport. Left-clicking in an inactive viewport will activate the viewport but deselect the current selection.

Home grid

The grid you see in each viewport represents one of three planes that intersect at right angles to one another at a common point called the origin. Intersection occurs along three lines (the world coordinate axes: X, Y, and Z) familiar from geometry as the basis of the Cartesian coordinate system.

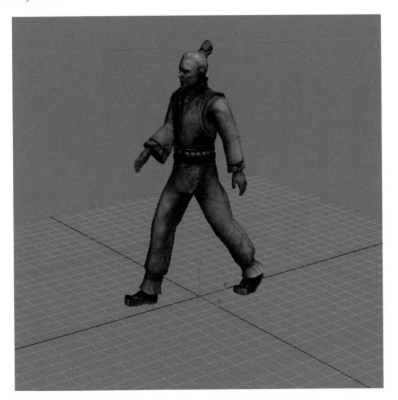

The XY plane of the home grid

The three planes based on the world coordinate axes are called the home grid; this is the basic reference system of the 3D world. To simplify the positioning of objects, only one plane of the home grid is visible in each viewport. (Most commonly it is the XY plane shown, where you place characters and objects.) The next illustration shows all three planes as they would appear if you could see them in a single perspective viewport.

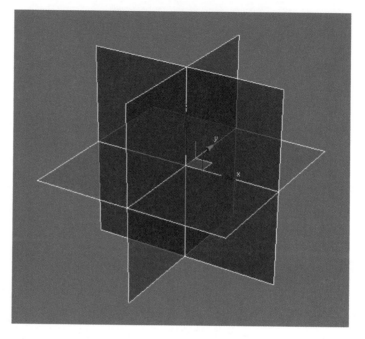

The three home grid planes of each viewport

Axes, planes and views

Two axes define each plane of the home grid. In the default Perspective viewport, you are looking across the XY plane (ground plane), with the X axis running left-to-right, and the Y axis running front-to-back. The third axis, Z, runs vertically through this plane at the origin.

3ds Max uses a unique Reference Coordinate System. The axis labels will be based on the selected system. If you use World, these axes will remain constant. If you use View (the default), the viewport axes will change based on which view is active. The Reference Coordinate System is chosen on the main toolbar.

AutoGrid

The AutoGrid feature lets you create and activate temporary grid objects on the fly. This lets you create geometry off the face of any object by first creating the temporary grid, and then the object.

The auto grid feature

Note: *To make the grid permanent, hold down the Alt key before you click. The grid becomes active and 3ds Max turns AutoGrid off.*

Understanding views

There are two types of views visible in viewports:

- Axonometric views show the scene without perspective. All lines in the model are parallel to one another. The Top, Front, Left, and User viewports are axonometric views.
- Perspective views show the scene with lines that converge at the horizon. The Perspective and Camera viewports are examples of perspective views.

Understanding 3ds Max

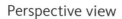

Perspective view

A perspective viewport, labeled Perspective, is one of the startup viewports in 3ds Max. You can change any active viewport to this "eye-like" point of view by pressing **p**. Perspective views most closely resemble human vision, where objects appear to recede into the distance, creating a sense of depth and space.

A building from a perspective view

Axonometric views

There are two types of axonometric views you can use in viewports: orthographic and rotated. An orthographic view is a straight-on view of the scene, such as the view shown in the Top, Front, and Left viewports. You can set a viewport to a specific orthographic view using the viewport's right-click menu or keyboard shortcuts. For example, to set an active viewport to Left view, press **L**. You can also rotate an orthographic view to see the scene from an angle while retaining parallel projection. This type of view is represented by a User viewport.

The same building from a rotated axonometric view

Axonometric views provide an undistorted view of the scene for accurate scaling and placement. A common workflow is to use axonometric views to create the scene, and then use a perspective view to render the final output.

Camera view

Once you create a camera object in your scene, you can change the active viewport to a camera view by pressing **C** and then selecting from a list of cameras in your scene. You can also create a camera view directly from a perspective viewport, using the **Create Camera from View** command (or use the hotkey combo **Ctrl+c**). A camera viewport tracks the view through the lens of the selected camera. As you move the camera (or target) in another viewport, you see the scene move accordingly. This is the advantage of the Camera view over the Perspective view, the Camera view can be animated over time. If you turn on **Orthographic Projection** on a camera's **Parameters** rollout, that camera produces an axonometric view like a User view.

The camera view

Understanding 3ds Max

Controlling viewport rendering

You can choose from multiple options to display your scene. You can display objects as simple boxes, or render them with smooth shading and texture mapping. If you want, you can choose a different display method for each viewport.

The same model in box display, wireframe display and smooth shading

Tip: *If you want to display individual objects as wireframe, you can use Wireframe materials. If you want individual objects to display as boxes, you can select the object and choose Display as Box on the Display properties rollout on the Display panel.*

The rendering level you choose is determined by your need for realistic display and accuracy versus speed. For example, Box Mode display is much faster than Smooth Shading with Highlights. The more realistic the rendering level, the slower the display speed.

Note: *Viewport rendering has no effect on final renderings.*

Rendering methods and display speed

The rendering methods not only affect the quality of your view display, they can also have a profound effect on display performance. Using higher quality rendering levels and realistic options slows display performance.

After setting a rendering method, you can choose additional options that adjust display performance. One of these controls, Adaptive Degradation, speeds up display performance when you use realistic rendering levels.

Creating shapes

A *shape* is an object made from one or more curved or straight lines. Shapes are 2D and 3D lines and groups of lines that you typically use as components of other objects. Most of the default shapes are made from splines. You use these spline shapes to generate planar and thin 3D surfaces or to generate extrusions. 3ds Max supplies 11 basic spline shape objects. You can quickly create these shapes and combine them to form 2D and 3D objects.

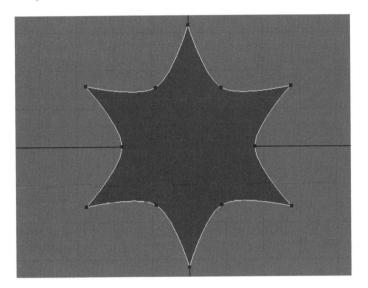

A star created from a shape

Modeling objects

You can start with a variety of 3D geometric primitives to model objects. You can also use 2D shapes as the basis for lofted, lathed or extruded objects. You can convert objects to a variety of editable surface types, which you can then model further by pulling vertices and using other tools.

Understanding 3ds Max

Introduction

Modifying objects

You sculpt and edit objects into their final form by applying modifiers from the Modify panel. They can change the geometry of an object, and its properties. Bend and Twist are examples of modifiers. There are other general things to know about using modifiers:

- You can apply an unlimited number of modifiers to an object or part of an object.
- When you delete a modifier, all its changes to the object disappear.
- You can move and copy modifiers to other objects.
- The order or sequence in which you add modifiers is important. The modifier stack is a set of instructions to the program, in a sense a history. Each modifier affects those that come after it. The modifiers at the bottom of the stack are performed first, then each modifier operation is performed next, moving up the stack to the top.

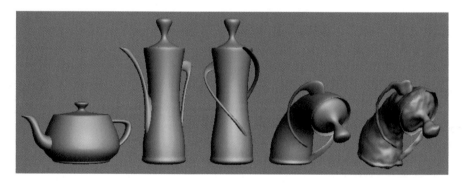

Each step of the teaport transformation with four different modifiers

Using the modifier stack

The modifiers you apply to an object are stored in a stack. The modifier stack and its editing dialog are the keys to managing all aspects of modification. By navigating up and down the stack, you can select and change the effect of a modifier, revisit and adjust it's parameters or remove it from the object entirely. Changing the order of the modifiers can produce a completely different effect. You can also choose to "collapse" the stack and make your changes permanent.You use these tools to:

- Find a particular modifier and adjust its parameters.
- View and manipulate the sequence of modifiers.
- Copy, cut, and paste modifiers between objects, or sets of objects.
- Deactivate the effect of a modifier in the stack, the viewport display, or both.
- Select a modifier's components, such as gizmo or center.
- Delete modifiers.

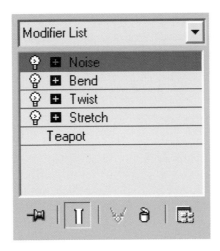

The modifier stack of the teapot objects

The modifier stack (or "stack" for short) is a list on the Modify panel. It contains the accumulated history of a selected object and any modifiers you have applied to it. Internally, the software "evaluates" an object beginning at the bottom of the stack and applies changes to the object by moving sequentially to the top of the stack. You should therefore "read" the stack from bottom up to follow the sequence used by the software in displaying or rendering the final object. With the stack feature, no modification has to be permanent. By clicking an entry in the stack, you can go back to the point where you made that modification. You can then rework your decisions, temporarily turn off the modifier, or discard the modifier entirely by deleting it. You can also insert a new modifier into the stack at that point. The changes you make ripple upward through the stack, changing the current state of the object.

Understanding 3ds Max

The Skin modifier

The Skin modifier is a skeletal deformation tool that lets you deform one object with another object. Mesh objects can be deformed by bones. Applying the Skin modifier and then assigning bones gives each bone a capsule-shaped "envelope." Vertices of the modified object within these envelopes move with the bones. Where envelopes overlap, vertex motion is a blend between the envelopes.

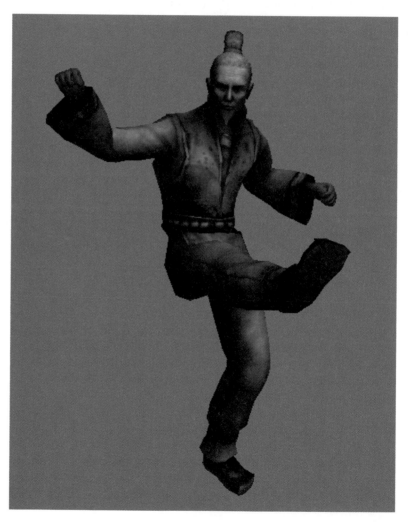

The Skin modifier deforms the fighter's body

The UVW mapping coordinates

Mapping coordinates specify the placement, orientation, and scale of a map on the geometry. Coordinates are often specified in terms of U, V, and W, where U is the horizontal dimension, V is the vertical dimension, and W is the optional third dimension, representing depth. Most Geometry objects have an option for generating mapping coordinates. Objects need these mapping coordinates if you plan to apply a mapped material to them. You can apply mapping coordinates through the use of various modifiers, such as the UVW Map Modifier, or the Map Scalar Modifier. Mapped materials include a wide range of rendered effects, from 2D bitmaps to reflections and refractions.

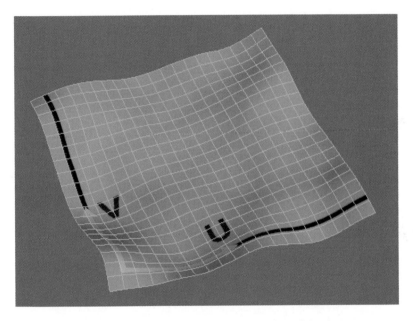

The UV coordinate map follows the noisy surface of the object

Note: *Mapping coordinates are local to each object, so they are termed UV or UVW coordinates, as opposed to the XYZ coordinates of the scene as a whole.*

Understanding 3ds Max

Unwrap UVW

The Unwrap UVW modifier is used to assign planar maps to sub-object selections, and to edit the UVW coordinates of those selections. Existing UVW coordinates on an object can be unwrapped and edited as well. Maps can be adjusted to the proper fit on a polygon model. The Unwrap UVW modifier can be used as a self-contained UVW mapper and UVW coordinate editor.

The unwrapped UVW mapping coordinates of the fighter

Material design

You design materials using the Material Editor, which appears in its own floating dialog. You use the Material Editor to create realistic materials by defining hierarchies of surface characteristics. Maps can also be used to control the appearance of environmental effects such as lighting, fog, and the background.

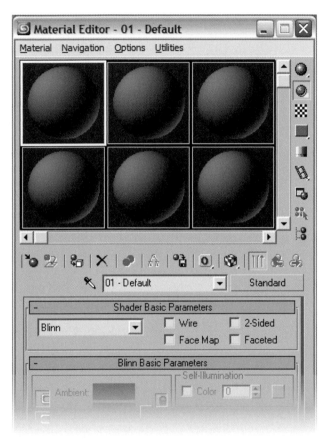

The Material Editor

You can enhance the realism of a material by applying maps to control surface properties such as texture, bumpiness, opacity, and reflection, among others. Most of the basic properties can be enhanced with a map. Any image file, such as one you might create in a paint program, can be used as a map, or you can choose procedural maps that create patterns based on parameters you set. The program also includes a raytrace material and map for creating accurate reflections and refraction. The program also includes specialized materials for use with mental ray, the advanced renderer that comes with 3ds Max.

Animation

You can begin animating your scene at any time by turning on the Auto Key button. Turn the button off to return to modeling. You can also perform animated modeling effects by animating the parameters of objects in your scene. When the Auto Key button is on, 3ds Max automatically records the transform and parameter changes you make, not as changes to a static scene, but as keys on certain frames that represent time. 3ds Max is unique in its approach to animation, for virtually every parameter available in the Command Panels can be animated. If you need a box to grow, you can animate its height, rather than using a scale transform. To animate an obejct bending, simply animate the bend angle or direction value. The possibilities are limitless; this is one of the chief reasons 3ds Max is such an exciting program to use. This paradigm sets 3ds Max apart from most other animation and modeling programs available on the market today. You can also animate many parameters to make lights and cameras change over time, and you can preview your animation directly in the 3ds Max viewports.

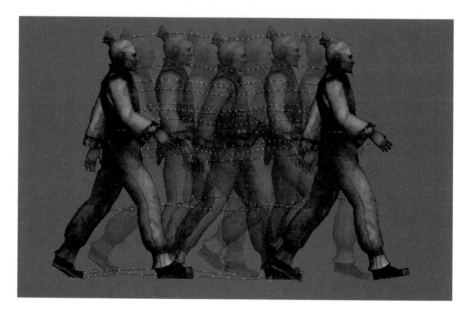

The animation steps of a walk cycle

Editing animation

You edit your animation by opening the Track View window, or using the Trackbar, or by changing options on the Motion panel. Track View is like a spreadsheet that displays animation keys along a time line. You edit the animation by changing the keys. Track View has two modes. You can display the animation as a series of function curves that graphically show how a value changes over time in the Curve Editor mode. Alternatively, you can display your animation as a sequence of keys or ranges on a grid in the Dope Sheet mode. Keyframes are also displayed in the Trackbar directly below the timeslider, and a Mini Curve Editor can be opened there as well for quick access to function curves.

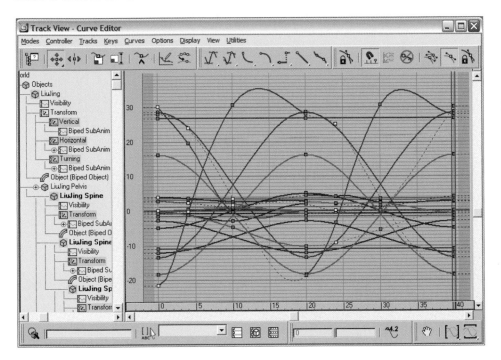

The animated keys represented in the Curve Editor

Understanding 3ds Max

Lights

You create lights with various properties to illuminate your scene. The lights can cast shadows, project images, and create volumetric effects for atmospheric lighting. Physically based lights let you use real-world lighting data and compute global illumination (bounced lighting) in your scenes.

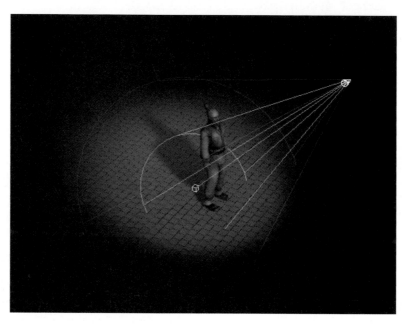

The Spot light effect

Rendering

Rendering turns your 3D model into a 2D image, adding color and shading as part of the process. The renderers available with 3ds Max includes features such as selective ray tracing, analytical antialiasing, motion blur, volumetric lighting, and environmental effects. When you use the default scanline renderer, a radiosity solution can provide accurate light simulation in renderings, including the ambient lighting that results from reflected light. When you use the mental ray renderer, a comparable effect is provided by global illumination.

A render of a building using mental ray renderer

Conclusion

Now that you have a basic understanding of what 3ds Max is designed to do, it is time to start working with the system directly. The concepts outlined in this introduction will become clearer as you gain experience with them firsthand.

Understanding 3ds Max

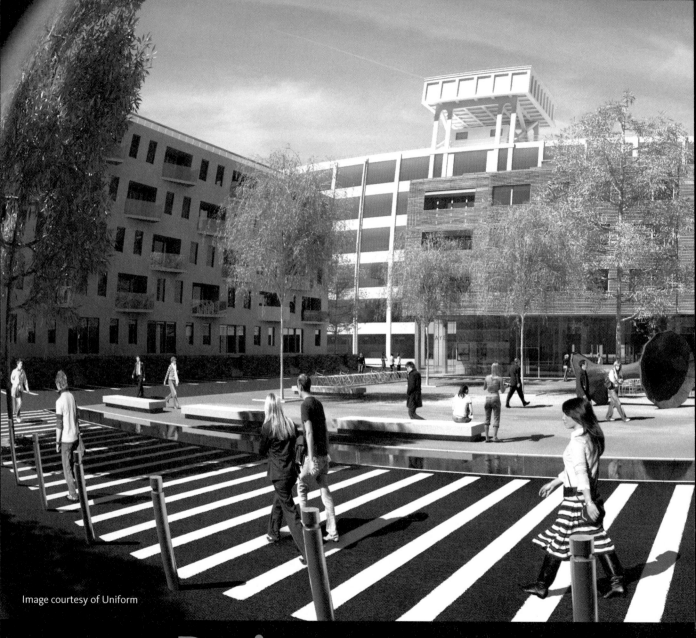

Image courtesy of Uniform

Project 01

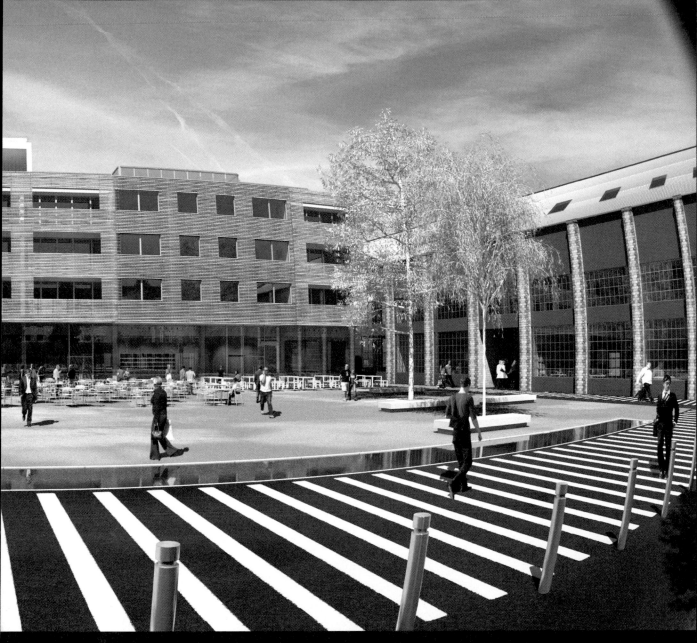

In Project One, you are going to learn the basics of object creation, along with the fundamentals of animation, materials and textures. This will give you the chance to explore the Autodesk® 3ds Max® software interface while building your scene.

You will start by creating a building from a design visualization point of view. You will then fill it with simple models in order to learn about creating, moving, and modifying objects. Then, you will experiment with materials and textures to render your scene. Once that is done, you will explore the fundamentals of hierarchies and animation by creating a simple door animation.

These lessons offer you a good look at some of the key concepts and workflows that drive 3ds Max. Once this project is finalized, you will have a better understanding of the 3ds Max user interface and its various modules.

Lesson 01
Primitives

This lesson teaches you how to build and transform basic objects in 3D space to create a simple environment and building visualization, which you will use to set up all animation in this book. You will explore the Autodesk® 3ds Max® user interface (UI) as you learn how to build and develop your scene.

In this lesson you will learn the following:

- How to set up project folders in 3ds Max;
- How to set up display units;
- How to create basic primitive objects;
- How to use the Snap tool;
- How to use the modifier stack;
- How to change the viewport settings;
- How to apply texture-mapped materials to a plane;
- How to create an Editable Poly object from a spline;
- How to clone objects with the Clone tool;
- How to extrude polygons with the Bevel modifier;
- How to align objects to each other;
- How to clone objects with the Array tool;
- How to change the display of your objects;

Setting up 3ds Max

The first step is to install the Autodesk® 3ds Max® 2008 software. When installing 3ds Max, notice that you can choose which files to install and where to install them. Take note of the default locations selected and change them only if you have good reason. Don't try to install 3ds Max onto a removable drive, such as an external USB drive. Stick to an internal nonremovable drive or you will have license issues.

During the install you will also observe that some of the files that are part of the 3ds Max software package don't install as a default, and some won't install with any option, you have to manually copy them from the DVD to your own local hard drive. In particular the scene files required for the 3ds Max tutorials do not install, nor do the samples folders. Use Windows® Explorer or *My Computer* to copy the *Samples* and *Tutorials* folders files to your local 3ds Max root directory after the install process is finished.

Now run 3ds Max by clicking the desktop icon, or choosing **Start** → **All Programs** → **Autodesk** → **Autodesk 3ds Max 2008 32-bit MAX**.

It is important to check that your software will actually run at this point. If you have downloaded a trial version of the software, and the software doesn't run, you may have a corrupted download. Try to download it again, try using Firefox® instead of Internet Explorer.

The first time you start 3ds Max you should see a screen that asks you which type of video drivers you want to use. It's usually a good idea to accept the defaults during these installations; just click OK and continue. 3ds Max then will start and you will see the 3ds Max interface with four viewports surrounded by tools of all kinds.

At this point, you can minimize the 3ds Max window, and copy the Learning 3ds Max 2008 Foundation support files to your Max *projects* folder. The support files are found in the *support_ files* directory on the DVD-ROM included with this book. Why didn't you do this earlier? Because in order to find your *projects* folder, you need to launch 3ds Max at least once so that it creates your personalized user directory structure. Here is where the *projects* directory is typically located on your machine (substituting your own name for [username]):

C:\Documents and Settings\[username]\My Documents\3dsmax

> **Note:** *After copying the files to your local projects folder, ensure that the support files are not read-only after you copy them from the DVD-ROM. To do this select all the files, right-click, and choose Object Properties and turn off Read Only.*

In order to follow the lessons in this book, you should be using default preferences. If you have been working with 3ds Max and have changed any of your user interface settings, you may want to delete or back up your preferences in order to start with the default 3ds Max configuration. These preferences are stored in a file called *3dsmax.ini*. The default location for this file is:

C:\Documents and Settings\[username]\Local Settings\Application Data
Autodesk\3dsmax\2008 – 32bit\enu\3dsmax.ini.

Note: *This location will change if you are running the 64 bit version of 3ds Max, or if you are running another language version other than English.*

If you shut down Autodesk 3ds Max and then rename the *3dsmax.ini* file and relaunch the program, a new *3dsmax.ini* file will be created. This is a way to reset your preferences to the factory defaults. You could also edit this file using Notepad, but that practice is not for the faint-of-heart.

Creating a new project

3ds Max uses a project directory structure to store and organize all of the files (scenes, images, materials, textures, etc.) related to a particular scene. When building a scene, you create and work with a variety of file types and formats. The project directory allows you to keep these different file types in unique subdirectory locations within the project directory. This makes moving files from machine to machine a lot easier, so it's good practice to understand the project folders.

1 **Launch 3ds Max**

2 **Set the project**

To manage your files, you can set a project folder that contains subdirectories for different types of files that relate to your project.

- Go to the **File** menu and select **Set Project Folder...**

 A window opens that directs you to the Max projects directory.

- Click on the folder named *project1* to select it.

Lesson 01: Primitives

Project 01

The Browse for Folder window

- Click the **OK** button.

 This sets project1 as your current project and ensures that 3ds Max is looking into the proper subdirectories when it opens up scene files.

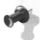

Note: *If you don't see the project folders you want, you can click Make New Folder to create new ones. You should have created these, however, when you copied the DVD files to your own local installation.*

3 **Make a new scene**

- Select **File → New...**

- In the dialog box that appears, select **New All → OK.**

 This will create a new scene in the current directory when you save it.

- Select **File → Save As**. In the **Save File As** dialog give the file the name *MyBuilding.*

> **Tip:** *You can get very involved with your work and forget to save! It's a good habit to start by saving a scene with an appropriate name. As soon as you save, the clock is turned on for the AutoSave function. So if you save at the start, the program will then AutoSave every 15 minutes thereafter.*

Build the environment

Every scene you create in 3ds Max will most likely contain 3D objects of various types. These could be objects created within 3ds Max, or objects brought in from other programs. In the CAD world you'll often import geometry from Revit® or Autodesk Architecture, (or even AutoCAD®). In the entertainment world you may be importing characters or vehicles from Mudboxx or Maya®, Lightwave® or modo. For this scene, you will create a building, but first, you will need a large outdoor environment.

To start, you will build a ground plane surrounded by a large sky dome. These first objects will be a plane primitive and a sphere primitive. You can view the finished scene to get an idea of what you are about to create by opening the file called *01-building_01.max*.

1 Set World Units

To create a real-world scene in 3D space, you have to make sure that you are working in real-world units, like the metric system. By default, 3ds Max uses Generic Units, which have no counterpart in real-world distance.

- To change these units, from the main menu select **Customize** → **Units Setup...**

- In the **Display Unit Scale** option of the **Units Setup** dialog that appears, select the **Metric** option and use the **Meters** scale from the drop-down list.

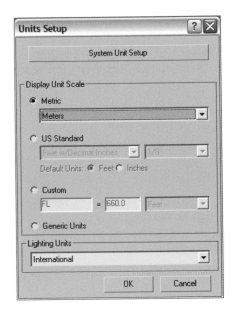

Units Setup option dialog

Because you will work with large-scale objects in your scene, you must also change the 3ds Max system unit to centimeters.

- To set the System Unit, select the **System Unit Setup** from the previous **Units Setup** windows.

The **System Units Setup** *dialog will pop up.*

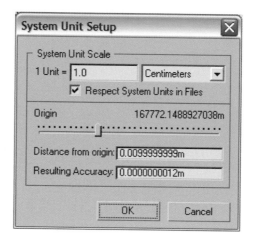

The System Unit Setup dialog

- With the drop-down menu in the **System Unit Scale** option, change the unit from **Millimeters** to **Centimeters.**

- Click the **OK** button to accept and close the **System Unit Setup** dialog, and click **OK** again to accept and close the **Unit Setup** dialog.

The System Unit and the Display Units work together to handle the calculations in the scene. If the System Unit is too small, it can get in the way of entering values in text entry fields. If the Display Units are too small you will experience viewport navigation anomalies.

2 Change Command Panel

There are six main command panels in 3ds Max: *Create, Modify, Hierarchy, Motion, Display* and *Utilities*. These panels are accessible by icons in the top-right corner of your 3ds Max interface and are used to access almost every tool in 3ds Max. You can also access most of these tools from the menu bar as well.

- From the *Create* panel at the right side on the 3ds Max interface, there are seven icons in a second row. The first icon is highlighted, with a yellow background. Move your cursor over the highlighted icon and pause for a moment. A Tooltip will appear.

Hover your mouse over any tool to display a Tooltip identifying its purpose

- Just below the Create submenus, there is a drop-down box that lets you specify the kind of geometry you want to create. Notice that the Standard **Primitives** option is selected.

Geometry submenu of the Create command panel

3 Create a polygonal plane

A Plane primitive will be used as a large construction site for the building. You will build it using polygonal geometry. Throughout this lesson and in the next project, you will learn more about this geometry type.

- Select **Plane** from the box buttons.

 Once you click the Plane button, new options relevant to plane creation will appear in your Create control panel. Some rollout options are closed but can be displayed using the + sign next to the rollout name to open them.

Polygonal plane created

- Move your cursor over the Perspective viewport, which should be highlighted in yellow. Notice that the cursor changes to show you what tool it is. Press and drag out a plane across the grid visible in the viewport. The first point where you press the mouse button down sets a corner of the plane. Moving the cursor defines the height and width, and releasing the mouse button sets the second corner and ends the creation of that object. The Plane tool is still active and ready to create a second object.

- Look in the Parameters rollout. You can see the Length and Width in meters.

- Enter **1000** for both **Length** and **Width**. Swipe the field with your cursor, type in the value, and then use the **Tab** key to move to the second field. Press **Enter** to complete the operation. Now the entire viewport is filled with the plane; no empty space is visible.

- Press **Alt+Ctrl+Z**, the hotkey for Zoom Extents. The huge plane is now visible in the viewport.

Note: *You can undo viewport changes by pressing SHIFT+Z. Try it now. Then try to zoom in or out in any view to see the entire scene by rotating your mouse wheel up or down.*

When you created the plane you dragged it out in the viewport and then adjusted its size immediately thereafter. If you want to reverse the process you can use the Keyboard Entry rollout, where you define the size and location and then click **Create**. Use this method if you know the precise size and location of an object ahead of time.

4 Modify the plane

You should rename the plane to make it easier to find later.

- Make sure that your plane is selected and go to the **Modify** panel to access the Modify menu for your plane object.

- Press and drag on the *Plane01* name at the top of the modify panel to highlight the text for editing.

- **Type** the name *ground* and then press the **Enter** key.

 As you can see, all the plane parameters are visible in the Modify panel.

Plane option rollouts

Lesson 01: Primitives

Note: *Next to the plane name, you have an Object color box with the actual color of your plane. You can click on it to change the color of your plane, but it's only a temporary color that will change later when you apply a material.*

- Change your viewport display to *wireframe* mode by pressing **F3**.

 The F3 key is a toggle to switch between the Smooth+Highlight and Wireframe viewport shading modes. You will use it often during your lessons to check your scene in wireframe mode.

- On the Modify panel, in the Parameters rollout, decrease the **Length Segs** and **Width Segs** parameters to **1**. You can click the down spinner to cycle through the integer values.

 Notice how the wireframe of the plane changes in the viewport.

Plane object with changed parameters

5 Create the sky

You will now create another object to be used as a large sky dome. To make sure the sky is centered at the same position as the plane created before, you will use the Snap tool.

- Click the Create panel tab.
- Notice that the **Geometry** sub-menu is already active.
- In the Object Type rollout, select **Sphere** to activate the Sphere Parameters rollout.
- Set the **Hemisphere** value to **0.5**
- Go to the **Top** viewport by pressing **T**.
- Activate the **Snap** tool by pressing **S**.

 By default, the Snap tool will snap your cursor to the grid points of the viewport. Other snapping options can be set by right-clicking the **Snaps Toggle** *icon in the main toolbar.*

The Snap tools

Note: *When you zoom in or out in any orthographic view (top, left, or front), the grid side changes, making the Snap tool more or less precise. Try different zoom levels in theses views to see how the Snap tool reacts.*

- **Click** and **Hold down** the **LMB** from the center of the world, **Drag** the mouse to one side of the plane, and release the **LMB.**

Tip: *You can also toggle the snap on and off during an object creation using the S key, so you can snap the center point but not snap the radius of the hemisphere, for example.*

Tip: *You can toggle on and off your objects' edged faces in the smooth+highlight mode by pressing the F4 key . Edged face mode combines wireframe and shaded modes; it shows the geometry and the surface at the same time.*

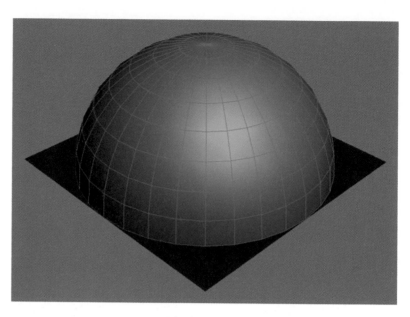

The ground plane and the sky dome with edged faces

6 Flip the normals

The sphere you've created has the right size and position but needs some modification to be useful as a skydome. The dome will be used as a sky for your scene but right now, you cannot see what is inside the dome except by putting your camera into it. In order to see what's inside from any position, you will make your sky dome polygon visible only from the inside.

- **Rename** the *Sphere01* to *Skydome*.

- Go to the **Modify Panel** and click on the **Modifier List** drop-down arrow.

 A huge list of modifiers will show up, revealing all the modifiers you can apply to this object.

- Select the **Normal** modifier and activate the **Flip Normals** check box from its parameters.

 The Normal modifier is applied to the sky dome and now appears in the modifier stack higher up in the control panel.

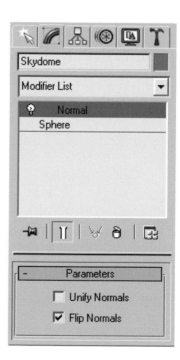

The modifier stack with the Normal modifier applied to the Skydome

The skydome turns black because the face normals on the sphere are now facing inward. The back sides of the polygons are shown in black, because a property named BackFace Cull is off by default. If you zoom the view until you are inside the sphere you will see the scene properly. Toggle the Flip Normals modifier to see the surface display and disappear.

Note: *You can activate and deactivate the modifier by clicking on the light next to its name in the modifier stack.*

7 BackFace culling

You will now hide the faces pointing away from the camera, which will allow you to see through the skydome geometry.

- **RMB** on the skydome to display the **Transform** quad menu.

The quad menu of the sky dome (only two menus showing)

• **Select Object Properties...** from the *Transform* quad menu.

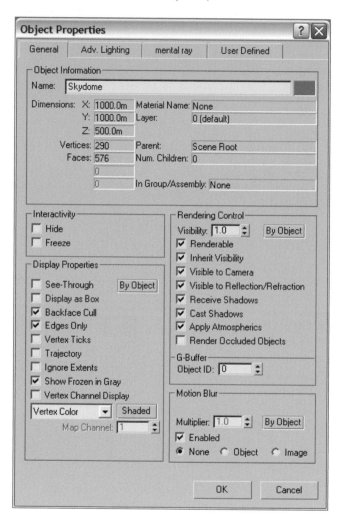

The Object Properties for the skydome object

• Activate the **Backface Cull** check box from the **Display Properties** and click **OK**.

With the Backface Cull option activated and the normals flipped, it is now possible to see through the skydome. It will be easier that way to work underneath the sky geometry.

8 **Deleting a polygonal face**

Notice that on the ground, the skydome and the ground are on the same level, making it hard for the viewport to decide which one to draw. To correct that, you will delete the polygons of the skydome floor.

- Add the **Edit Poly** modifier to the skydome object.

- Click the **Vertex** icon in the **Selection** rollout menu.

 *Notice that the **Edit Poly** modifier in the modifier stack has turned yellow to show that you are in a subobject level of the modifier. You can always access theses subobject levels using the + sign next to the name of the modifier in the modifier stack. Or you can use the hotkeys 1 through 4 to cycle through the subobject selection levels.*

- In the viewport, select the vertex in the middle of the world and press the **Delete** key.

 The polygons attached to this vertex have disappeared and the ground is now easier to see.

- Click again on the **Vertex** icon in the **Selection** rollout menu to exit the vertex sublevel.

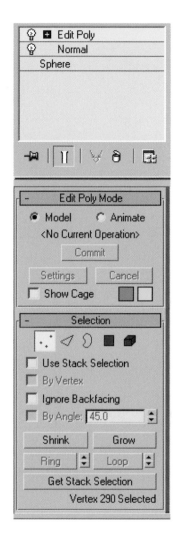

The Edit Poly modifier for the Skydome object

Lesson 01: Primitives

Project 01

The final skydome and ground objects

Viewing the scene

When you work in 3D space, it is important to see your work from different angles. The different viewports let you see your work from the front, top, side and Perspective angles. The viewports that are at right angles to the world are called orthographic views (Front, Back, Top, Bottom, Left, Right). The viewports that are not square to the world are either Perspective, User, or Camera viewports, often called three-quarter views in traditional animation practice. Perspective and Camera viewports use a vanishing point perspective, while User views are isometric—there is no convergence; diagonal lines stay parallel to each other.

The Viewport Navigation tools can be used to move about your viewport. You can Zoom in and out, Pan up, down and sideways. You can use the Arc-Rotate tool to move in a circle around your scene. If you are in a Camera viewport, you'll have the added ability to animate the camera move.

Once you are familiar with these tools, you can use keyboard shortcuts to invoke them, or keystroke+MMB combinations as well. There are even special controllers you can buy to move through 3D space in your viewport.

1 **Navigate the Perspective view**

- To zoom in and out in the Perspective viewport, click the magnifying glass icon in the **Viewport Navigation** controls; then press and drag in the viewport. Moving the mouse up zooms you in, moving the mouse down zooms you back in space. Press **ALT+Z** to access zoom through the keyboard.

The Zoom (magnifying glass) icon

- To pan the viewport, click the Pan Hand icon, and then move in the viewport. The movement will stay aligned to the picture plane or the frame of the viewport. You might say the movement happens in "Screenspace". Press **CTRL+P** to activate this command with hotkeys.

The Pan Hand icon

- To orbit the viewport, click the Arc-Rotate icon, which displays a Navigation Orb in the viewport. Move your cursor within the navigation orb and press and drag within the navigation orb. If you press on the small yellow square you can orbit in a constrained manner, along a single axis.

The Arc-Rotate icon

Tip: *Notice that the world axis in the lower corner of the viewport changes as you Arc-Rotate your view.*

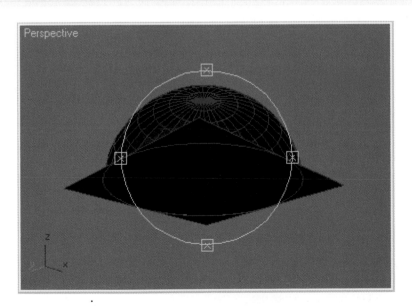

Perspective Viewport with World Axis

Lesson 01: Primitives

{}

You can also use the **MMB** with two keys to orbit, pan, and dolly in your Perspective view.

- Change your view using the following key combinations:

 MMB + Alt to orbit;

 MMB + Ctrl to pan;

 MMB + Alt+Ctrl to dolly.

Note: *Notice that when you navigate into your scene, the object switches to wireframe mode until you release the MMB. This display is called Adaptive Degradation. You can toggle this option on and off with the O hotkey. This feature will help you navigate in a scene that has many polygons, but if your computer is fast enough, you'll prefer to keep the smooth+highlight mode on with no degradation while navigating your scene.*

- You can dolly using the **mouse wheel**.

 *This technique will dolly but not as smoothly as with the **MMB+Alt+Ctrl** keys. Still, it is useful when you want to dolly quickly on a precise section of the view or dolly out to get the general look of the scene and come back to the same view as before.*

- You can also undo and redo view changes using the following keys:

 To **undo** views use **Shift+Z**;

 To **redo** views use **Shift+Y**.

Walk Through Mode on Flyout menu

- You can also navigate through your scene using Walk Through mode. Notice the Pan Hand icon has a small blade triangle in the lower right corner. Press and hold the LMB on this icon, and a flyout menu will appear. Drag to the picture of two footprints and release the mouse. Now you can navigate in the viewport like a first-person camera in a video game. Press and hold the LMB, then press the **Up Arrow** on the keyboard. Once this mode is activated, you will see an aim target as your cursor. Use the **LMB** to control the camera view and the four directional arrows at the same time to navigate in your scene. You can increase your moving speed using the **]** key or make it slower using the **[** key.

Tip: *If you like the key configuration of first person shooter games, you can also use the **W,A,S,D** keys to move the camera.*

2 Four viewports

By default, four windows are shown in the user interface; the Perspective view and three Orthographic views—top, side, and front—that show you the model from projected views. You can maximize one of these views by clicking in the viewport to select it (the viewport will be highlighted in yellow), and use the **Alt+W** key. You can also use the **Maximize Viewport Toggle** button from the Viewport Navigation Controls; it's at the bottom-right corner of the lower interface toolbar.

The Maximize Viewport toggle button

3 Zoom Extent and Zoom Extent All

Another quick way to navigate in the scene is to use the *Zoom Extent* tools. Theses tools are located in the viewport **Navigation Controls** at the bottom-right corner of the *lower interface toolbar*. If you press and hold a second on it with the **LMB**, new icons will appear on a flyout menu. These new icons are Zoom Extents Selected (with the white box) and Zoom Extents All Selected. They are the same as the Zoom Extents and Zoom Extents All features but will zoom back to frame on the selected objects rather than the whole scene; and if no object is selected, they will frame the whole scene as the *Zoom Extent* tool. These are really handy when you have a complex scene and you need to navigate to see a certain object. Just select the object by name and do a Zoom Extents Selected.

The Zoom Extent and Zoom Extent All buttons

Note: *Any icon that has a tiny black triangle in its lower-right corner has a flyout menu.*

- Select the *ground* plane.
- While in the *four view* ports, press the **Alt+Ctrl+Z** hotkey to frame everything in your scene but only in the highlighted viewport.
- Now press the **Shift+Ctrl+Z** hotkey to frame everything in your scene in the four views.
- Press the **Z** hotkey to frame the selected objects in all viewports.

4 Hide the grid

You can hide the home grid to simplify your view using one of two options:

- From *any* viewport's name in the top-left corner, use the **RMB** to display its option menu and select **Show Grid** to hide the grid for that view only.

 OR

- Simply press **G** on the keyboard to hide or unhide the grid in the active viewport.

5 Save your file

You've created a skydome and a groundplane and turned the dome inside out. This is a good time to stop and save your work.

- On the menu bar choose **File** → **Save As**.
- In the Save File As dialog give the file a name like *MySkydome.max* in the file name field and press **Save**.

Tip *Never use Save, always use Save As. It's too easy to Save over something you don't mean to save over when you use Save.*

Building reference

Now that you know how to place objects and interact with the Perspective view, you can create the building itself. To do so, you will import a blueprint to be used as a reference.

Note: *In the world of design visualization, you would probably import a DWG file from a CAD program, rather than draw on top of a blueprint texture, as we're doing here. Don't let that worry you; you'll be learning good fundamentals here just the same. And you never know when you'll have to model a building from a napkin sketch!*

Project 01

1 Loading the blueprint as reference

To create the building, you will have to
load the blueprint image in your scene as
a reference. It will help you as a guideline
when you will create the basic structure of
the building. To avoid flickering between
the blueprint and the ground, you will
hide the ground while creating the
building.

- Select the ground.

- Use the **RMB** to activate the *quad menu.*

- Select **Hide Selection** from the *display
quad menu.*

- Maximize your Top viewport and frame
your whole scene.

- **Create** a new plane like the one you
made for the ground, by going to
Create Panel and choosing **Plane**.
Then open the *KeyboardEntry rollout*
of the Plane Creation tool, and set the
following:

 Length to **72**;

 Width to **165**.

- Hit **Create** to create your plane.

- Use the **Z** hotkey to zoom to the
extents of your new plane.

- **Rename** your plane as *Building
Blueprint.*

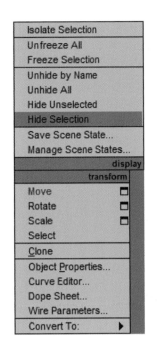

The Hide Selection option from the quad menu

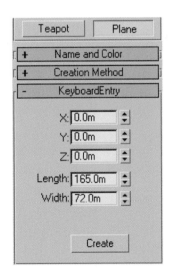

The KeyboardEntry rollout

Lesson 01: Primitives

2 Texture preferences

Before you can add the blueprint texture, you will change the display preferences to get a better texture resolution in your viewport.

- From the main menu, go to **Customize → Preference...**
- From the new **Preference Settings** dialog, go to the **Viewports** tab.
- **Select Configure Driver...** at the bottom of the dialog in the **Display Drivers** option.

The configuration options

- In the Configure Direct 3D dialog, activate the check box called **Match Bitmap Size as Closely as Possible** from the **Download Texture Size** section.

> **Note:** *These changes won't take immediate effect, they will only be enabled the next time you launch 3ds Max. You probably won't need this now, but if your bitmap looks choppy in the next section, you could click **Edit** → **Hold**, then exit 3ds Max, restart it, and then do an **Edit** → **Fetch** to return to this point in time.*

- Click the **OK** button to close and save the option window.

3 Open the Material Editor

- To open the Material Editor dialog, use its icon on the main toolbar or simply press the **M** hotkey.

The Material Editor icon from the main toolbar

In the Material Editor, you will see six default materials that all look the same; the first one, in the top-left corner, should be highlighted in white. If it is not, just click on it to highlight it.

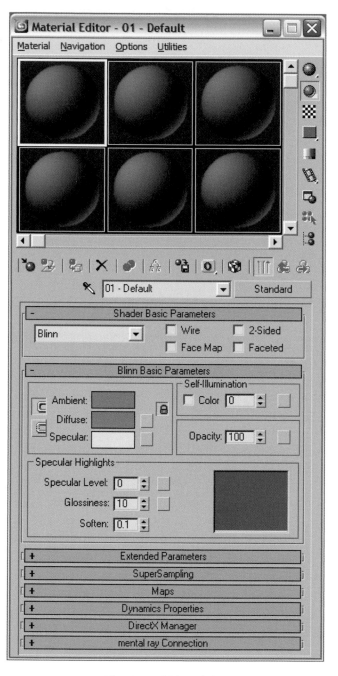

The Material Editor dialog

4 Create the blueprint material

- Swipe the *material name* dialog box and enter *Building Blueprint*.
- Click on the small blank gray square button to the right of the Diffuse color swatch in the Blinn Basic Parameters rollout, to select a new texture map.

The Material/Map Browser dialog will appear.

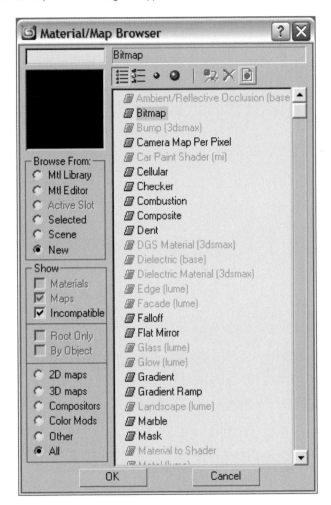

The Material / Map Browser dialog

Note: *Some map are in gray and are not selectable because they are mental ray maps, which can only be used when the mental ray renderer is activated. You'll only see these maps in the list if Incompatible is turned on in the Show group.*

• Select **Bitmap** from the map list and accept your selection with the **OK** button.

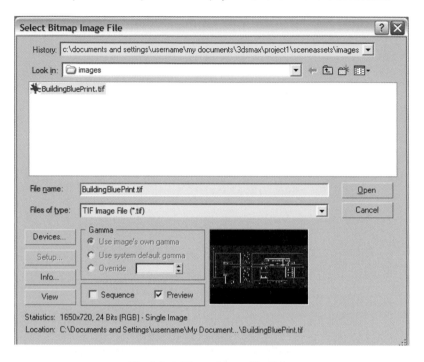

The Select Bitmap Image File dialog

Note: *The* **Select Bitmap Image File** *dialog should be by default in the project1\sceneassets\ images folder once you install the book's support files.*

• Select the *BuildingBlueprint.tif* and select **Open.**

The material preview in the Material Editor will update to display the texture.

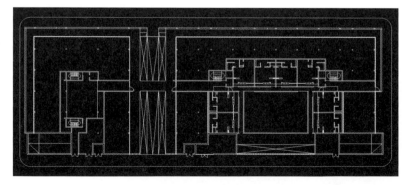

The blueprint to be used as a reference

- **Drag+drop** the *Material Sample* directly to the plane in your viewport or use the **Assign material to selection** button on the toolbar below all the Material Sample Slots.

 The material is assigned, but the plane merely turns gray because that is the diffuse color of the new material.

- To activate the diffuse map, use the **Show Map in Viewport** button on the toolbar below all the *Material Previews*.

 The blueprint should now be visible in the viewports. If the Top viewport doesn't display the bitmap, make sure Smooth and Highlight mode is active by pressing F3.

Create a sidewalk

Your first model will be a building pad on top of which you will model the building.

1 Sidewalk curve

Using the blueprint as a reference, you will create a curve to represent the sidewalk and building pad. You'll first freeze the blueprint plane to make it easier.

- Make sure the top view is active, and that the viewport is maximized.

- Set the viewport in **Smooth+Highlight** mode if it isn't already.

- Select the Building Blueprint object, then right-click to display the quad menu. In the Transform group, choose Object Properties. In the Display Properties section, turn off Show Frozen in Gray. In the Interactivity section, turn on Freeze. Now you can still see your blueprint texture, but you can't select it.

- In the **Create** panel, go to the **Shapes** icon (right next to **Geometry**), and then in the Object Type rollout, select the **Rectangle** tool.

 The Rectangle tool will create a 2D spline object that will be visible as a series of lines in your viewport.

The Create Shape menu option

Lesson 01: Primitives

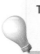

- Expand the **Interpolation** rollout, and then click the **Adaptive** check box.
- In the **Parameters** rollout, set **5m** for the **Corner Radius** value to make the corner of the sidewalk round, as in the blueprint.
- Create the rectangle in the viewport by making a selection from the top left corner of the purple line of the blueprint to the bottom right. Try to match the line as closely as possible.

> **Tip:** *If the rectangle is not as you would like it to be, just hit the **Delete** hotkey to start a new one. Or use the Move tool to reposition the spline, and then use the Modify panel parameters to fine-tune the size to fit.*

- **Rename** your spline to *Sidewalk.*

2 **Extrude the sidewalk curve**
- Add the **Extrude** modifier from the modifier drop-down list on the **Modify** control panel.

This modifier will set the height for your spline. To see a visual representation, go to the front view or the Perspective view and frame your sidewalk.

- In the **Parameters** rollout of the **Extrude** modifier, enter **0.15m** for the **Amount** value.

This extrudes the sidewalk 0.15 meter above the ground plane.

- Check the **Cap End** option to create the geometry all over the sidewalk.

The sidewalk over the blueprint

3 Sidewalk border

The sidewalk has a good shape but it would be nice if it had a small groove all around it. To add this, you will duplicate the spline you created earlier, and create a second piece of sidewalk.

- Select the *sidewalk* and **RMB** to show the Transform quad menu.
- Select the **Clone** option from the quad menu.

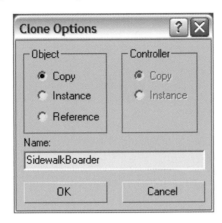

The Clone options

- Make sure the **Object** mode is set to **Copy.**
- **Rename** the copy object to *SidewalkBorder* and click on **OK** to clone the sidewalk.

 The new object you just cloned is exactly the same as the original. The modifier stack is also preserved but in this case, you do not need the Extrude modifier.

- Make sure you have the *SidewalkBorder* selected.
- In the Modify panel, on the modifier stack, **RMB** on the *Extrude* modifier name and select **Delete.**

Note: *You can also delete a modifier by activating it in the stack and then clicking on the garbage icon in the modifier stack area.*

The Remove Modifier from Stack icon

Lesson 01: Primitives

Project 01

- Make a new **copy** of the *SidewalkBorder* object using the Clone tool and **rename** it to *SidewalkBorderOut*.

- Go to the **Modify** panel to change some parameters of this new spline.

- Add **0.2m** to the current **Length** and the **Width** values.

The spline should now be bigger by 0.2m as shown in the following image. You'll have to zoom in close to see this in your viewport.

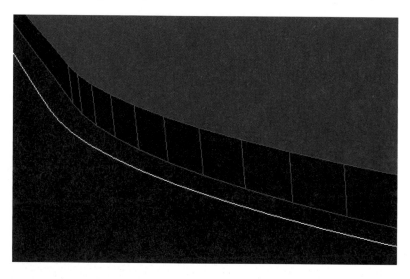

The new SidewalkBorderOut spline

4 Attach the curves together

- **Select** the spline called *SidewalkBorder* created earlier. If you can't find it by clicking in the viewport, press the **H** key on the keyboard.

Select From Scene dialog

The Select from Scene dialog appears.

- Click the Display: shapes icon (second from the left), and then double-click the Sidewalk Border object name to select it and close the dialog.

- Add the modifier call **Edit Spline** on it.

- Go to the **Geometry** rollout and click the **Attach Mult.** button.

The Geometry rollout of the Edit Spline modifier

A new window will appear, giving you the choice of the available splines that can be attached.

- Select the *SidewalkBorderOut* from the name list and hit **Attach** to accept your choice.

The two splines are now attached together, making them a single spline object.

5 Bevel the sidewalk border

- Go to the front view and frame one end of the sidewalk.

The end of the sidewalk

- Add a **Bevel** modifier to your new spline object, called *SidewalkBorder*.

- Set the following:

 End check box of the **Capping** section to **On**;

 Generate Mapping Coords check box of the **Surface** section to **On**;

 Smooth Across Levels check box to **On**;

 Segments to **2**;

 Curved Sides to **On**.

- Increase the value of the **Height** in the **Level 1** section.

 *You can match the height of the side walk with only the **Level 1 Height** value, but try to match it by activating the **Level 2** and **Level 3** checkbox and sharing the value between the three levels. You can also use the **Outline** value for each level to give the SidewalkBorder a nice round look.*

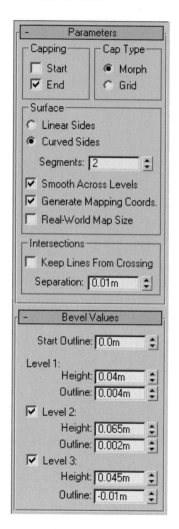

The bevel modifier

Tip: *If your values are too large in the Outline fields, you'll get crossed lines. You can go back down the stack to the Rectangle parameters and lower the corner radius to 4.45 m to counteract this.*

- Press **F4** to turn on Edged Face mode. **Tweak** the bevel modifier until you have the look you like.

The side view of the SidewalkBorder

Construct the building's foundations

Now that you have the sidewalk ready, you can start the construction of the building. You will need the blueprint again as reference. To make it easier, you will raise the blueprint plane on top of the sidewalk to create the new spline directly on the sidewalk.

1 **Align the blueprint**

- RMB in the viewport; then in the quad menu choose **UnFreeze All** from the **Display** quad**.**

- **Select** the *Building Blueprint* plane.

- From the **main toolbar**, hold down the **Quick Align** icon to display the flyout menu.

- **Select** the **Align** tool on the top of the icon list.

 Notice that your cursor has changed to the Align icon.

- Make sure you are in the front view (as you were before when creating the sidewalk border earlier) and hit the **H** hotkey to bring up the **Pick Object** dialog.

The available Align tools

- Click the Display: Shapes icon; then select the *Sidewalk* object from the list and hit **Pick** to accept your choice.

 *The **Align Selection** dialog will appear.*

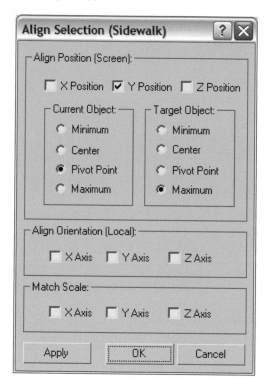

The Align Selection dialog

- You want to raise the blueprint, so enable only the **Y Position** checkbox.

- In the **Target Object** option box, change the target to the **Maximum** to place the plane on top of the sidewalk.

 *In the left viewport you can see the plane move as a preview when changing the **Target Object** option. Optionally, try the other target to see how it reacts.*

- Click **OK** to align the plane on top of the sidewalk.

- **Hide** the *sidewalk* and the *sidewalk border* by selecting them by name; then **RMB** and choose **Hide Selection**.

2 Draw the building outline

- Go to the top view and zoom to the extents of the *Building Blueprint*.

- Go to the **Shapes** submenu of the **Create** panel and select the **Line** tool.

- Activate the **AutoGrid** check box, located just above the Line tool button.

 This feature will start the creation of the Line on the surface of the object under your mouse cursor. In this case, it will start directly on the Building Blueprint.

- In the **Creation Method** rollout menu, make sure that the **Initial Type** and **Drag Type** options are set to **Corner.**

- Trace the contour of the first floor by clicking on each corner of the building, starting from the left side.

The Line tool options

Tip: *After creating your first point on one side of the building, hold the Shift key to draw straight lines.*

Note: *The first floor is represented in the blueprint as white lines. The green lines will be used for the other floors.*

3 Closing a spline

When you need to close a spline, you can simply select the first point displayed in yellow when the Line tool is still active. Doing so will bring up a confirmation window from which you can specify to close the current spline.

- With the Line tool still active, reselect the first point displayed yellow.
- In the dialog box, click **Yes** to close the spline.

Your first building contour is now created. To see it clearly, switch the viewport to wireframe mode using the F3 toggle.

4 Finish drawing all the outlines

Still in line-drawing mode, continue drawing the contour of the other building section. After making the entire contour, you should get something similar to the following:

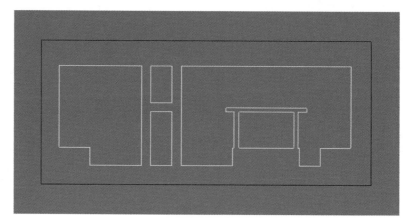

The contour of the building's first floor

- To **Rename** your new lines *Building Floor 01 Section 01* to *Building Floor 01 Section 05*, do the following: Select the splines by name using the **H** key; then, on the **Tools** menu, choose **Rename** Objects. Enter *Building Floor 01 Section* as the Base Name, and turn on **Numbered**, set the Base number to **1**, and click **Rename**. Press the **H** key again and you will see that the splines have been renamed.

5 Extrude the first floor

- Select the *Building Floor 01 Section 01* and apply an **Extrude** modifier on it.
- Increase the **Amount** value to **3m** from the **Parameters** rollout.
- Make sure that the **Cap End** and the **Generate Mapping Coords** options are enabled.
- **RMB** on the **Extrude** name of the modifier stack and select **Copy**.

- Now select the *Building Floor 01 Section 02* and **RMB** on the modifier stack and select **Paste Instanced**.

 *You should now see the **Extrude** modifier in the stack but written in italic type. This means that all the modifier values and options are linked together.*

- **Paste Instanced** the modifier on the other building sections.

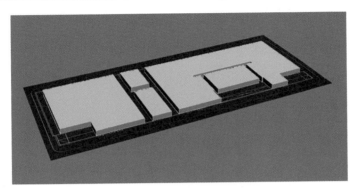

The extruded building floor

Tip: *If you select all the Building sections together, you should see the instanced Extrude modifier appear in the stack. So you can modify the Extrude modifier by selecting one or all the building sections at the same time.*

6 **Align the blueprint**

You will now continue with the second floor. All the remaining floors of the building will be alike, so you will create the first one and clone it after. You will start by placing the building blueprint on top of your first floor with the Move tool.

- **Select** the *Building Blueprint* plane.

- **RMB** in the viewport and choose the small button to the right of Move in the Transform quad menu.

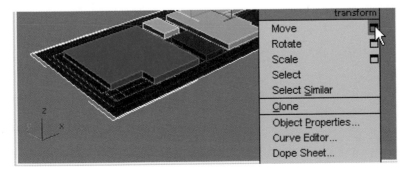

Move Settings button on Transform quad.

- In the **Offset: World Z** field type in **3m**. This will raise the blueprint 3 meters upwards, the same height as the extrusion.
- **Hide** all the building sections to focus on the next floor.
- Go to the top view and **zoom** to the extents of the *Building Blueprint*.

7 Construct the other floors

The remaining floors will be made of a single section.

- Start the contour of this section by following the green line on the blueprint.

Note: *Where the green lines are not connected, use the white line to complete the contour.*

- Use the **Line** tool to draw the contour with the **AutoGrid** feature activated. If you make a mistake, press backspace on the keyboard to delete the last vertex you've placed.

You should get a contour line as follows:

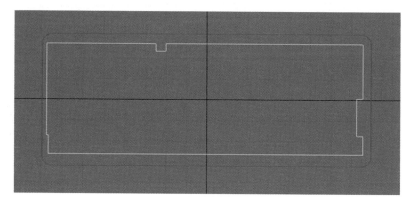

The second floor line contour

- **Rename** your new contour spline to *Building Floor 02*.
- Add the **Extrude** modifier to it.
- Notice that the **Amount** value is already set to **3m,** like the first floor.
- Enable the **Generate Mapping Coords, Cap End,** and **Cap Start** options if they're not already.

These options will ensure that floors and ceilings are properly created.

- The building blueprint is no longer required, so **hide** it.

8 **Unhide your models**

• **RMB** anywhere in the view and select the **Unhide by Name** option from the **Display** menu.

A list of all hidden objects in your scene will show up.

• Select the objects you would like to show and select **Unhide**.

9 **Create the remaining floors**

To create the other floors, you will use a different technique than what you have done so far. The *Array* tool will clone an object by incrementing its transformations equally for each new object.

• From the main menu, select **Tools** → **Array...**

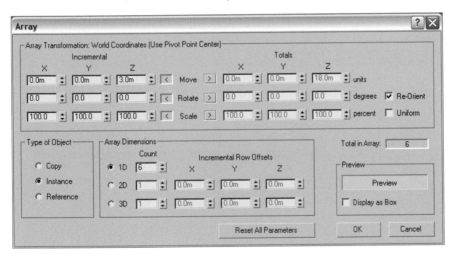

The Array tool

• Change the **Type of Object** option to **Instance** to make the transformation the same for each new object, if it's not already selected.

• Activate the **Preview** button to see the final result as you change the values.

• In the Array Dimensions section change the **Count** value to **6**.

• Add **3m** to the **Z** axis under **Incremental** transformations.

You should see the new floors appear directly over the second floor.

• Hit **OK** to create the floors.

Note: *The Array tool also increments the name of the source object.*

Lesson 01: Primitives

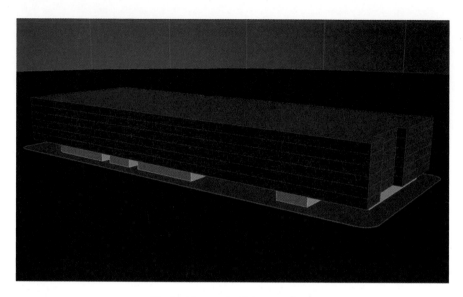

The building with all the new floors

10 **Save your work**

The basic structure of the building has been completed. This is a good time to save your work.

- From the **File** menu, select **Save As...**

- Enter the name *My01-building_02.max* and click the **Save** button.

 Make sure you save this file, since you will be continuing with it in the next lesson.

Note *Throughout this book you can give the prefix "My" to the files you save. This will allow you to save your own versions of the files, rather than overwriting the provided support files. This same convention is used in the 3ds Max tutorials as well.*

Note: *Throughout this book, you will be using the final saved file from one lesson as the start file for the next, unless specified otherwise. Save your work at the end of each lesson to make sure you have the start file ready. If you run into a problem, don't worry, you can use the scene files from the support files.*

Conclusion

Congratulations! You have completed your first exercise using Autodesk 3ds Max software. You should now be able to navigate the different views and change the basic display settings easily. You should also be confident in creating, duplicating, transforming, and renaming objects. You now know how to draw splines using the Line tool, and use the Extrude modifier as well. You can align and array, and apply materials with textures showing in the viewport.

In the next lesson, you will explore in greater depth how to model objects and details.

Lesson 01: Primitives

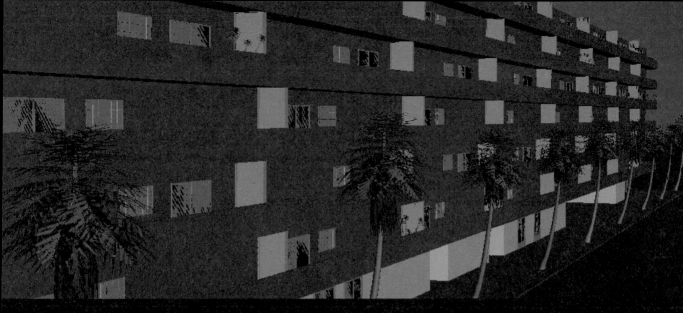

Lesson 02
Adding Details

In this lesson you will modify existing models to enhance the richness of the scene. You will first change the shape of the building to get its final look. You will then add palm trees, using a different creation technique. This provides an opportunity to experiment with basic modeling tools and concepts.

In this lesson you will learn the following:

- How to open a scene;
- How to slice polygonal objects;
- How to extrude and move polygons;
- How to insert and bevel edges;
- How to use the Transform Type-In tool;

Working with an existing file

Use the scene that you saved in the previous lesson or use the one provided in your scenes directory, *01-building_02.max*.

1 Open a scene

There are three ways to open a scene in Autodesk® 3ds Max®.

• From the **File** menu, select **Open...**

OR

• Press **Ctrl+O**.

OR

• Drag and drop the file from Windows Explorer into the viewport and then choose Open.

2 Find your scene

In the **Open File** dialog, if you cannot immediately locate *01-building_02.max*, it might be that your project is not set correctly or that 3ds Max did not direct you into the *scenes* directory.

The Open File window

Note: *The* **Look in** *drop-down list shows the folder where 3ds Max is looking. At the top of the window, the* **History** *drop-down list displays your previous path; click the down arrow to display others you have used recently.*

- Go to the *project1/scenes* folder.

- Select *01-house_02.ma* and click **Open**.

 *A preview of the 3ds Max scene is shown in the **Thumbnail** area.*

 If you get a "missing external files" message, then in the Configure External File Paths dialog that appears, click the Add button and navigate to the project1 folder, and then to the sceneassets\images subfolder, and select Use Path. Click OK to close the dialog.

3 Save Scene As

Since you will be modifying this scene, it is a good idea to save this file under a new name right away. Doing so will allow you to keep a copy of the previous lesson in case you decide to start this lesson over.

- Select **File → Save As...**.

- Type *My 02-addingDetails_01* in the **File name** field.

- Select **Save** to save your file.

> **Tip:** *Next to the Save button, there is a button with a plus (+) sign on it. This button will increment the name of your scene by giving it a number higher than the previous one. In the future, click the plus button to incrementally save your work.*

Balconies

In this example, you will add details to the building structure. You will start by creating the balcony for every apartment.

1 Editing instances

- Select the *Building Floor 07*. This is the topmost floor in the building.

- In the **Modify** panel, add an **Edit Poly** modifier to it.

 Because all the floors are instances of the second floor, all the modifications you will do will be applied to every floor at the same time.

- Press the **4** hotkey to go into the *Polygon* subobject mode of the floor.

> **Tip:** *There are several hotkeys for the subobject modes of an Editable Poly object. The more you use 3ds Max, the better you will know the difference between these modes. The Edit Poly hotkeys are listed here:*
> *1 – Access the Vertex subobject mode*
> *2 – Access the Edge subobject mode*
> *3 – Access the Border subobject mode*
> *4 – Access the Polygon subobject mode*
> *5 – Access the Element subobject mode*

- Press **Ctrl+A** to select all the polygons of the floor.

 The edge of the polygon will be highlighted in red to show that it is currently selected. If your selection is solid red, press F2 on the keyboard to toggle Shade Selected Faces off.

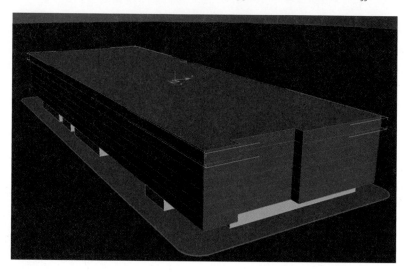

The floor with selected polygons

Tip: *You can also **click+drag** around face centers to select faces. Combine this action with the **Ctrl** key to add faces to the current selection or the **Alt** key to deselect faces from the current selection.*

- Right-click anywhere in the *Front* viewport to activate it without changing the selection.

Note: *If you are working with a maximized viewport, you may have developed the habit of changing views using Hotkeys. You can press T to change a viewport to display the top view, F for front view, L for left view, P for Perspective and so on. However, if you are in the subobject level of the Edit Poly modifier, the hotkeys will not do what you expect. The F will Flip Normals, all the floors with turn. The hotkey changes to adapt to the tool you are using. You must use the **Keyboard Shortcut Override Toggle** icon in the Main Toolbar to use the Main UI shortcut. Inactivate it, so it's not highlighted if you want to use the viewport hotkeys.*

The Keyboard Shortcut Override Toggle icon when it's active

You can see the different groups of shortcut configurations in the menu
Customize →Customize User Interface.... *Use the* **Group** *drop-down list to see the different groups available.*

The Customize User Interface window

Project 01

2 Slicing polygons

- In the **Edit Geometry** rollout of the Edit Poly modifier, select the **Slice Plane** tool.

The Slice Plane tool

A yellow rectangle will be drawn in your Perspective viewport, representing where the plane will slice your polygon. This plane can be moved, rotated and scaled.

- **Move** the plane to the left to make sure that the plane extends over each side of the building.

- **Move** the plane **0.3m** up.

*To make it easier and more precise, you can use the **Transform Type-In** tool by pressing the **F12** hotkey to give the exact value to your transformation. This is a very useful tool for giving an object an exact position, rotation, or scaling value. Use the **Offset Screen Y** value to move the plane up. You can also access this via the right-click menu by clicking the Settings button to the right of the Move entry in the Transform quad.*

The Transform Type-In tool

> **Note:** *If you return to the Perspective view, you will see the plane around the building and the new edge that will be created after slicing your polygons.*

- Click the **Slice** button below the **Slice Plane** button in the **Edit Geometry** rollout to slice the polygons.
- Click the **Slice Plane** button again to exit the *Slice Plane* tool.

This new polygon will be used to create the balcony.

The selected polygons defined by the Slice tool

3 Extrude the balcony

You will now extrude polygons to create a balcony. There are many ways to select polygons in 3ds Max. You can select them one by one with the **Ctrl** key, you can drag a selection box, or you can convert your selection from one subobject selection level to another.

- Go into the **Edge** subobject mode by pressing the **2** hotkey.
- **Select** any edge that you have created with the **Slice Plane** tool.
- In the **Selection** rollout of the **Edit Poly** modifier, click the **Loop** button.

 The Loop tool expands the selection as far as possible, in alignment with the selected edges.

- Hold the **Ctrl** key and click on the **Polygon** submenu icon in the *Selection* rollout.

 All the polygons around theses edges have been selected.

- Switch to the **front** view.

Lesson 02: Adding Details

- **Click+drag** a selection rectangle while holding the **Alt** key on the upper series of polygon to deselect them. You should only have a narrow strip of polygons selected that loop around the building

Now that you have the proper polygons selected, you will extrude them to make the balcony.

- In the **Edit Polygon** rollout, click the *settings* icon next to the *Extrude* button. It will display the Extrude tool options in a dialog.

The Extrude tool options

- Change the **Extrusion Type** to **Local Normal** to extrude outside the building.
- Set the **Extrusion Height** to **2m**.
- Use the Zoom Region tool to zoom in up close so you have a good view of what you're doing. Notice that you can change the Extrusion Height interactively to taste if you like, or just leave it at 2 meters.
- Click **OK** to create the balcony.
- Zoom back a little and notice that since the six floors are instanced, they all have balconies extruded now.

4 Balcony railing

The balcony is missing a railing; we'll add it now.

- Use the **Grow** tool in the *Selection* rollout.

This will expand your previous selection to select the whole balcony.

- In the **Edit Polygon** rollout, click the **Inset settings** icon next to the **Inset** button.

This will display the options for the Inset tool in a dialog.

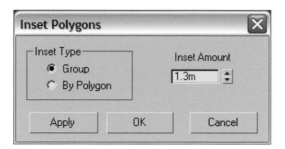

The Inset tool window

- Set the **Inset Amount** to a value of **1.3m** to cut the polygons around the balcony border.
- Click **OK** to inset the polygons.
- Select the new polygons you have just created.

 Try to select them one by one around the building to familiarize yourself with the selection tool. You might have the best luck doing this in the Top viewport. Zoom in so you can see clearly what you are selecting, and then gradually move around the entire perimeter of the balcony.

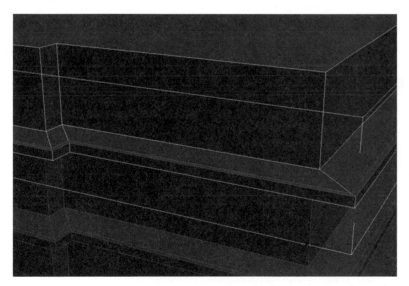

Selection of the balcony border

Lesson 02: Adding Details

- In the **Edit Polygon** rollout, click the **Bevel Settings** icon next to the **Bevel** button.

 It will display the options of the Bevel tool in a dialog.

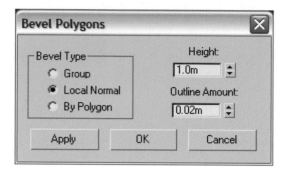

The Bevel tool window

- Change the **Bevel Type** to **Local Normal**.
- Set the **Height** value to **1.0m**.
- Set The **Outline Amount** to **0.02m**. Notice that you can see the result before you commit to it. You can try out various values and observe the result in the viewport.
- Click **OK** to create the polygons for the railing.

Rooftop

Now that the balconies are done, you will need to refine the rooftop. At this point, the roof is flat and could use some more details to make it more like a real-world rooftop.

1 Extrude a roof polygon

- **Select** the roof's top polygon.
- Use the Insert tool from the **Edit Polygon** rollout to add an **Insert Amount** of **0.4m**.
- Click **OK** to create the polygon with the **Insert** tool.
- Use the Extrude tool from the **Edit Polygon** rollout to add an **Extrusion Amount** of **−0.4m**.

 Make sure you enter a negative value to extrude inward, inside the polygon.

- Change the **Extrusion Type** to **By Polygon**.
- Click **OK** to extrude the polygon.
- **Deselect** the roof polygon by clicking in open space, and exit the *Polygon* subobject menu with the **4** hotkey.

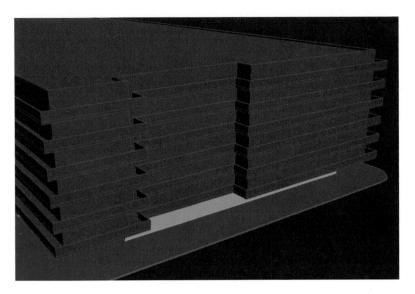

The final building structure

2 **Save your work**

 • **Save** your scene as My*02-addingDetails_01.ma*.

Double doors

In this exercise, you will add doors to your building. To create them, you will use pre-made, easily customizable doors that are already set up to be opened and closed. These doors are very useful when you want to animate doors opening in a visualization animation; they animate with the keyframing of a single parameter.

You will start this exercise by placing the pivot doors on the first floor.

1 **Scene file**

 • **Continue** with your own scene file or **open** *02-addingDetails_01.ma*.

 • **Unhide** the *Building Blueprint* to see the actual location of the doors on the floor.

 • **Align** the *Building Blueprint* under the first floor with the Align tool.

> **Tip:** *To make it easier to work, hide all the other floors above the first one, along with the sidewalk and its border.*

2 Creating the doors

There are eleven door openings on the blueprint. Some openings don't have any doors, but you can add doors to those sections if you want. There are six double doors in the front of the building.

- To make it easier, select the **Building Floor 01 Section 01** object, and press **ALT+X** to turn the object see-through. This will make it easier to see the blueprint reference plane.

- **Zoom region** to the first door opening on the left side of the *Building Floor 01 Section 01*.

- In the **Geometry** submenu of the **Create** control panel, select the *Doors* object from the drop-down list.

- Select the **Pivot** tool to create a pivot door. Make sure that the **AutoGrid** feature is checked to create the door on the Blueprint.

- In the **Parameters** rollout, activate the **Double Doors** and **Generate Mapping Coords** options.

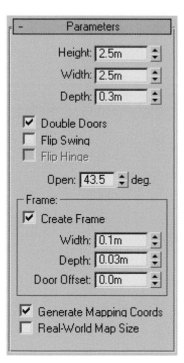

The Pivot Doors Object rollout

- Create the door by pressing and dragging your **LMB** from the right side of the door near the wall to the left side. When you release your **LMB**, you will be able to set the depth of the door.

- Press the **LMB** again to set the depth of the door, release and move your cursor upward to set the height of the door.

- Click again on the **LMB** to complete the door.

 The depth and the height of the door are up to you. As you know, in 3ds Max you can create an object and then define its parameters afterward to make sure that the depth is great enough to enter the building.

- **Rename** the door to *Building Floor 01 Double Door 01*.

Note: *You can change the parameters of the doors after creating them by using the Modify panel.*

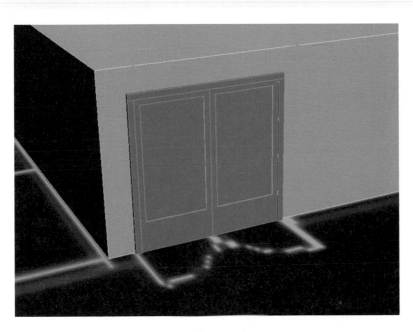

The Double Door object

Lesson 02: Adding Details

Project 01

3 Tweak the door position

At this point, the rotation of the door may not be exactly parallel to the wall. To make sure it is, do the following:

- Switch to the **Select** and **Rotate** tool by pressing the **E** hotkey.
- **Use the Transform Type-In** to give the door the following values:

 90 for the **X** axis of the **Absolute:World**;

 – 0 for the **Y** axis of the **Absolute:World**;

 –180 for the **Z** axis of the **Absolute:World**.

> **Note:** *The Transform Type-In will adapt to the transformation mode you are in. You can switch between these modes with the hotkeys listed here:*
> **Q** – *Switch to the Select Object mode;*
> **W** – *Switch to the Select and Move mode;*
> **E** – *Switch to the Select and Rotate mode;*
> **R** – *Switch to the Select and Scale mode.*

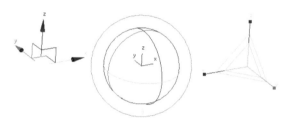

The three different Transform gizmos: Move, Rotate, and Scale

> **Note:** *Keep the door selected, switch between these modes, and notice how the Transform Type-In changes and how your cursor is also changing.*

- There is no hole in the wall for the door, so at this moment you may not see the door yet. Use the Move Transform (W) to shift the door away from the wall so it's visible in the rendering. If you like, you can toggle the transparency of the wall using Alt+X.

4 Clone the doors

Now that you have created the first door, you will clone it as you did for the floors, but this time with another technique.

- **Select** the *Door* and switch to the **Select and Move** mode.

- **Frame** the view to see the two other doors on the right.

- Hold the **Shift** key and press and drag on the red X axis of the transform gizmo with the **LMB**. As soon as you press on the X axis, the new door is created and can be moved along the X axis.

- **Click+drag** the new door next to the second door location on the blueprint and release the **LMB**.

 The **Clone Option** *window will appear but this time with the Number of Copies option.*

- Enter **5** as the **Number of Copies** value to create the other doors.

> **Note:** *Make sure the object is cloned as a* **Copy,** *because if you choose to clone it as an Instance, the Open value of all the doors will be linked; so when you will open a door, all the other doors will open at the same time.*

5 Place the doors

- Select the new doors one by one and **move** them to their appropriate positions as shown on the blueprint.

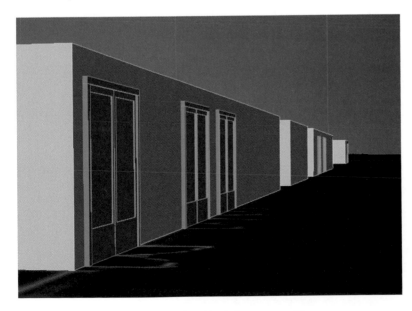

The doors placed in their correct positions

6 Open and close a door

Try to open the door with the **Open** value in the **Parameters** rollout of one of the doors. You might need to turn on **Flip Swing** in the Parameters rollout. Also, in the same area you can define the doorframe, if needed, or turn it off if not.

> **Note:** *There are no holes in the walls where the doors have been added. If you needed to open the door and show the interior, you would manually cut a hole in the mesh of the wall using a Boolean compound object. In this example you don't actually need to see into the interior, so you'll skip this step for now.*

Single doors

Now you will create the single doors for the first floor. To make sure that the single doors have the same design as the double ones, you will modify the double door object.

- Select any double door from the last exercise.
- **Clone** this door as a **Copy** using the Clone tool.
- **Rename** this door *Building Floor 01 Single Door 01.*

> **Tip:** *Select the blueprint plane and then press **Alt+Q** to enter Isolation mode. This is a fast way to hide everything in the scene and just concentrate on the selected objects. Use this to find the position of the single doors. Click the yellow **Exit Isolation** button to return to the complete scene.*

- **Move** and **Rotate** this door to a single door location on the blueprint.

 To make sure the door rotates in the right direction, open the door to see which way it opens.

- Disable the **Double Doors** option from the **Parameter** rollout.

> **Note:** *If the door doesn't open in the same direction as in the blueprint, you can toggle the* **Flip Hinge** *option.*

- Change the **Width** of the door to the new value of **1.5m**.

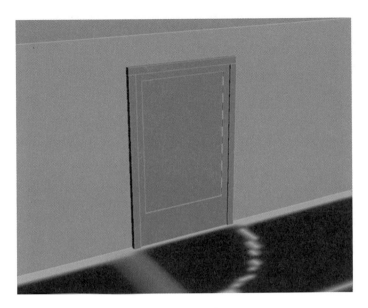

The single door object

- **Clone** the door as a **Copy** and place the copies using the **Move** and **Rotate** tools according to the blueprint.

Sliding doors

So far, you have seen two basic types of door. In the following steps, you will create sliding doors for all apartments on all floors.

- If you've hidden the other floors, unhide them now.
- In the **Create** panel click the **Geometry** icon if it isn't active already.
- Click the drop-down arrow and choose **Doors**.
- Click the **Sliding** tool and make sure that the **AutoGrid** feature is checked to create the door on the balcony.
- In the **Parameters** rollout, activate **Generate Mapping Coords.**
- **Create** the door the same way you created all the other ones.
- **Rotate** the door if necessary to make it parallel to the wall.
- **Rename** the door to *Building Floor Sliding Door 01.*

Lesson 02: Adding Details

The sliding door object

1 **Clone the remaining sliding doors**

• **Select** the sliding door and **Clone** it as a **Copy** using the **Array** tool.

The Array tool can clone objects along one, two, or three axes. In this case, you will copy the door along two axes to cover the front of the building.

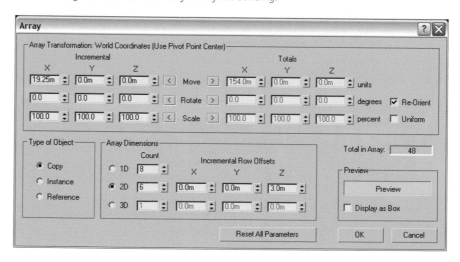

The Array tool

- Click on the Preview button to see what the Array tool is doing as you set it.
- Enter a value of **8** for the **Count** option next to the **1D** option.

 This will copy eight doors along the wall.

- Enter a value of **19.25m** for the **X Incremental** option of the **Move** transform in the upper-left corner of the Array window.

 This will move each door 19.25m from to the other door.

Tip: *Click+drag as a slider on the scrolling widget next to the entry field to dynamically change the value. This is useful when you are cloning an object and you want to see its final location.*

- Change the **Array Dimensions** option to **2D**.
- Enter a value of **6** for the **Count** option next to the **1D** option.

 This will copy the eight doors along the wall on the other six floors.

- Use the slider next to the **Z Incremental Row Offsets** on the same row of the **2D** option to move the doors up **3m** high.
- Click the **OK** button to clone the new doors.

Note: *With the Array tool, you've just created 47 new doors in a single step. This tool is very useful for cloning along different axes with a move, rotate, or scale incremental transformation.*

2 Change the door placements

All the doors are cloned but they are too symmetric. To break the symmetry, move the doors on the second, fourth, and sixth floors as you would like.

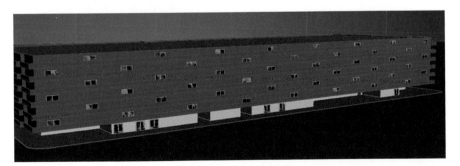

The look of the front wall with all the sliding doors

There are several ways you could select the sliding doors you want to change. One way would be to select one sliding door, and then **RMB** and choose **Select Similar** from the **Transform quad** menu. All the sliding doors will be selected this way. Then hold down the **Alt** key and click on the sliding doors that you want to remove from the selection set, or use a selection rectangle to remove multiple doors at once.

Windows

The next step is to place the window for each individual apartment next to its door.

- In the **Geometry** submenu of the **Create** control panel, select the **Windows** object from the drop-down list.

- In the **Creation Method** rollout, select the **Width/Height/Depth** option.

 Because you will start creating the window directly from the wall and not on the floor as you did with the door, you will need this creation method to create your window.

- In the *Parameters* rollout, click **Generate Mapping Coords.**

- Create the windows next to the door by starting from the top to the bottom to set the height, move right to set its width, and finish with the depth to complete the window.

- If necessary, rotate the window to make it parallel to the wall.

- **Rename** the window to *Building Floor Sliding Window 01.*

- In the **Modify** panel, adjust the window parameters to match the illustration above.

- Now clone this new window with the **Array** tool.

- Reposition the individual windows as you would like.

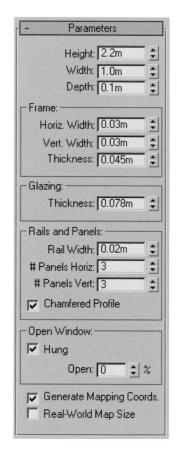

The Sliding Windows parameters rollout

> **Tip** *Use Isolation Mode to help select/deselect the windows you need. Select all the windows using Select Similar; then press **Alt+Q** to Isolate. Make your selection from among just the windows in Isolation mode, and then Exit Isolation to return to the complete scene. Also use the plus and minus keys on the keyboard to increase the size of the Move Transform Gizmo while you work.*

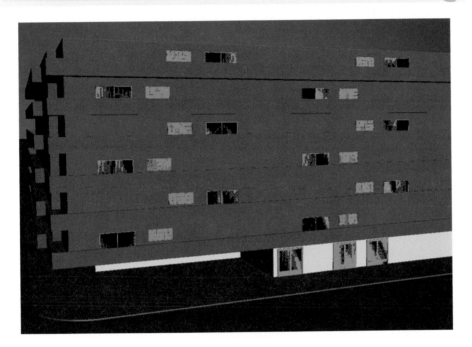

The final front wall

1 **Save your work**

 • **Save** your scene as *My02-addingDetails_02.max*.

Ornamentation

In this exercise, you will add ornamentation to your building to make it look more realistic.

1 **Scene file**

 Use the scene that you saved in the previous exercise or use the one provided in your *scenes* directory from the *support-files, 02-addingDetails_02.ma*.

2 Add divisions to the balcony

The balcony should be divided for the different apartments.

- In the **Geometry** section of the **Create** panel, select the **AEC Extended** object from the drop-down list.

- Select the **Railing** tool and make sure that the **AutoGrid** feature is checked.

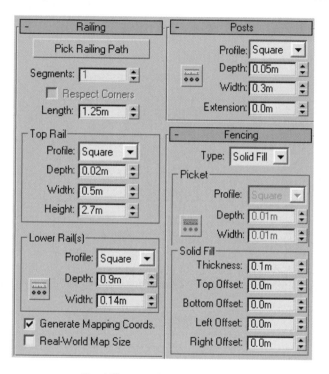

The different Railing object rollouts

- In the **Railing** rollout, activate the **Generate Mapping Coords.**

- Create the division by **click+dragging** from the wall to the balcony rail, and then set its height to reach the ceiling of the next floor.

- **Rotate** and align the division to the wall.

- **Rename** the railing to *Building Floor Railing 01*.

- **Clone** this new railing with the **Array** tool.

Tip: *This time you can* **Clone** *the object as* **Instance**. *If you ever need to change the look of the division, you will be able to modify only one to change them all.*

- Select the divisions that are on the third, fifth, and seventh floors and **move** them where you would like them to be.

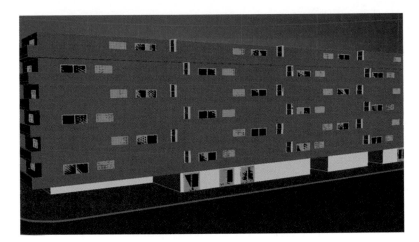

The front wall with all the divisions

Note: *You can customize your divisions with the Modify panel and play with the options of the Railing object. You will be able to customize the railing itself, the posts and the fencing using their respective rollouts.*

Foliage

You will now add different types of foliage around the building, consisting of pre-built customizable trees and plants. These pre-built objects will help you quickly increase the level of detail of your scene. You will start by planting palms trees in front of the building.

1 **Add foliage**
- Hide the blueprint object and unhide the sidewalk if it's hidden.
- In the **Geometry** submenu of the **Create** panel, select the **AEC Extended** object from the drop-down list, if it isn't already selected.
- Select the **Foliage** tool and make sure that the **AutoGrid** feature is checked.
- Scroll and select a tree such as the *Generic Palm* tree.

The Foliage Creation rollout

- In the **Favorite Plants** rollout, activate the **Automatic Materials** feature if it's not already turned on.

 This will apply the palm material with textures directly to the models.

- Confirm that in the **Parameters** rollout the **Generate Mapping Coords** check box is **on.**

- **Create** the first palm tree by simply clicking on the sidewalk where you want it to grow.

2 **Customize the tree look**

The palm is created, but it is too small compared to the building. You can change its size by using the Modify panel.

- Go to the **Modify** panel.

- Change the **Height** value to **10m** in the **Parameter** rollouts.

- Change the **Pruning** value to **0.84.**

 This will make the tree look different each time you create a new one.

- Click on the **New** button next to the **Seed** option as needed to give the palm tree a random look.

- **Rename** the palm tree to *Foliage Palm 01*.

> **Tip:** *Foliage is sometimes too heavy in terms of geometry and can slow down your performance when you navigate through your scene. In the Foliage parameters rollout, there is an option called Viewport Canopy Mode that can help you improve performance. This option will determine when the object is replaced by an optimized version of the final foliage. Try to switch between the modes to see the difference.*

3 Clone the tree

- **Clone** the palm tree as a **Copy** with the **Array** tool, or simply by holding down **Shift** and moving the object.

- Clone **9** new palm trees, and distribute them along the **X** axis.

 *If you are using Array, the **X** incremental value should be around **19m** to make the last palm on the opposite corner of the sidewalk.*

4 Tweaking each tree

At this time, the palm trees look all the same. To make them unique, you will change some of their options.

- Change the **Height** of each palm to a random value between **9.5m** to **10.5m**.

- Click the **New** button on each palm tree to give them a new curve and look.

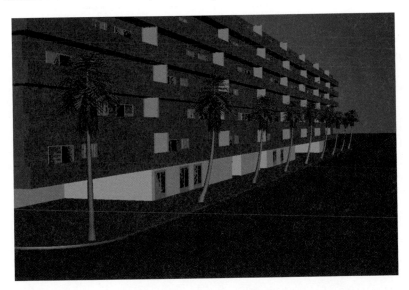

The palms placed along the building

Lesson 02: Adding Details

5 Adding more plants

Add more foliage for some apartments to complete the look of the building.

- Select the **Foliage** tool from the **Create** control panel.
- Plant some **Big Yucca** foliage randomly on the balconies.

 Make sure that the **AutoGrid** *feature is checked, to plant them directly on the floor.*

- Change the **Height** on the foliage and the **Seed** value to make each one unique.
- **Rename** your new foliage accordingly.

Note: *Watch out, don't put too much foliage into your scene. The more you add, the more your performance will degrade when you navigate through your scene and during rendering in later lessons. Your average plant costs between 7 and 10K polygons. There are other, cheaper methods of adding foliage that use much less geometry. You can use opacity mapped planes, or add them using third-party plug-ins.*

Tip: *Press 7 on the keyboard to display statistics in the viewport. This will show you the number of polygons and vertices in your scene as you work.*

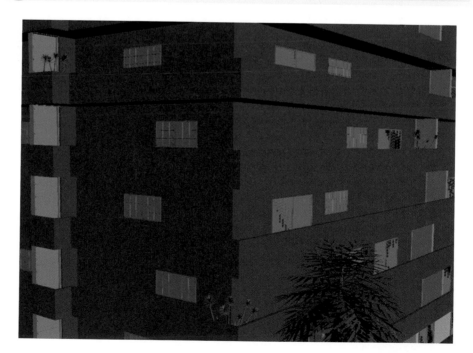

The Yucca foliage on the balcony

6 Save your work

- **Save** the scene as *02-addingDetails_03.max*.

Conclusion

You have begun to develop skills that you will use throughout your work with Autodesk 3ds Max. You will get to do more in-depth modeling in the next project, but for now, you will continue exploring different general 3ds Max topics.

In the next lesson, you will bring colors into your scene by assigning shaders and textures to your objects.

Lesson 03
Materials and Texture Maps

Now that you have created an environment, you are ready to add materials and render your scene. The rendering process involves the preparation of materials and textures for objects. You've already had some exposure to this creating the blueprint texture for the reference plane.

In this lesson you will learn the following:

- How to work with a menuless UI;
- How to change the current renderer;
- How to work and navigate in the Material Editor;
- How to create a gradient map;
- How to create Arch & Design materials;
- How to set new mapping coordinates;
- How to render a single frame.

Expert Mode: Hiding the UI

In the first two lessons, you used menus, numeric input fields, and other UI elements to work with your scene. In this lesson, you will hide most of the user interface and rely more on the quad menu and hotkeys to access the UI without actually seeing it onscreen. Sometimes it's distracting to have the UI visible; here you'll try out Expert Mode, which lets you focus on your design.

1 **Scene file**

- Continue using the file you created from the last lesson or open *02-addingDetails_03.max* from the *support_files/scenes* directory.

2 **Turn off all menus**

- Press **Ctrl+X** to enter the **Expert Mode** UI.

 The Expert Mode will remove the 3ds Max title bar, the main toolbar, the command panel and the entire interface below the trackbar. Only the menu bar, the time slider, and the trackbar will remain in your user interface.

The Expert Mode user interface

Now the various menus are hidden and you must rely on the quad menu and the hotkeys to access tools.

- If you have the *Perspective* viewport maximized, press **Alt+W** to bring back the *Four Viewport* layout.

Tip: *You can resize the Four Viewport layout.* **Click+drag** *the splitter bars to change the width/height of the different windows in the layout. You can also use the* **RMB** *at the division point to reset to the original layout.*

The four viewports layout after being resized

You now have a nice layout to work with materials in the viewport. You will do that work using the Material Editor to define the desired look.

Tip: *If at all possible get a second monitor and use dual screens. Then you can have the Material Editor open on a second screen without covering up the viewports.*

Lesson 03: Materials and Texture Maps

Changing the renderer

The default renderer in Autodesk® 3ds Max® is the *scanline* renderer. This renderer will use the basic material type and the basic maps. In this lesson, you will use architectural materials on your scene that only the *mental ray* renderer can provide.

1 **Change the renderer to mental ray**

 • Press the **F10** hotkey to bring up the **Render Scene Dialog**.

 • Select the **Common** tab at the top of the window, if it isn't already selected.

 • Roll up the **Common Parameters** rollout by clicking the small minus button on the left of the rollout.

 • Expand the **Assign Renderer** rollout at the bottom to reveal its options.

The Assign Renderer rollout

 • Click the **Choose Renderer** button next to the **Production** field.

 • From the list of available renderers, select **mental ray Renderer.**

 • Click **OK** to select the renderer.

 • **Close** the Render Scene window.

 Now that you have the mental ray renderer, you will be able to create more types of materials and maps to texture your building.

The sky material

In the first lesson, you created a basic material with a texture on it. In the following examples, you will create materials with several maps that define the material qualities of the sky, ground, sidewalk and building objects.

1 Sky material

- Press the **M** hotkey to bring up the Material Editor window.

 Note that the material you built previously for the blueprint is still there.

- Highlight the next material sample sphere, from which you will create the sky material.

- **Rename** the material to *Sky*.

- **Click+drag** the material onto the skydome object.

> **Note:** *Before releasing the **LMB** on the object, you will see a Tooltip in the viewport with the name of the object on it. This will help you assign the material to the proper object.*

2 Adjusting the material

Now you will adjust the material so it looks like a sky.

- Click on the **Show Map in Viewport** button to see the map in your viewport. You won't see anything yet, because you haven't assigned a map.

- Scroll down in the Material Editor window to the **Blinn Basic Parameters** section.

- Change the value to **100** for the **Self-Illumination** option.

 You will notice in the viewport that the skydome is now fully lit up.

- Click on the small blank square next to the gray **Diffuse** color swatch.

 This will bring up the Material/Map Browser.

The Blinn Basic Parameters rollout

Lesson 03: Materials and Texture Maps

Note: *Because the mental ray renderer is now active, the mental ray maps are now available.*

- Select the **Gradient** map from the list and click **OK**.

The Gradient Parameters rollout

- In the **Gradient Parameters** rollout, click the **Color #1** color box to pick a color.

 This will display the Color Selector window.

The Color Selector window

- Select a **dark blue** color.

OR

- Enter the following custom values:

 Red to **17**;

 Green to **32**;

 Blue to **65**.

> **Tip:** *You can keep the Color Selector window opened to select other colors.*

- Click on the **Color #2** color box.
- Choose a light blue color or enter the following values:

 Red to **154**;

 Green to **173**;

 Blue to **200**.

- Click on the **Color #3** color box.
- Choose a sunrise orange color or enter the following values:

 Red to **255**;

 Green to **183**;

 Blue to **105**.

- **Close** the Color Selector.

3 *Mapping coordinates*

The sky now has better colors, but you will notice that no orange color is visible. This is because the mapping coordinates were created for a full sphere, which you have cut in half, thus removing the lower portion of the mapping coordinates. You will correct this by changing the coordinates directly in the gradient maps.

- Go to the **Coordinates** rollout of the *Gradient* map.
- Change the **Tiling** value of the **V** coordinate to **2**. You should now see the blue color of the sky.
- Change the **Offset** value of the **V** coordinate to **0.25**.

You may now see some of the gradient colors in your sky.

The Coordinates rollout of the Gradient map

4 Gradient color position

- Go back to the **Gradient Parameters** rollout.

- Change the **Color 2 Position** value to **0.05**.

 You may now see all three colors in the sky. If you don't, you can increase the V Tiling Value to around 4.0, then decrease the V: offset to around 0.13, and then change the Color 2 Position value while watching in the viewport. These values will be different for your particular perspective viewport vantage point, so your mileage may vary.

The sky gradient looks like a sunrise

Project 01

Ground material

For the next material, you will use the mental ray Arch & Design material. This material shader is designed to support most materials used in architectural and product-design renderings.

1 Ground material

- Highlight a new default material and **rename** it *Ground.*
- Next to the material name, click the **Standard** button.
- This will bring up the Material/Map browser window.
- Select the **Arch & Design (mi)** material.

The Material/Map Browser window

- Click the **OK** button.
- From the drop-down list of the **Template** rollout, select the **Rough Concrete** template.

LEARNING AUTODESK 3DS MAX 2008 | FOUNDATION

<div style="writing-mode: vertical">Lesson 03: Materials and Texture Maps</div>

- **Assign** the material to the *Ground* object. To do this, press the **H** key and select the *Ground* object by name; then you can use the **Assign Material to Selection** button in the Material Editor to associate the material with the object.

- Activate the **Show Map in Viewport** option to see the material in your viewport.

2 UVW mapping

The texture seems too big compared to the size of the building. To fix this, you will change the coordinate of the object rather than changing the material itself.

- Exit the Expert Mode by clicking on the lower right **Cancel Expert Mode** button or press the **Ctrl+X** hotkey again.

- Select the *Ground* object if it isn't still selected.

- On the Modify panel, add the modifier called **UVW Map**.

*By applying mapping coordinates to an object, the **UVW Map** modifier controls how mapped materials appear on the surface of an object. The UVW coordinate system is similar to the XYZ coordinate system. The U and V axes of a bitmap correspond to the X and Y axes. The W axis, which corresponds to the Z axis, is generally only used for procedural maps.*

The Parameters rollout of the UVW Map modifier

- In the **Parameters** rollout, change **Length** and the **Width** value to **5**.

Tip: *If you have a hard time seeing the Mapping, try a different angle in the Perspective viewport. Look at the ground from up in the sky and the lighting will be better for examining the mapping.*

The proper concrete look

Sidewalk material

The sidewalk material will be textured using a procedural masonry shader.

1 **Masonry material**

- **Click+drag** the *Ground* material onto a new default material to copy its settings.

- **Rename** this new material *Sidewalk.*

- From the dropdown list of the **Template** rollout, select the **Masonry** shader.

- **Assign** the material to the sidewalk object.

- Add the **UVW Map** modifier to the sidewalk object and set the following in the **Parameters** rollout:

 Length to **2**;

 Width to **1.5**.

Doing so creates a planar projection on the Y axis.

The sidewalk object texture with masonry

2 **Map the sidewalk border**

- **Copy** the **UVW Map** modifier by using the **RMB** on the modifier name in the modifier stack and choosing **Copy** from the right-click menu.

- **Select** the *SidewalkBorder* object.

- **Paste** the **UVW Map** modifier by using the **RMB** on the modifier stack.

- **Assign** the same *masonry* material to the *Sidewalkborder* object.

- In the **Parameters** rollout, set the following:

 Mapping Mode to **Box**;

 Height to **1.5m**.

3 **Rotate UVW coordinates**

Because the mapping coordinate are now similar to the previous sidewalk material, the tiling of the masonry looks identical. To make the border look like it has been built separately, you will rotate the UV coordinate.

- In the modifier stack, **expand** the **UVW Map** modifier submenu.

- Click on the **Gizmo** button to access the *Transform UV Gizmo*.

 The Gizmo button will now be highlighted in yellow. In this mode, the standard transform gizmo is replaced by the Transform UV Gizmo. In the viewport, they look the same, but the results are different.

- **Rotate** the mapping coordinate using Edit → Transform Type-In by **90** on the **Z** axis and by **90** on the **Y** axis. Zoom in to a closeup view so you can see the results.

- Click the **Gizmo** button again to exit the *Transform UV Gizmo*.

The final look of the sidewalk and its border

Building materials

1 **Polished concrete**

- **Click+drag** the *Ground* material to a new default material to copy its settings.

- **Rename** this new material *Building*.

- From the dropdown list of the **Template** rollout, select the **Polished Concrete** shader.

- Select the entire building structure.

- **Assign** the material to the objects all at once with the **Assign Material to Selection** button located in the *Material Editor.*

- **Select** the second floor object only and add a **UVW Map** modifier.

 Because all the floors have been cloned as instances, the UVW Map modifier will be set for all the floors.

- In the **Parameters** rollout, set the following:

 Mapping Mode to **Box**;

 Length to **10m**;

 Width to **10m**;

 Height to **3m**.

- Select all the foundation sections and add a **UVW Map** modifier.

 Notice that the Transform UV Gizmo surrounds the five sections and not individual sections. This will make it easier to set the mapping coordinates on all of them at once.

- In the **Parameters** rollout, set the following:

 Mapping Mode to **Box**;

 Length to 10m;

 Width to 10m;

 Height to 3m.

The textured building

2 **Division material**

You will now texture the divisions with a wood material. Because they were all instanced from the same original object, you will only need to modify the mapping coordinate of one to change them all.

- **Click+drag** the *Building* material to a new default material to copy its settings.

- **Rename** this new material *Divisions*.

- From the dropdown list of the **Template** rollout, select the **Satin Varnished Wood** shader.

- **Select** all the division objects.

Tip: *To select them easily, press F3 to change to wireframe mode, then click on the wireframe of the Building Floor Railing object. RMB and choose Select Similar to select all the dividers.*

- **Assign** the material to all the divisions at the same time by clicking the **Assign Material to Selection** button.

The divisions with texture

3 **Resize the Material Editor**

At this time, you have created six materials and there should be no more default material slots in the Material Editor. In order to get more default materials to start from, you can do any of the following:

- Scroll using the sliders beside the material preview area.

- Resize the entire preview area by **click+dragging** between any material previews.

- Select **Options → Cycle 3x2, 5x3, 6x4 Sample Slot** in the Material Editor to cycle between the three presets.

The material slots expand to 5x3

4 **Door material**

- Highlight an empty material**.**
- Click on the **Standard** button next to the material name.
- From the **Material/Map Browser** window, select the **Multi/Sub Object** material.
- Select the **Discard old Material?** option when the **Replace Material** pop up comes up, and then click the **OK** button.

The Multi/Sub-Object material lets you assign different materials at the sub-object level of your geometry. The door primitive already has its material ID set.

Note: *You will see in a further project how to set material IDs on different polygons for the same object.*

- **Rename** this new material *Door***.**
- **Select** every door object; the double, the single, and the sliding ones. You can do this by pressing **H** on the keyboard; then, in the **Find: field**, enter ***Door**, and then press the **Enter** key.
- **Assign** the new material to all of them.

5 **Tweak the Multi/Sub-Object material**

At this time, you will not see any difference between the materials. To texture the doors, you will use two different materials.

- Frame the view on a double door.
- Click the **Set Number** button in the **Multi/Sub-Object Basic Parameters** rollout.
- Change the **Number of Material** option to **2** and click **OK**.
- **Click+drag** the **Arch & Design** material used for the divisions into the **Sub-Material** button of the material ID 1.

A new window will ask whether you want to copy or instance the material.

- Choose the **Copy** method and click **OK**.
- Repeat the previous steps for the material ID 2.
- Rename the material ID 1 to *Window* and the material ID 2 to *Frame*.

These names can be used as a reference to sort which material is which. Your Multi/Sub-Object Basic Parameters should look like the following:

The Multi/Sub-Object Basic Parameters rollout

6 **Frosted glass**

- Click the material **ID 1 Sub-Material** button

- **Rename** this material *Window*.

- From the dropdown list of the **Template** rollout, select the **Frosted Glass (Physical)** shader.

- In the **Main Material Parameters** rollout, set the following:

 Weight value of the **Translucency** option to **1**;

 Translucency color to **Black**.

7 **Brushed metal**

- **Select** all the door objects.

- Go to the next material ID by clicking the **Go Forward to Sibling** button located to the right side of the horizontal icon bar.

The Go Forward to Sibling icon

- **Rename** this material to *Frame*.

- From the dropdown list of the **Template** rollout, select the **Brushed Metal** shader.

The textured doors

- Click the **Go to Parent** button, next to the **Go Forward to Sibling** button, to go back to the material top level.

8 Window material

- **Copy** the *Door* material to a new material slot.
- **Rename** the material to *Window*.
- **Select** all the window objects.
- **Assign** the window material to the window objects.

The window objects have the same material ID as the door object. So there is no more modification to do to texture the windows.

Test render

At this time, you can see a preview of the final look into the viewport, but it would be better to see how everything looks when rendered. Now is a good time to test render the scene.

1 **Display the Safe Frame**

Your current viewport may not be displaying the actual proportions that will be rendered. You can display the output file resolution to see how the scene will actually render by showing the Safe Frame.

- **Maximize** the Perspective view.

- **RMB** on the viewport label, the actual word "Perspective."

- From the menu, select **Show Safe Frame** to activate it.

The view is adjusted to show a bounding box that defines how the default render resolution of 640x480 pixels relates to the current view.

- **Dolly** into the view so that it is well composed within the safe frame line. Try to set up a view where you see something like this illustration.

The Perspective view with a Safe Frame displayed

2 Your first render

- Press **F9** to render your scene from the current view.

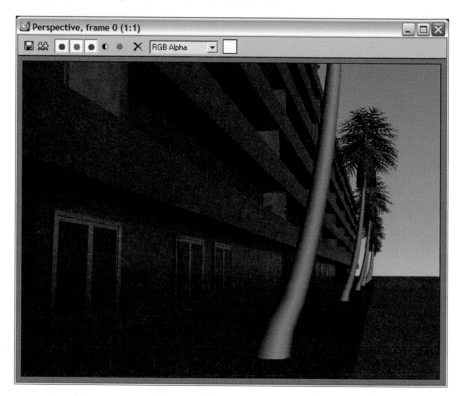

The Render View panel

You can now see a rendered image of your scene. However, because you have not created any lights, the image renders using the default lighting.

3 Zoom into the rendering

- Use the **Ctrl** key and the **LMB** and **RMB** to zoom in and out of the view or **scroll** up and down with your **MMB**.

- Once in closeup view, you can pan using the **Shift** key with the **LMB**.

 Now you can evaluate in more detail how your rendering looks at the pixel level.

4 Save your work

- Select **File** → **SaveAs...** from the **File** menu.

- Enter the name *My03-textures_01.max*, and click the **Save** button.

Conclusion

You have now been introduced to some of the basic concepts for texturing and rendering a 3D scene. The 3ds Max Material Editor offers a lot of depth for creating the look of your objects. You have learned how to create materials, select templates, and apply texture maps, and you have rendered a single frame to preview the look of your materials with default lighting.

In the next lesson, you will animate simple objects to introduce yourself to the basics of animation.

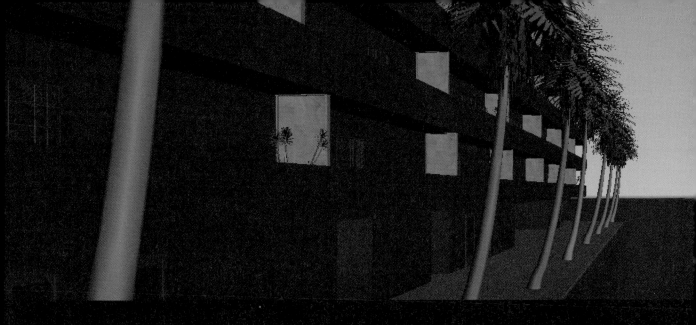

Lesson 04
Animation Basics

This lesson will cover some basic animation techniques and terminology, as well as hierarchies and relationships between objects. Autodesk® 3ds Max® software provides tools for animation, but to animate well, you also need to understand and use the laws that govern animation.

In this lesson you will learn the following:

- How to change the undo level;
- How to create hierarchies;
- How to build a custom Schematic View;
- How to understand parent inheritance;
- How to control a pivot point;
- How to use the Time Slider;
- How to use the Curve Editor;
- How to select animation keyframes;
- How to change keyframe tangents.

Undo level

When you work with animation, it's important to be able to undo any modifications you have made. Make sure to set your preferences to have a high number of undo levels. By default, 3ds Max allows a small number of undos in order to reduce the memory usage of your computer. You will now specify the number of undo levels you would like.

- From the main menu, select **Customize** → **Preferences...**
- Select the **General** tab.
- In the **Scene Undo** option at the top-left corner, change the **Levels** value to a higher value, such as **50**.
- Click on **OK** to confirm the change.

> **Note:** *Setting a high undo level is not a good thing to do when you are in production using large files. For this exercise you will do this, but if you are working on large design visualization projects you probably can't afford to increase the undo levels at all, in fact you may find you need to lower them to save on memory.*

Building a hierarchy

Before animating objects, you need to make sure that the task will be as simple as possible. You will need to find the objects in your scene easily and animate them as intended. Placing objects logically into a hierarchy will do just that. To accomplish that, you will learn how to parent objects together as well as how to use the Schematic View dialog.

The following example explains how to create a hierarchy of objects.

1 **Scene file**
 - **Open** the scene *04-animationBasics_01.max*

> **Note:** *If you get a "File Load: Units Mismatch" message, accept the default setting and click **OK**.*

 This file contains an example scene of a robotic arm.

2 **The Schematic View**
 It is very important to understand the concept of a hierarchy. A hierarchy consists of a grouping of child nodes under parent nodes. When a parent node is transformed, all of its children will inherit its transformation.

- To better visualize what you are about to do, click the **Schematic View** button from the menu bar.

The Schematic View icon

The Schematic View dialog lists all the nodes in your scene along with their hierarchies. Currently, there is no hierarchy between the objects.

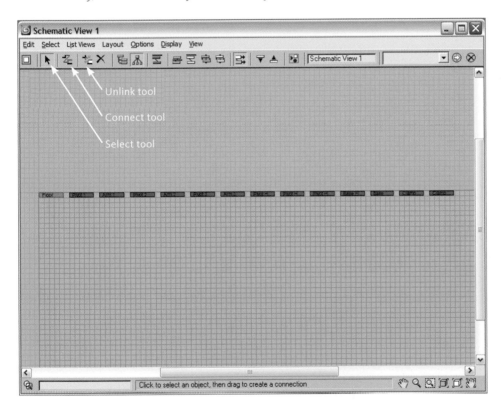

The Schematic View dialog

Note: *You can zoom in and out in the* **Schematic View** *by scrolling with the* **MMB** *or with the* **Zoom** *tool, located in the lower-right corner.*

Lesson 04: Animation Basics

3 Parenting

- In the Schematic View dialog, click on the *Clamp Down* node, hold down **Ctrl**, and click on the *Clamp Up* node to select both of them.

- Select the **Connect tool** icon

 The cursor will change to the icon that appears when you move it over a node.

- **Click+drag** from one of the clamp nodes to the *Pivot Head 360* node.

The two nodes connected to their parent node

You will see a dashed line coming from each clamp node. When you release the mouse button, the two objects will be connected to their parent object. You may need to zoom into the view to find the nodes; you will find the view navigation tools at the bottom-right corner of the Schematic View.

Tip: *You can unlink nodes by selecting them and then clicking the Unlink button.*

4 Completing the hierarchy

- Organize the hierarchy so that it looks like the following:

The completed hierarchy

Note: *You don't have to use Schematic View to create hierarchies; in fact most users just create hierarchies directly in the viewport using the Select and Link tool found on the main toolbar. Schematic View can be easier to use when you have a model like this one with many nicely named parts. The more complex the model, the more likely you'll use this Graph Editor.*

Customizing a Schematic View

A nice feature of the Schematic View is the ability to display a reference image in the background and lay nodes out on it for a better understanding of the scene's content and hierarchy.

Tip: *You can create a custom Schematic View for any setup you build.*

1 Create a custom Schematic View

You will customize the robot Schematic View to make the animation process easier.

- From the Schematic View menu, select **Options** → **Preferences...**

- In the **Background Image** option, click the **None** button.

- Browse for the image called *SchematicViewRobot.tif* from the *support_files*. The file should be under the *project1\sceneassets\images* subfolder.

- Make sure that the **Show Image** option for the **Background Image** is activated.

- Click **OK** to exit the Preferences menu.

You will now see the background image in your Schematic View.

The background image loaded into the Schematic View dialog

<div style="writing-mode: vertical">Lesson 04: Animation Basics</div>

- Press the **g** hotkey to turn off the grid so the background image is easier to see.

> **Note:** *Make sure the* **Keyboard Shortcut Override Toggle i**s *active to access the shortcuts specific to the* **Schematic View.** *Turn it on and off to activate it, if necessary.*

2 **Lay out the nodes on the reference image**

- **Zoom** in the image until the nodes are reasonably sized in the reference image.

 Only the nodes are affected when zooming in the view; the background remains static. This is because you have not yet locked the zoom and pan functions in the Preferences.

- In **Options → Preferences**, activate **Lock Zoom/Pan** from the **Background Image** and click **OK**. Now you can zoom the background in the viewport to fit it to your Schematic View dialog.

- Place the nodes over each object they represent as shown in the following illustration.

The nodes placed on the reference background image

Note: *The easiest way to place the nodes is to start with the top parent of the hierarchy, since all the child nodes will follow. If you don't want the children to move, go to the Schematic View menu bar and turn off* **Options** → **Move Children**.

- Select the nodes that are not intended for animation, such as the *Arms, Base Holding* and *Floor*.

- **RMB** in the Schematic View to bring up the quad menu and select **Shrink** → **Shrink Selected**.

This will simplify the display of the nodes and make them easier to manipulate.

The final schematic view with animatable nodes only

Lesson 04: Animation Basics

3 **Save and recall your custom layout**

- **Rename** the schematic view to *Robot Arm* in the name field at top of the schematic view.

The name box of the Schematic View dialog

- Close the Schematic View dialog.

- When you need to recall the layout you have just created, you will be able to access it using the menu **Graph Editors** → **Saved Schematic Views** → **Robot Arm.**

Getting ready for animation

Hierarchies play a big role in animation. For instance, if you transform a parent object, all of its children and grandchildren will follow that transformation. You must also make sure that every object's pivot is appropriately placed for the intended animation of the object and that the animator will not be able to break the setup inadvertently.

1 **Reference Coordinates System**

- Before you try to move an object, make sure that the *Reference Coordinate System* on the main toolbar is set to **Local**.

The Reference Coordinate System list lets you specify the coordinate system used for a transformation (move, rotate, and scale). The Local system uses an individual coordinate system for each object, based on its pivot point.

The Reference Coordinate System list

2 **Pivots placement**

Some objects may not have their pivots at a proper location by default. It is a good idea to revise and place the pivots where the rotation pivot of the object is intended.

Note: *By default, the pivot is place in the middle of the object's bounding box.*

You will now see how a well-placed pivot can greatly simplify your task when animating an object.

- Select the *Clamp Up* object and **rotate** it.

 The clamp is rotating from its center, which is not the appropriate motion.

- **Undo** the previous action to bring the clamp back to its original position.

- Go to the left view using the **l** hotkey and **frame** the object.

- Still with the *Clamp Up* selected, go to the **Hierarchy** control panel and click the **Affect Pivot Only** button in the **Adjust Pivot** rollout.

- **Move** the pivot to the middle of the orange circle at the base of the clamp.

The Affect Pivot Only button

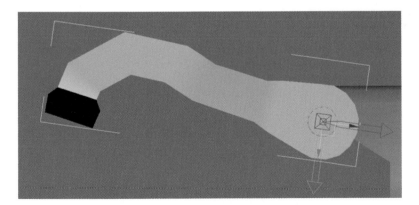

The new clamp pivot position

- Select the *Clamp Down* object.

 Even if you change your selection, you will stay in **Affect Pivot Only** *mode.*

- **Move** the pivot to the middle of the orange circle at the base of the clamp.

- Click the **Affect Pivot Only** button again to exit the tool.

 Now the pivots are well placed and the robot's clamp can rotate the way it is supposed to.

3 Locking rotation

When you're using the Rotate tool, the three rotation axes are available on the rotation gizmo, but mechanical objects are sometimes constrained to move in only one or two axes. You will lock the unnecessary axes to avoid animating them.

- Make sure you are in **Local** reference coordinate system.

- Select the *Base* object.

- In the **Hierarchy** control panel, change the sub menu from **Pivot** to **Link Info**.

 - In the **Locks** rollout, in the Rotate group click in the check box of the **X** and **Y** axes.

 These two axes will no longer be part of the rotation transform gizmo.

The Link sub-menu of the Hierarchy control panel

- Select all the other rotational objects.

- **Lock** the **X** and **Y** axes to lock the rotational axis at the same time.

> **Note:** *The* **Lock** *option locks the axes in the local reference coordinate system. The X, Y and Z axes can vary between objects, so you should double-check that they are all locked in the intended way.*

4 Freeze the objects

Some parts of the robot will never be animated and should thus not be movable. It is useful to freeze them to make sure you will never accidentally select them during the animation process.

- Select the *Floor, Base Holding* and *Arm* objects.

- **RMB** to bring up the quad menu.

- Select the option **Object Properties...**.

- In the **Display Properties** option box, deactivate the **Show Frozen in Gray** option.

- In the Interactivity group, turn on **Freeze.**

 This will freeze all the selected nonrotational joints .

5 Revise the setup

Take some time to go through each node and make sure each one can only be manipulated for its intended purpose.

6 Save your work

* Save incrementally using the plus button and add "My" to the front of the name of the provided file.

Animating the robot

You now have enough knowledge of scene hierarchy and object inheritance to create your first simple animation. Before jumping into animation, you need to understand the controls that make it possible.

The Time Slider

The Time Slider provides an easy way to move through the frames of an animation. To do this, just drag the Time Slider button in either direction. The Time Slider button is labeled with the current frame number, followed by the total number of frames. The arrow buttons on each side are used to move to the previous and next frame. You can use the < and > keys on the keyboard to do the same thing.

The Time Slider

The Time controls

The Time controls include buttons to play back the animation, to jump to the start or the end of the animation, or to step forward and back by a single frame or to the next/previous keyframe. You can also jump to an exact frame by entering the frame number in the Frame Number field.

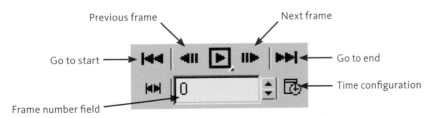

The Time Control buttons

Lesson 04: Animation Basics

The Time Configuration dialog

The Time Configuration dialog is used to set the number of frames in your animation and let you set the speed for your animation playback.

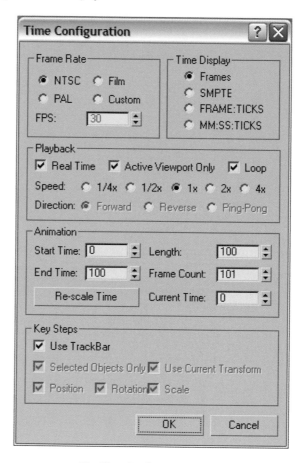

The Time Configuration dialog

1 Animation length

The first step in creating an animation is to determine how long you want the animation to be. The length of your animation will depend on how many frames are played per second. By default, Autodesk® 3ds Max® plays animation at a rate of 30 frames per second (FPS), which is a standard rate used for TV. If you want your animation to last one second, you will need to animate 30 frames.

• Click on the **Time Configuration** button in the Time Control section.

- Change the **End Time** value to **59**.

 *Notice that the **Frame Count** value has also change.*

- Click **OK** to change the animation length.

 The Time Slider now goes from 0 to 59, or 60 frames. This is two seconds of animation at 30FPS.

> **Tip:** *You can quickly change the animation length by pressing the Ctrl+Alt hotkey and clicking on the timeline with the LMB to set the Start Time, the RMB to set the End Time, or the MMB to pan along the time.*

2 Setting keyframes

When you keyframe an object, it defines a particular state on an object at a particular point in time. Animation is created as the object moves or changes between two different keyframe states. Luckily, you do not need to animate every single frame in your animation. When you set keyframes, 3ds Max will interpolate the values between the keyframes, giving you animation. To help you set your keyframes, you will use the Key Control section next to the Time Control buttons.

The Key Control menu

- **Open** the key filters dialog box with the **Key Filters...** button.
- **Deactivate** all the set key filters, except the Rotation from the list of the available filters. Leave Rotation turned on.
- Click the **Go to Start** button from the Time Control to make the current frame **0**.
- **Select** the *Pivot 3*.
- Click on the **Set Key** button to set a rotation key at frame 0 on *Pivot 3*.

 A green key is now visible at frame 0 in the timeline.

> **Tip:** **Set Key** *can also be executed by pressing the* **k** *hotkey.*

- Activate the **Auto Key** mode by clicking the AutoKey button, or with the **n** hotkey.

 The Auto Key feature will automatically keyframe a modification on an object.

- In the frame number field, type **30** and press **Enter**.

 Notice the position of the current frame mark in the Time Slider.

Lesson 04: Animation Basics

- **Rotate** the *Pivot 3 object* by **60** degrees up. This rotates the rest of the chain, which includes the Arm and two Clamp objects.

 During the rotation, you will see a blue arc that shows you the rotate angle you made and three digits the represent the exact value of the rotation. If, for some reason, you don't see the heads-up display of the values, you can watch the values in the coordinate fields at the bottom of the interface, directly below the trackbar.

The new arm rotation

Note: *After you release the LMB to complete your rotation, a keyframe will be added automatically into your timeline.*

- Select the *Pivot Head Vertical* object.
- **Rotate** the object **60** degrees downward.

 *Because you are in auto key mode, a keyframe is created on the current frame, but there is also a new one set on frame **0** with the original object position.*

- Select the *Pivot Head 360* object.
- **Rotate** it **90** degrees to the left.
- Select all children of the Pivot Head 360 object by using the Page Down hotkey.

Tip: *You can walk through your selections in the hierarchy by using the Page Up and Page Down hotkeys. However, you won't be able to go through a frozen object in the hierarchy.*

- **Rotate** the clamps by about **25** degrees so they touch each other.
- Exit the **Auto Key** mode with the **n** hotkey

The robot's new position on frame 30

3 **Play back the animation**

- Click the **Go to Start** button, and then click the **Play** button in the playback controls section to see your animation. You can also use the **/** hotkey to play the scene.
- To stop the playback of the animation, click the **Play** button again or use the **/** hotkey again.
- You can drag the current frame by **click+dragging** in the Time Slider area.

Tip: *You can also press the < and > hotkeys to navigate to the next and previous frames. If you hold either key down, it will play your animation forward or backward.*

Project 01

4 Tweak the animation

You now have a partially animated robot, but it is still missing refinement. Maybe you think the animation is too slow or too fast. In order to change the timing of the animation, you can drag keyframes directly in the Time Slider.

- With the *clamps* still selected, **press+drag** a selection in the timeline to select the two keyframes.

The keyframe should be white when selected.

 Tip: *You can also select the keyframes one by one by holding the Ctrl key and clicking on each keyframe.*

The selection box around the two keyframes

- **Drag** the second keyframe to frame **59**.

*The clamps animation now starts at frame **29** and stops at frame **59**.*

- Click anywhere in the Time Slider to remove the keyframe selection.
- Select the Pivot Head Vertical object using the Page Up hotkey.
- Click on the keyframe on frame **0** to select it.
- **Drag** the selected keyframe to frame **15**.
- **Play back** your animation.

You will notice that the clamps are closing later in the animation and the Pivot Head Vertical starts later but moves faster.

5 Track View

With Track View, you can view and edit all the keys that you create. Track View uses two different modes, *Curve Editor* and *Dope Sheet*. Curve Editor mode lets you display the animation as function curves, while the Dope Sheet mode displays the animation as a spreadsheet of keys and ranges.

Note: *Keys and curves are color-coded for easier identification.*

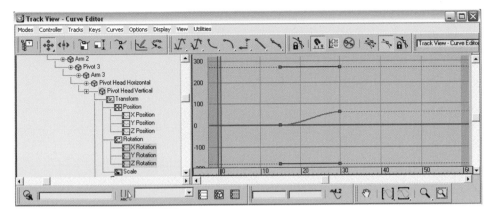

The Curve Editor

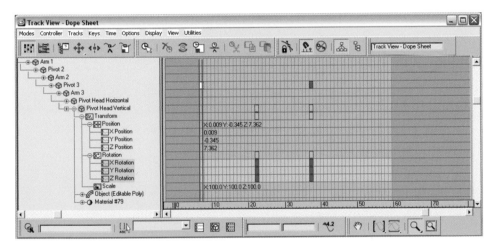

The Dope Sheet

- Select both *Clamps*.

- Select **Graph Editors** → **Track View – Curve Editor...**.

 In order to modify only the Rotate Y keyframes without affecting other animation curves, you can display only the desired curve in the Curve Editor. You will now modify the animation so the clamps progressively gain speed as they are closing.

- On the list on the left side of the Track View, hold down the **Ctrl** key and click to deselect the **X Rotation** and the **Z Rotation** track that are highlighted in yellow to focus on the **Y Rotation** curve.

Project 01

• Use the **Navigation tool** at the bottom right of the track view to frame the selected curve.

The Navigation toolbar of the Curve Editor

The two clamp curves framed in the Curve Editor

6 Modifying keyframes

• **Press+drag** a selection box around the two keyframes at frame **59**.

• **Play back** your animation.

• While the animation is playing, change the tangents of the keyframe with the **Keys Tangents** toolbar.

The Set Keys Tangents toolbar

Notice the difference in speed between the different tangent modes.

• Choose the best tangent type for your animation by clicking the **Set Tangents to Fast** button.

• **Stop** the playback of your animation.

• Continue experimenting, by selecting different keyframes and changing their tangents with the Curve Editor for all the different parts of the robot. Once you like your animation, close the Curve Editor.

7 **Save your work**

- **Save** your scene as *My04-animationBasics_02.max.*

Conclusion

You have now touched upon some of the basic concepts of hierarchies and animation. Autodesk®
3ds Max® software utilizes more powerful tools than described here to help you bring your
scenes to life, but these basic principles represent a great step forward. Besides learning how to
parent objects together, you also learned about locks and link info, inheritance of transformation
and animation and worked with two of the most useful graph editors—the Schematic View and
the Track View dialogs.

The next lesson is a more in-depth look at most of the tools that you have been using since the
beginning of this project. Once you have read this lesson, you will be able to make your own
decisions about workflow, whether to use hotkeys, quad menus, use the menu bar or click on
icons to launch most operations.

Lesson 04: Animation Basics

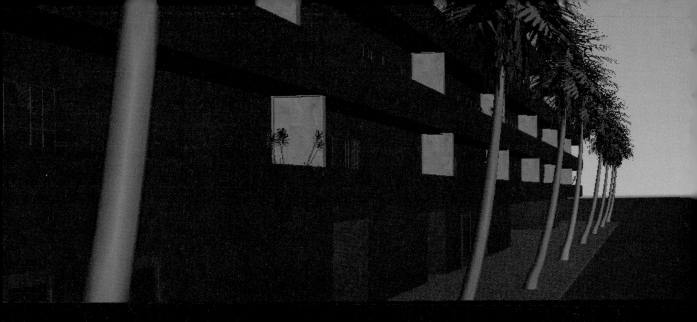

Lesson 05
Working with Autodesk 3ds Max

If you have completed the first four lessons, you have worked with Autodesk® 3ds Max from modeling and animation to materials and rendering. Now is a good time to review some of the user interface concepts that you have used and introduce some new tools in order to provide a more complete overview of how 3ds Max works.

It is recommended that you work through this lesson before proceeding with the subsequent lessons in the book. This lesson explores the basic user interface actions that you will use in your day-to-day work.

In this lesson you will learn how to:

- Set up a layout configuration;
- Set up user interface schemes;
- Control the viewport ;
- Use the command panel;
- Use the quad menus;
- Use the status bar;
- Use the main toolbar.

The user interface

You have learned how to build and animate scenes using different viewports and user interface tools. The viewports offer various points of view for evaluating your work—such as Perspective views and Orthographic views—while the tools offer you different methods for interacting with the objects in your scene. Shown below is the user interface and its key elements:

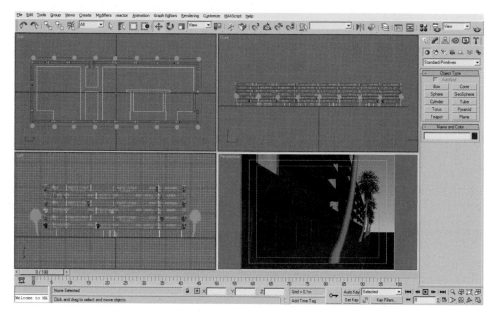

The 3ds Max user interface

Layouts

3ds Max is flexible in how you can arrange the viewports and how your model appears in each viewport. As you work, you may want to change to other view layouts. By default, 3ds Max opens with four equal-sized viewports. You can change this layout with the Viewport Configuration dialog.

Change your view layouts:

- **Use the RMB** on any viewport label; located in its top left corner, to access its options.
- Select **Configure…** from this menu to access the **Viewport Configuration** dialog.
- Go to the **Layout** tab and select a new layout configuration from the fourteen different configurations available.

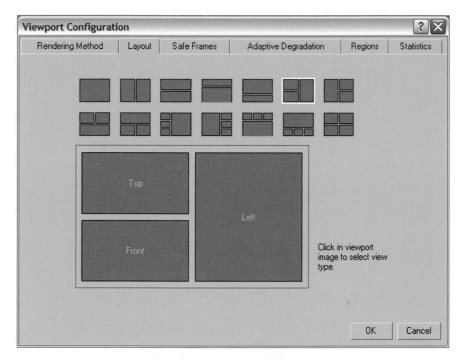

The available layout configuration

- In this dialog, you can also choose which view is displayed in each panel by clicking one of the panels in the viewport image.
- Once your layout and the viewport content are set, click **OK** to accept your changes.

Note: *The layout configuration is saved with your scene in your 3ds Max file.*

Change your viewport content

The content of any viewport can be changed in the Layout panel of the Viewport Configuration dialog, but it can also be set directly in the interface via the right-click viewport label menu. The viewport content is not limited to perspective and orthographic views, you can also set Schematic View, Track View and others editors to display within a viewport.

- **RMB** on the name of any panel, located in the top-left corner, to access its options.
- From this menu, extend the View menu to access all the available options and click on the content you want to make visible.

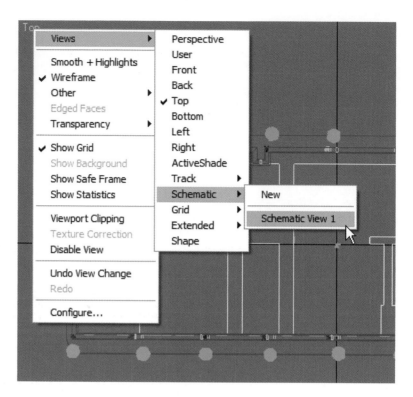

Extending the Views menu

Note: *You can always extend any panel to a full-screen view with the Maximize Viewport Toggle button or with the Alt+W hotkey.*

Tip: *You can't tear off a viewport and float it separately from the others. You can do this with the graph editors such as Schematic View, if you have dual monitors, it's a good idea to let these float so you can move them to the second screen.*

User interface schemes

You can customize your workspace by saving and loading custom user interface (UI) schemes. A custom UI scheme is saved as a set of six files:

.cui : Stores toolbar and panel layouts.

.clr : Stores all color settings (except quad menu colors).

.mnu : Stores menu bar and quad menu contents.

.qop : Stores quad menu colors, layout, and behavior.

.kbd : Stores keyboard shortcut assignments.

.ui : Stores the icon scheme (Classic or 2D Black and White).

You can load and save each of these files individually from their respective tabs in the *Customize User Interface* dialog. You can also load an entire set of UI scheme files at once with the *Load Custom UI Scheme* dialog, and you can save the current UI scheme as a complete set with the *Save Custom UI Scheme* dialog, available through the **Customize** main menu.

> **Tip:** *There are four basic UI schemes in the UI folder in the 3ds Max installation directory. When you choose Load Custom UI, you'll need to navigate from the project folder to the root 3ds max installation. A typical path would be:*
> *C:\Program Files\Autodesk\3ds Max 2008\ui.*

Viewport features

The viewports include many features to help you during your work; all of them can be found in one menu displayed when you **RMB** on the viewport label of any panel.

Show statistics

You can quickly access various statistics related to your current selection and entire scene.

- Activate the viewport in which to display statistics.
- Toggle the statistics display by pressing the **7** hotkey.

> **Note:** *You can customize the statistics display from the Statistics tab of the viewport configuration located in the* **Customize → Viewport Configuration....** *menu*

The statistics information displayed in the viewport

Viewport Clipping

This option lets you interactively set a near and far range for the viewport clipping plane. Geometry within the viewport clipping range is displayed. Any faces outside the clipping range are not displayed. This is useful in complex scenes where you want to work on details that are obscured from view. Turning on viewport clipping displays two yellow slider arrows on the edge of the viewport. Adjusting the lower arrow sets the near range, and the upper arrow sets the far range. Tick marks indicate the extents of the viewport. Viewport Clipping can also be turned on and off in the Viewport Configuration dialog.

The viewport near and far clipping plane

Disable a viewport

A disabled viewport behaves like any other viewport while active. However, when you change the scene in another viewport, the view in the disabled viewport does not update until you next activate it. Use this function to speed up screen redraws when you are working on complex geometry. Toggle this option using the **d** hotkey on any active viewport.

The world axis

In the lower-left corner of each viewport you can find the world axis, which shows the current orientation of the viewport with respect to the world coordinate system. The world axis colors are red for X, green for Y, and blue for Z. You can toggle the display of the world axis in all viewports by turning off or on **Display World Axis** in the Preference Settings window.

The world axis

Command panel

The command panel is one place in the 3ds Max user interface where you will spend a lot of time. This is where all the specific parameters, settings, and controls are located. The command panel is split into six panels, each accessed via a tab icon located at its top. You can resize the command panel by dragging on its left edges toward the center of the interface. This will allow for multiple columns of parameters to be displayed.

Create panel

The first command panel is the Create panel. It contains different levels of creation parameters that allow you to build different types of objects.

Geometry

In the Geometry area, you find commands to create 3D geometric objects.

Shapes

Shapes are divided into two basic types: splines and NURBS curves. Shapes are typically 2D but can be created in 3D as well.

Lights

Lights are used to illuminate the 3D scene in 3ds Max to create realism. Two types of lights are available: standard and photometric.

Cameras

Cameras allow you to frame your compositions in a way that captures the attention when an action is taking place. There are two types of cameras in 3ds Max, both of which can be animated.

Helpers

There are a number of helper types. A helper is a nonrenderable object whose purpose is to help you model and/or animate objects in the scene.

Space warps

Space warps produce various kinds of distortions in the space which can affect other objects and systems. Some space warps are meant especially for use with particle systems. They create force fields that deform other objects, deflectors to interact with particles, and create the gravity, wind and other elements that work in dynamics simulations.

Systems

Systems combine objects, controllers, and hierarchies to provide objects associated with some kind of behavior. The list also contains sunlight and daylight systems that simulate sunlight in your scenes.

Modify panel

The Modify panel controls let you modify the parameters of objects or change them by stacking modifiers. Modifiers are tools for reshaping or otherwise affecting an object. While they mold the final appearance of the object, modifiers do not change its underlying creation parameters.

Hierarchy panel

The Hierarchy panel is used when manipulating objects that are linked to one another. In such a situation the objects are in a parent/child relationship. This panel controls some of the relationships between these objects such as the inheritance of transforms from parent to child, and the locking of axes for individual transforms. The panel is also used to control the location and orientation of an object's pivot point.

Motion panel

The Motion panel is used to control the animation of objects. Animation controllers can be assigned to objects in this panel.

Display panel

The Display panel is used to control an object's color, visibility, freeze status, and other display properties.

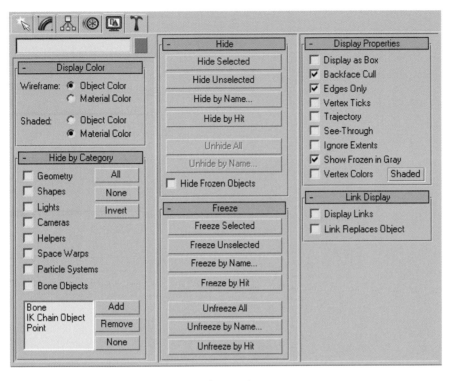

The Display panel options

Use the **Hide by Category** rollout to hide objects by respective category. This method of hiding objects is a temporary filter for fast selection of objects to hide. You will not be able to unhide them with the **Unhide by Name** tool. You will have to deactivate the object category filter to unhide the object of a specific category.

The **Display Properties** rollout will give you access to the same options included in the *Object Properties* dialog accessible using the quad menu.

Utility panel

The Utility panel contains a variety of commands generally not found elsewhere in the user interface. To see the full list of utilities installed, click the More button in the Utilities rollout. You can customize the buttons that display in this panel by clicking Configure Button Sets, and then choosing your favorite utilities.

Quad menu

When you click the right mouse button anywhere in an active viewport, a quad menu is displayed at the location of the mouse cursor. The quad menu can display up to four quadrant areas with various commands. The quad menu allows you to find and activate most commands without having to travel back and forth between the viewport and rollouts on the command panel. It speeds up the workflow, by moving the tools you're looking for right under your fingertips.

An example of the quad menu

The two right quadrants of the default quad menu display generic commands, which are shared between all objects. The two left quadrants contain context-specific commands, such as mesh tools and light commands. Each of these menus provides convenient access to functions found in the command panels. You can also repeat your last quad menu command by clicking the title of the quadrant.

The quad menu contents depend on what is selected. The menus are set up to display only the commands that are available for the current selection; therefore, selecting different types of objects displays different commands in the quadrants. Consequently, if no object is selected, all of the object-specific commands will be hidden. If all of the commands for a quadrant are hidden, the quadrant will not be displayed.

Some of the selections in the quad menu have a small icon. Clicking this icon opens a dialog where you can set parameters for the command.

Additionally, a specialized quad menu becomes available when you press any combination of **Shift**, **Ctrl**, or **Alt** while right-clicking in any standard viewport.

Status bar

The 3ds Max user interface contains a prompt area at the bottom and a status line with information about your scene and the active command. There is a coordinate display area in which you can type in transform values. There is also a lock for selection sets.

The status bar

MAXScript Mini Listener

The MAXScript Mini Listener is a single-line view of the contents of the MAXScript Listener window. The MAXScript Listener window is divided into two panes: one pink, and one white. The pink pane is the MacroRecorder pane. When the MacroRecorder is enabled, everything that is recorded is displayed in the pink pane. The

```
viewport.resetallviews()
```

The MAXScript Mini Listener

pink line in the Mini Listener shows the latest entry into the MacroRecorder pane. The white pane is the Scripter window where you can create scripts. The last line you type in the white area of the Listener will appear in the white area of the Mini Listener. You can type directly into the white area of the Mini Listener and use the arrow keys to scroll the display.

Lesson 05: Working with Autodesk 3ds Max

Status line

The status line displays the number and type of object or objects selected. The status line is located at the bottom of the screen, just above the prompt line.

The status line

Selection Lock Toggle

Selection Lock Toggle turns selection locking on and off. Lock selections so you don't inadvertently select something else in a complex scene. When your selection is locked, you can drag the mouse anywhere on screen without losing your selection. The cursor displays the current selection icon. When you want to deselect or alter your selection, click Lock Selection again to turn off locked selection mode. This is useful when you want to keep objects selected while you make a different viewport active or when the selection is tiny, or crowded and difficult to select. The spacebar is the hotkey for this function.

The Selection Lock Toggle

 Tip: *If you find you can't select something in the viewport, check to see if Lock Selection has been turned on accidentally. It's easy to hit the spacebar by accident and then you won't be able to select anything until you unlock the selection.*

Absolute/Offset Mode Transform Type-In

When this is off, the software treats values you enter into the X, Y, and Z fields as absolutes. When it is on, the software applies transform values you enter as relative to current values; that is, as an offset.

The Absolute/Offset Mode Transform Type-In

Prompt line

The prompt line, located at the bottom of the window under the status line, provides ongoing feedback, based on the current cursor position and the current program activity. When you don't know what to do next, look down here for instructions.

Click and drag to select and move objects

The prompt line

The Main toolbar

The main toolbar provides quick access to tools and dialogs for many of the most common tasks in 3ds Max. This toolbar can float, be resized, or docked in other positions. Generally it's best to leave it where it resides in the default user interface, at the top of the interface just below the menu bar.

Selection Filter List

The Selection Filter list lets you restrict selection with the selection tools to specific types and combinations of objects. For example, if you choose Cameras, you will only be able to select cameras with the selection tools; other objects will not respond. When you need to select objects of a certain type, this is useful as a quick method of freezing all other objects.

The Selection Filter list

Selection Region flyout

The Selection Region flyout provides access to five methods you can use to select objects by region. Clicking the Selection Region button displays a flyout containing the Rectangle, Circular, Fence, Lasso and Paint Selection Region buttons.

The Select Region flyout

Window/Crossing Selection Toggle

The Window/Crossing Selection toggle switches between window and crossing modes when you select by region.

Crossing mode ⟶ ⟵ Window mode

The two options of the Window/Crossing Selection toggle

In *Crossing* mode, you select all objects or subobjects within the region, plus any objects or sub-objects crossing the boundaries of the region.

In *Window* mode, you select only the objects or sub-objects within the selection.

Use Center flyout

The Use Center flyout provides access to three methods you can use to determine the geometric center for transform operations. Note that each transform can use a different method; the workflow is to first choose a transform and then choose a Use Center method.

⟵ Use Pivot Point Center

⟵ Use Selection Center

⟵ Use Transform Coordinate Center

The Use Center flyout

Use Pivot Point Center will let you enable rotation or scaling around the selected objects' respective pivot point. If you rotate several objects using this method, they will all rotate as individuals around their own pivot points.

Use Selection Center will let you enable rotation or scaling around the selected objects' collective geometric center. Rotating several objects in this case results in the objects rotating a group around a shared point.

Use Transform Coordinate Center will let you enable rotation or scaling around the center of the current coordinate system. This choice also results in multiple objects rotating around a single point.

Select and Manipulate

The Select and Manipulate command lets you edit the parameters of certain objects, modifiers, and controllers by dragging manipulators or gizmos in viewports. This is a little-used feature, since most modifiers and transform tools already give you gizmos in the viewport.

The manipulator icon

Note: *Unlike Select And Move and the other transforms, this button's state is nonexclusive. As long as Select mode or one of the transform modes is active, and Select and Manipulate is turned on, you can manipulate objects.*

- The following features have custom manipulators built in, which you can use to change parameters on the objects:

 Primitives with a Radius parameter;

 UVW Map Modifier;

 Target Spotlight;

 Free Spotlight;

 Spotlight parameters;

 IK Solver Properties rollout (HI Solver);

 Reaction Controllers.

The manipulator gizmo of the sphere object

Conclusion

If you look at the main toolbar, you will see that this chapter has just scratched the surface of all the tools found there. It's a good idea to take a little time and move your cursor over all the main toolbar tools and read the Tooltips. Also explore all the flyouts and have a look at the wealth of hidden tools found there.

You now know more about the 3ds Max interface and where everything is located. The techniques you learned here will be applied throughout the rest of this book. You have the knowledge now to determine how you want to use the interface.

The instructions for the following projects will not specify whether you should use the quad menu or menus to complete an action—the choice will be yours.

In the next lesson, you will build a human character and you will learn more about the polygonal modeling and texturing tools.

Image courtesy of Bedlam Games

Project 02

In this project, you will create a character named LiuJing, one of the fighters from the Bedlam game called *Kung Fu: Deadly Arts*. You will begin by modeling him using several polygonal modeling tools. Once that is done, you will set up his skeleton and rig him so that you can fully animate him. You will then complete the animation rig by adding morph targets to the fighter to give him facial expressions.

Lesson 06
Editable Poly Modeling

In this lesson, you will model the fighter LiuJing. The character will be created starting from a primitive. You will use many polygonal tools and modifiers until the desired shape is achieved. Throughout this lesson, feel free to take extra time to experiment and refine the model to your liking.

In this lesson you will learn the following:

- How to model starting from a cylinder;
- How to model and refine polygons;
- How to mirror geometry;
- How to weld vertices together;
- How to use the Cut tool;

Set up your project

Since this is a new project, you must set a new directory as your current project directory. This will let you separate the files generated in this project from other projects. To see the final scene for this lesson, refer to *06-LiuJing_05.max* in the support files.

1 Set the project

- Go to the **File** menu and select **Set Project Folder...**

 A window opens, pointing you to the Max projects directory.

- Click on the folder named *project2* to select it.

- Click on the **OK** button.

 This sets the project2 directory as your current project.

 OR

- If you did not copy the support files onto your drive, create a new project called *project2* and copy the support files there.

2 Make a new scene

You will now load the startup scene *06-LiuJing_01.max*.

- Select **File → Open...**

- Load the file *06-LiuJing_01.max* from the *project2/scenes* folder. If you get a File Mismatch error, accept the defaults and continue.

 This scene also includes three planes with reference textures of LiuJing on it, ready to start the modeling. The world units were also changed to match the units used in the first project.

The scene 06-LiuJing_01.max

Starting to build the fighter

You will build the fighter starting from a polygonal cylinder primitive. Faces will be extruded to create the more complex biped shape required, which will then be refined to create the fighter shape.

> **Tip:** *It is a good idea to look at reference images from this project to give you an idea of the finished product.*

3 **Primitive cylinder**

- Go to the **Top** viewport.

- Select **Create** → **Geometry** → **Standard Primitives** → **Cylinder**.

- Press and drag out a cylinder in the viewport.

- In the **Parameters** rollout, modify the parameters:

 Radius to **0.14m**;

 Height to **0.4m**

 Height Segments to **5**;

 Side to **10**.

- **Right-click** the cylinder in the Top viewport, and choose the **Move** settings button on the right side of the Transform quad.

- In the **Move** Transform Type-In dialog, set the following:

 X to **0.0m**

 Y to **0.0m**

 Z to **0.94m**;

- **Rename** the cylinder to *Torso*.

The primitive cylinder to be used for the torso

- **RMB** and choose the Rotate settings button from the right side of the Transform quad. **Rotate** the cylinder **18** degrees on the **Z** axis.

 Doing so will place a vertical row edge centered on the origin from the front and will make the model easier to split later in the lesson. If Perspective view is in Edged Face mode, you can see this happen in the viewport. If you can't see it, activate the viewport and press F4 to toggle this mode back on.

- In the **Modify** command panel, **RMB** in the modifier stack and select **Convert to: Editable Poly**.

 After you convert an object into an editable poly object, you can no longer parametrically adjust either the creation parameters or the individual modifiers. Essentially, you are collapsing the data structure into a collection of connected points in space, rather than the history in a modifier stack. If you need to maintain that, you can use an Edit Poly modifier on the stack, rather than converting the object, as you've just done. However, collapsing the stack uses less memory, improving performance.

- Open the **Vertex** sub-object selection level of the torso object with the **1** hotkey.

- In the front view, **select** all the vertices on the left side of the torso and delete them.

- Exit the **Vertex** mode with the **1** hotkey.

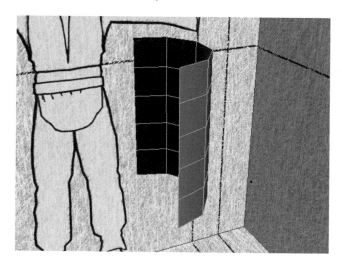

The torso object after deleting its left side vertices

4 Mirror the geometry

- In the main menu, select **Tools** → **Mirror...** and set the following options:

 Mirror Axis to X;

 Clone Selection to Instance.

- Click **OK** to create the other side of the torso.

 This tool clones an object on a predefined axis to create a mirrored instance of the geometry. Instanced objects maintain the same shape as the original object, but they can be moved in space like any other object. When you create a mirrored instance, each time you modify one side of the body, the other side will update accordingly.

Note: *There's also a Mirror modifier, along with a Symmetry modifier that will do the same thing if you need to do this in the context of the modifier stack.*

- **Rename** the left side of the *Torso* to *Mirror*.
- Select both *torso* objects.
- In the **Display** command panel, activate the **See-Through** option from the **Display Properties** rollout. The shortcut for this is **Alt+X**; you can also do this in Object Properties off the Transform quad menu.

 Doing so will make the torso objects transparent, so you can see the reference images through the geometry.

5 **Adjust the shape of the torso**

- Select the right side of the torso and enter its **Vertex** submenu by pressing the **1** hotkey.
- In the *front* view, place the vertices according to the reference image. Be sure to select the vertices by dragging around them rather than clicking on them. You can select vertices in the front and back of the torso, and if you click to select, you only select single vertices instead.

The vertices placed according to the front reference image

Note: *Notice that instanced geometry is also updating its shape. Once the object is cloned as an instance, you can edit the cloned object and the original object will also receive the transformation. If you clone as a Reference object, then you can add modifiers to the Reference and they won't be propagated to the other similar clones.*

- Exit the **Vertex** sub-object selection level and select the left side of the torso.
- **Repeat** this step from the *left* view.

The vertices placed according to the left reference image

- **Repeat** from the *top* view.

The vertices placed according to the top reference image

6 Create polygons

During the construction of the character, you will need to create new polygons to connect different parts or simply split new polygons from existing ones. In this case you will create new polygons to complete the upper part of the shoulder.

- Go to the *front* view and frame on the left shoulder.
- In the **Polygon** submenu object, click on the **Create** button in the **Edit Geometry** rollout.

 The cursor will change to let you know that you are in polygon creation mode. When the cursor gets over a vertex, it will change to let you know that any vertex created at this location will be snapped on this vertex.

- **Click** on the vertex located on the border of the shoulder to define the first vertex of your new polygon.
- **Create** the next vertex at the top shoulder from the reference image, **create** another vertex following the shoulder toward the neck, and finally click on the neighbor vertex of the start one.
- Exit the creation mode by clicking the **Create** button or using the **RMB** in the viewport.

The new polygon

- **Create** a new polygon by snapping the new vertices counter-clockwise to the top vertices you have just created and to the vertices on the back of the shoulder. Do this in the Perspective viewport.

• **RMB** to turn off the **Create** button in the Edit Geometry rollout.

The new polygon attaching the shoulder to the back

• Go to the **Edge** sub-object selection level by pressing the **2** hotkey and select the **Chamfer** settings button from the **Edit Edge** rollout.

This tool replaces the defined edge with two new edges.

• Drag the **Chamfer Amount** spinner and watch in the Perspective viewport. When you have a wide new polygon, try increasing the **Segments** and observe the effect. You will see that a rounded chamfer is possible. Right-click the spinner to reset the Segments to 1, and click OK to end the chamfer operation.

The new edge created using the chamfer tool

Next you'll try out the new Preview Selection Multi feature.

- In the **Selection** rollout, turn on the **Multi** radio button.

- **Select** the three polygonal faces on the side of the torso where the arm will be extruded. Notice that as you move your mouse over the polygons they turn yellow; if you click on them they turn red.

- Click the **Delete** key to delete these polygons.

- Now, move your cursor over the edges and vertices in the left viewport. They highlight as you pass over them. Click on any vertex and glance at the Modifier window. You have just switched to vertex mode, without using a hotkey or icon.

- In the left view, reposition the vertices as follows:

Delete these faces

The shaped arm hole

- Press **Alt+X** to deactivate the **See-Through** option of the torso objects.

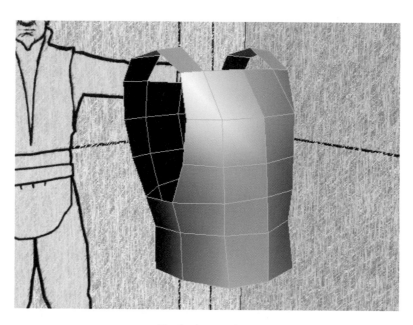

The final torso object

7 **Save your work**

- **Save** your scene as My06- LiuJing_02.max.

Creating the arms and legs

Now that you have a rough shape for the torso, you can extrude the arms and legs from it.

1 **Fill the arm hole**

- Go to the **Border** submenu object.

- Click on any edge around the arm hole.

 This will select all the border edges around the hole.

- Click the **Cap** button located in the **Edit Border** rollout.

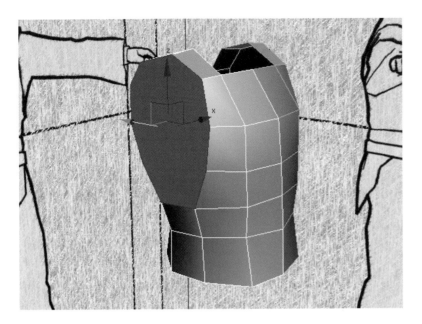

The new polygon create with the Cap tool

2 **Extrude and bevel the arm**

The **Extrude** tool lets you create new geometry by moving the poly in or out. When you want to also scale the poly in the same operation, you can use the Bevel tool.

- Make sure the new polygonal face is still selected.
- Go to the **Polygon** sub-object selection level and click on the settings button for **Bevel**.
- Make sure the **Bevel Type** option is set to **Group**.
- Give the **Height** a negative value of **−0.01m**.
- Set the **Outline Amount** to **−0.014m** to scale the polygon smaller to create the border of the jacket.
- Click **Apply**.

Lesson 06: Editable Poly Modeling

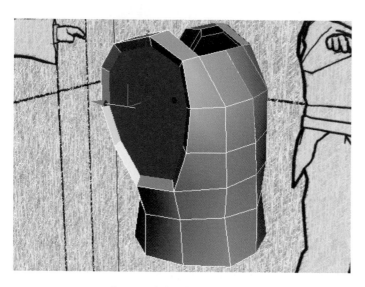

The extruded and scaled polygon

3 Continue extruding the arm

You can switch to the Extrude tool for the next operation.

- Select the **Extrude** tool on the **Edit Polygons**.

- **Click+drag** the same polygon to extrude it out to where the arm and shoulder meet in the reference image.

- **Scale, move** and **rotate** the polygon to match the reference image of the *front* and *top* views.

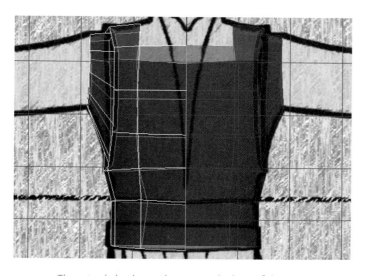

The extruded polygon that create the base of the arms

- Continue to **extrude** the polygon along the arm.

Each time you create an extrusion, reposition the polygon using the Move or Rotate transform tool to match the reference images.

The two new sections of the arms

- Select one vertical edge from the elbow and one from the shoulder.
- In the **Selection** rollout, click on the **Loop** button to select the edge loop around the elbow and around the shoulder.
- Click on the option button next to the Chamfer button to access the Chamfer options and enter the following:

 Chamfer Amount to **0.025m**;

 Segments to **2**.
- Click on **OK** to create a new edge.

The arm with new edges created by the Chamfer tool

Project 02

4 Save your work

- **Save** your scene as *06- LiuJing_03.ma.*

5 Create the legs

- **Create** a new polygon below the torso.

- **Extrude** that new polygon along the leg and between each extrusion, reposition the vertices to fit the reference images.

The extruded legs

6 Increase the definition of the leg

Because the leg was extruded from the base of the cylinder, it has only six polygons in circumference. This doesn't give us enough resolution to refine the leg properly. You will now add edges to the inside of the leg.

- Select the two rows of vertical edges from the inside of the leg.

- Use the **Chamfer** tool to add new edges.

- Click on **OK** to create the new edges.

The legs with more vertical definition

- Select one horizontal edge around the knee and one around the ankle, and then use the Chamfer tool to create more edges.
- Adjust the leg's vertices according to the reference images in the Left Viewport.

On the inside of the leg you can add detail using the Connect tool. Do the following:

- Select the edge at the bottom inside cuff of the leg, and then select **Ring** on the **Selection** rollout. You should see all the edges on the inside of the leg selected.

- Use the Connect settings tool to create new edges between the selected ring of edges in the pants. Use the Segments field in the Connect Edges dialog to determine how many edges you want to add. Two is probably enough. Click **OK** to add the new edges with the Connect tool. You can use this technique to add edges between the knees and ankles as well, just select the edge and choose **Ring** instead of Loop to select edges around the circumference of the leg.

The leg with all the detail in the pants

7 Refine the pelvis area

The legs are now properly modeled, but there are some corrections to bring to the pelvis region. The two first extrusions you created have produced polygons inside the pelvis that should be removed.

- **Hide** one side of the body to see the extra polygons.

- **Select** the two polygons and **delete** them.

The deleted polygons inside the pelvis

8 Save your work

- **Save** your scene as *My06- LiuJing_04.max*.

Extrude the shoes and hands

You can now start introducing details to your character. In the following steps, you should concentrate on refining the shape of the body parts so they look as good as you can make them without adding more topology to the surface.

1 Create the shoes

- **Select** the six polygons located on the front of the ankle, which will be used to extrude the shoe.
- **Extrude** the polygons **three times** to create the shoe.
- **Adjust** the vertices to match the shoe in the reference images.

The final shoe shape

2 Create the palm

- **Select** the polygon at the end of the arm.
- Create two **extrusions** to reach the base of the fingers.
- **Refine** the palm of the hand.

3 Model the thumb

You will now use a different type of extrusion, which will hinge from a predefined edge.

- **Select** the polygon where you want the thumb to be extruded.
- **Click** on the option box next to the **Hinge From Edge** button.
- Click on the **Pick Hinge** button and select the edge closest to the index finger from the polygon you have just selected.

Select this face to
extrude the thumb

Use this edge for the
Hinge From Edge tool

The polygon and the edge used to create the thumb

- Change the **Angle** value to **80**.
- Change the **Segments** value to **1**.
- Click on **OK** to extrude the base of the thumb.
- **Extrude** the selected polygon two times to create the thumb.
- Refine the vertices of the thumb to fit the reference images.

The extruded thumb

Tip: *Use the Perspective view to shape the thumb as well as possible. You will give it more detail later on.*

4 **Prepare the palm to extrude the fingers**

- Click on the **Cut** tool from **Edit Geometry** rollout.

 The Cut tool lets you split a polygonal face by defining a new edge.

- **Click** on the middle vertex on the top of the hand.

 A line tracks the cursor movement until you click a second vertex or edge.

- **Click** on the middle vertex at the bottom of the hand to create a new edge between these two vertices.

- **Create** two new edges on both sides of the edge you have just created.

 Doing so will define a total of four faces from which you will extrude the fingers.

The new edges created using the Cut tool

5 **Weld vertices**

Since you want all four faces to be made of exactly four vertices to extrude the fingers, you will now weld together the vertices on the extremities of the hand.

- **Select** the two vertices located at the top right corner of the hand.
- Click on the settings button for the **Weld** tool, located in the **Edit Vertices** rollout.
- Increase the **Weld Threshold** until you see the two vertices merging together.
- Click **OK** to weld the vertices.
- **Repeat** to weld the three other corners of the hand.

The vertices after being welded

6 Model the fingers

- **Select** the four polygons to be extruded.
- Make sure to set the **By Polygon** extrusion type from the Extrude settings button to extrude individual fingers.
- **Extrude** the polygons three times.
- **Refine** the vertices of the fingers to match the reference images.

The final look of the hand

7 Save your work

- **Save** your scene as *My06- LiuJing_05.max*.

Model the head

Perhaps the most difficult, yet constructive task when modeling a character is to build a good-looking head. When building a head, you must consider a basic principle; you must create the best-looking geometry with the fewest polygons possible. The number of polygons will be dictated by the scope of your project, in this case a real-time game engine.

This exercise will give you only basic guidelines into modeling the different parts of the head, but you will need to use your own artistic direction to achieve a good-looking model.

1 **Create the head**

- **Fill** the hole at the neck opening with polygons using the various techniques you have learned so far.

- **Refine** the vertices to prepare for the neck extrusion.

The polygon to be used for the neck extrusion

- **Extrude** the neck polygon once, up to the base of the head.

- **Extrude** again four times up to the top of the head.

- **Extrude** the four front polygons of the head to create the face of the character.

Tip: *Make sure the central row of vertices in the middle of the head stays aligned with the X axis.*

- **Delete** the hidden polygons that were created inside the head.

- Use the **Chamfer** tool to split the vertical edges around the head as follows:

The basic shape of the head

- **Adjust** the head shape to match the reference images.
- Make sure to place a polygon to cover the ear location, which will be used for an extrusion.
- Make sure to place a vertex directly in the middle of the eye, to be used to chamfer the eye socket.

The polygon used to create the ear

The vertex used to create the eye socket

The head after being refined

Lesson 06: Editable Poly Modeling

2 **Create the eye socket**

- Select the vertex of the eye and use the **Chamfer** tool to create the eye contour.
- **Extrude** the polygon face in the middle of the eye socket toward the inside of the body.
- **Cut** edges going out in a radial manner from the center of the eye socket.
- **Refine** the eye geometry to match the reference images.
- **Weld** the face inside the eye socket into a single vertex, if necessary.

3 **Create the eyes**

- In the front view create a **sphere** with a radius of **0.015m** and **24** segments.

 Doing so will align the poles with the pupil of the eyeball.

- **Rename** the sphere to *Eye Right.*
- **Place** the eye inside the head at its proper location.
- **Adjust** the vertices around the eye socket to fit the eyeball's surface.
- **Clone** the eye as a **copy** and place it on the other side of the head.
- **Rename** the new eye to *Eye Left.*

The eye sockets

4 **Create the nose**

- Use the **Cut** tool to create new edges around the nose according to the reference images.

- Use the **Hinge From Edge** tool with the edge on top of the nose to extrude the new polygon.

- **Delete** the hidden polygon inside the nose created by the extrusion.

- Use the **Cut** tool to give more detail to the nose.

- **Adjust** the nose shape as needed.

The refined nose

Note: *In order to generate the best geometry, you should start by building your models roughly. Once you have used the quickest solutions to get the geometry created, you can start refining the topology of the model to perfection. Remember that you will eventually move every single vertex in the entire character to your liking.*

Lesson 06: Editable Poly Modeling

5 Create the mouth

- Use the **Cut** tool to create new edges around and inside each lip.

- **Adjust** the lips to make them rounder.

- **Refine** the mouth and add edges in order to create a good mouth shape as in the reference images.

The mouth with more detail

6 Create the ears

- Use the **Cut** tool to contour the base shape of the ear.

- **Delete** all the edges inside the new ear contour.

 By doing so, you will end up with a single polygon for the ear which will be used in an extrusion.

- **Extrude** the ear polygon.

- Use the **Cut** tool to give more detail to the ear.

- **Adjust** the ear shape according to the reference images.

The ear with more detail

7 **Create the goatee**

- Use the **Cut** tool to create new edges around the chin where the goatee will be extruded.

- **Extrude** the polygons that are part of the goatee four times.

- **Delete** the hidden polygons inside the goatee.

- Select the vertices at the tip of the goatee and **weld** them together.

Note: *Make sure that the welded vertex is positioned directly on the* **X-axis***.*

- **Adjust** the vertices of the goatee as shown here:

The character's goatee

Lesson 06: Editable Poly Modeling

8 Refine the entire head

Now that you have created the main body parts for the head, you can spend time connecting and integrating them better. This is a tedious task that might require you to rewire entire parts of the geometry, but as you get better, you will be able to visualize the wireframe even before touching the model.

The final head

9 Smoothing the geometry

If you look at the fighter in the *smooth+hightlight* mode, you will see that some edges appear smooth and some others appear hard. This is normal since you have used various tools with different settings. You will now smooth all the edges to get a better view of your model before going on to refine its shape.

> **Note:** *Smoothing edges blend the shading between polygons to produce the appearance of a smooth, curved surface.*

- Go to the **Element** submenu mode and select all the polygons of the surface.
- Click on the **Auto Smooth** button located in the **Polygon: Smoothing Groups** rollout.

The geometry after smoothing the hard edges

Note: *The central line of the model does not appear smooth, because both sides of the body are separate objects. This will be fixed in the next lesson when you merge the entire body into a single piece.*

10 Save your work

- **Save** your scene as *My06- LiuJing_06.max*.

Conclusion

Congratulations, that was a lot of work. In this lesson, you learned how to model a complete character out of a basic polygonal primitive. In the process, you used several polygonal modeling tools to create the shape and details.

In the next lesson, you will add details to the fighter to generate the complete final model. This will allow you to experiment with other modeling tools and techniques.

Lesson 06: Editable Poly Modeling

Lesson 07
Adding Details

In this lesson, you will finalize LiuJing's model. You will use new polygonal tools and a modifier until the desired mesh is achieved.

Keep on modeling

You now have a good understanding of editable poly modeling basics. By continuing to refine the character, you will see that the time spent experimenting will provide invaluable experience. Throughout the modeling process, you can explore trial and error processes that will eventually achieve great solutions. At some point, you will be able to visualize the different steps to take without ever touching the model.

1 Scene file

- **Open** the scene *My06- LiuJing_06.max* from the previous lesson. If you had trouble completing that lesson, you can open the provided support file with the name *06-LiuJing_06.max*.

2 Creating the belt

- Select the polygons around the waist, where the belt will be located.
- Use the **Slice Plane** tool to divide this belt section into two parts as shown in the reference images.
- **Extrude** the polygons of the belt along their **Local Normal** by about **0.006m**.
- **Delete** the hidden polygons inside the body that the extrusion has created.
- Use the **Chamfer** tool on the edges in the middle of the belt to create new edge rings around the waist.
- **Adjust** the vertices of the belt to match the reference images.

The belt

3 **Clothing pieces**

- Select the two polygons under the front of the belt and two in the back to create the clothing pieces that extend from under the belt.

- **Extrude** theses polygons down to create the cloth.

- Use the **Cut** tool to remove the outside bottom corners of the cloth.

- Change the cloth to have a single sheet of polygons by **deleting** the polygons facing outside the extrusion, leaving only those underneath the cloth.

- Select the remaining polygons of the cloth.

 These polygons are black because their normals are facing away from the camera.

- Click the **Flip** button located in the **Edit Polygons** rollout.

4 **Flipping quad edges**

When creating polygons with four sides (i.e. *quads*), the software automatically cuts them into two triangles by splitting along two opposite vertices. This behavior is automatic and can sometimes generate quads that look wrong or interpenetrate with other geometry.

> **Note:** *This is especially true on nonplanar quads.*

Fortunately, these diagonal edges can be flipped by using the *Turn* function.

- Click on the **Turn** button located in the **Edit Polygons** rollout.

 This will highlight every diagonal edge of the model.

- Click on any diagonal edges to flip them.

The final cloth with all diagonals highlighted

- Use the **Create Polygon** tool to fill the gap between the cloth and the bolt.

Lesson 07: Adding Details

5 **Finish the jacket**

- Go to the *front* view and activate the **See-Through** option of the model.

- **Cut** polygons following the inner jacket line in the reference images, starting from the waist to the back of the neck.

- Use the **Chamfer** tool on the edges you have just created to insert two new edge loops.

The inner jacket edges

- Create the jacket border by pulling the new vertices as in the reference images.

The jacket border

6 Create the hair style

- **Cut** circular edges on the polygons on the top of the head where the ponytail is located in the reference images.

- **Delete** the polygons inside the area you have just cut to form the ponytail opening.

- **Create** a new polygon to fill in the opening and **extrude** it to create the base of the ponytail.

- Use the **Chamfer** tool to refine the base of the ponytail.

The base of the ponytail

- **Extrude** a row of faces twice, to create the lower part of the hair and adjust it as follows:

The refined ponytail

- **Extrude** the central polygon four times to create the upper part of the hair.
- **Adjust** the hair to match the reference images.

The final look of the hair

- **Delete** any hidden polygons on the inside of the ponytail.
- Use the **Auto Smooth** button to smooth all the edges of the model.

7 **Save your work**

- **Save** your scene as *07-addingdetail_01.max*.

Refining the model

Now that the basic shape of the character is established, you can concentrate on moving vertices around to refine its general silhouette.

1 **Adjust the geometry**

To refine the shape of the character, you do not need to add geometry just yet. Instead, you can edit the existing vertices to get the maximum potential from the current geometry.

- Go to the **Vertex** sub-object selection level for the body.
- Select one vertex located in the middle of the knee.

- Activate the **Use Soft Selection** tool located in the **Soft Selection** rollout.

 The Soft Selection tool controls the surrounding area of the subobject selection when using the move, rotate and scale functions. When this tool is enabled, a spline curve is applied to deform the soft-selected vertices surrounding the subobject selection. This provides a magnet-like effect with a sphere of influence around the transformation.

- Set the **Falloff** value to **0.1m**.

 This falloff is visible in the viewports as a color gradient surrounding the selection, conforming to the first part of the standard color spectrum: ROYGB (red, orange, yellow, green, blue). Red sub-objects selections are those you select explicitly. The highest-value soft-selected sub-object selections are reddish-orange; they have the same selection value as red vertices, and respond the same way to manipulation. Orange vertices have a slightly lower selection value, and respond to manipulation a bit less strongly. Yellow-orange vertices have an even lower selection value, and so on. Blue vertices are unaffected and don't respond to manipulation of the red sub-object selection; they represent the outer limit of the soft selection effect.

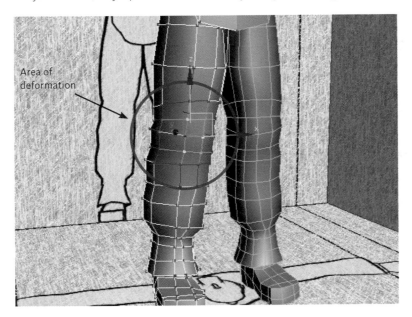

Area of
deformation

The Soft Selection tool once activated

- Try to move the selected vertex and see how the geometry is deformed.

Tip: *Make sure to always look through different viewports when modeling.*

Lesson 07: Adding Details

> **Tip:** *Don't be afraid of moving vertices one by one. You will most likely end up moving each vertex by hand for the entire model.*

Final touches

You will now go over some important points to finalize your model.

1 Clean the model

- **Delete** the instanced object called *Body Mirror*.

- **Delete** any remaining hidden polygons inside the half side of the body.

- Make sure that every vertex on the central line of the character is at position **o** on the **X axis**. If any vertex on the central line of the character appears off, use the Move settings button to set it back to **o.oo** for the **X** field.

- Select all the vertices of the model by pressing **Ctrl+A**, and then click on the option box of the **Weld** tool to bring up the Weld option dialog.

- Change the **Weld Threshold** to **o**.

 In the Number of vertex info box, you will see the difference between the original model and the one after the weld operation. If the numbers are different, it means there are vertices that are directly on top of each other.

- If there are vertices to merge together, click the **OK** button to weld the vertices together.

2 Reset the model

Use the *Reset Xform* utility to push object rotation and scaling values onto the modifier stack and align object pivot points and bounding boxes with the world coordinate system. Reset Transform removes all rotation and scale values from selected objects and places those transforms in an *XForm* modifier.

- Make sure the Body object is select.

- In the **Utilities** command panel, click on the **Reset XForm** button.

 *This will bring up the **Reset Transform** rollout.*

- Click on the **Reset Selected** button.

- Go to the **Modify** command panel.

- **RMB** on the **XForm** modifier and select **Collapse All** from the menu.

 A warning will appear, telling you that this action will remove everything in the stack.

- Click and hold **Yes** to confirm the collapsing of the modifier stack.

> **Note:** *Holding creates a fast save of the current file, in case you decide you want to return to this state (before the collapse of the stack). To return to this state, on the menu bar choose Edit → Fetch and the saved file will be loaded and you'll to the pre-collapsed model.*

3 **Add a freeform deformation modifier**

Sometimes when modeling, you sit back and look at your work thinking you could improve the proportions of the model. An easy way to change a model's proportions is to create and use a FFD (Free Form Deformation) modifier. A lattice surrounds a deformable object with a structure of points that can be manipulated to change the object's shape. Once you are happy with the new proportions, you can simply collapse the modifier stack, thus freezing the deformations on the model.

- Use the **Mirror** tool to clone a **mirrored instance** of the body.

- Add an **FFD(box)** modifier to the original object.

 A large lattice box is created around the model.

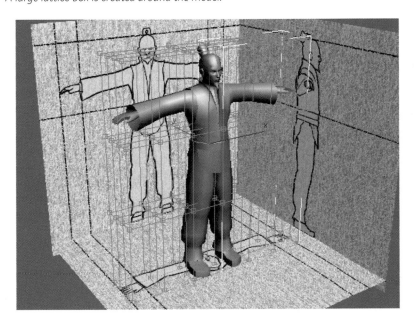

The lattice deformer

- In the **FFD Parameters**, you can change the lattice dimensions by setting the **Set Number of Points** button.

 Doing so will change the number of subdivisions in the FFD, which in turn adds more control points to deform the surface with. This will allow more control over the deformations.

4 Deform the lattice box

- Expand the **FFD(box)** modifier from the modifier stack.
- Enable the **Control Point** sub-object level.
- Select any control points on the right side of the model.
- **Adjust** the positioning of the control points to change the proportions of your model.
- Find the best proportions possible.

Note: *If you move control points in the center area of the model, it could affect the middle vertices and move them away from the central axis of the model.*

Tip: *This is a good time to place the character's feet on the world grid (ground plane), if they are not already there.*

5 Delete the FFD

If you simply deleted the FFD modifier, the geometry would snap right back to its original shape. In order to keep the deformation and freeze the geometry with the current shape, you need to collapse the modifier stack, which will automatically delete the deformer modifier.

- Select the *Body* geometry.
- **RMB** on the **FFD(box)** modifier and select **Collapse All** from the menu.

 A warning will appear telling you that this action will remove everything in the stack.

- Click **Yes** in the warning dialog.

Note: *Notice that the mirror object still has the FFD(box) modifier on it because when you collapsed the stack, it broke the link between the instance and the original.*

- **Delete** the mirrored body object.

6 Completing the model

At this point, your model can be considered final. The following steps show how to mirror and weld the geometry to create the final, complete body geometry.

- **Select** the *Body (Torso)* object.
- Add a **Symmetry** modifier.
- Activate the **Weld Seam** option, if it isn't already.

 This will weld all the vertices at position 0 on the X axis together.

Project 02

- **Collapse** the symmetry modifier.

The final model

7 **Save your work**

- **Save** your scene as *My07-addingdetail_02.max*. As always, you can compare your file with the provided support file of similar name.

Conclusion

In this lesson, you finalized the model to your liking. In the process, you have learned about new tools and modifiers that can help you speed up any refinement tasks. Among those were the Soft Modification tool and the FFD modifier, which allows you to manipulate a region of your model without the need to move the components one by one.

In the next lesson, you will create a skeleton for your character. This will allow you to experiment with tools and techniques that will add animation capabilities to your model.

Lesson 07: Adding Details

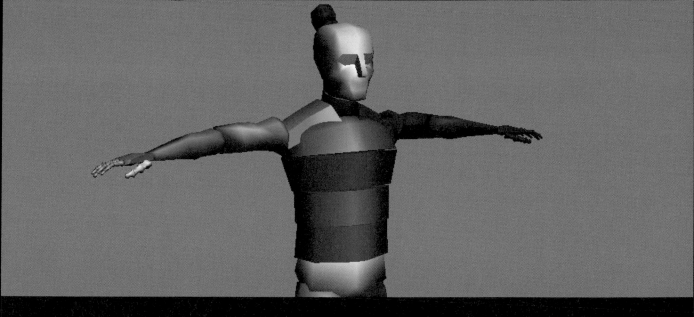

Lesson 08
Creating the Skeleton

In this lesson you will create the skeleton hierarchy to be used to bind the geometry and to animate your character. In order to create a skeleton, you need to create a series of bones to match the shape of your character. The geometry is then bound to the skeleton and deformations are applied.

In this lesson you will learn the following:

Creating the skeleton

To create the fighter's skeleton, you will use the animation system tool called *Biped* provided with the Character Studio plug-in included in 3ds Max. Biped builds and animates skeletal armatures, ready for character animation. Joints on the biped are hinged to follow human anatomy. By default, the biped resembles a human skeleton and has a stable inverse kinematics hierarchy. This means that when you move a hand or foot, the corresponding elbow or knee orients itself accordingly, and produces a natural human posture.

Tip: *Before adding a biped skeleton, activate the see-through feature and freeze your character mesh. When the mesh is frozen, you can still see it, but you can't select or alter it, reducing the chance for error or frustration.*

1 **Scene file**

• **Open** the last scene from the previous lesson or open the support file named *07-addingdetail_02.max*.

• Select all the objects in the scene, right-click and choose **Object Properties** from the Transform quad menu. In **Display Options** turn on **See-Through,** and then in **Interactivity** turn on **Freeze.**

2 **Biped skeleton options**

• On the **Create** panel, click the **Systems** button; then, in the **Object Type** rollout, click **Biped**.

• Change the **Body Type** to **Male**.

This option affects the look of the biped skeleton.

• Set the following:

 Ponytail1 Links to 2;

 Fingers to 5;

 Finger Links value to 3;

 Toe Links to 1.

The Create Biped rollout

- Expand the **Twist Links** sub-rollout menu.

 Here you can add a bone twist option for all limbs. These settings allow better mesh deformation on skinned models when twisting occurs on animated limbs.

- Activate the **Twists** option and set the following:

 Upper Arm to **3**;

 Forearms to **3**.

3 **Create a biped skeleton**

- Go to the *front* view.

- Activate the **Snap** tool to snap to **Grid Points** only.

- Create a biped by **press+dragging** in the viewport from the origin to the top of the head.

 By doing this, you interactively define the height of the biped.

The biped

Lesson 08: Creating the Skeleton

Project 02

- To know exactly how the Biped tool has created the bone hierarchy, open the Schematic View to see the complete hierarchy of the bone object.

The biped hierarchy

Note: *Biped body parts cannot be removed; however, unwanted parts can be hidden. If you delete parts of the biped, the entire biped will be deleted.*

- **Unfreeze** the twist bone objects of the arms and hide them. **RMB** and choose **Unfreeze All**. Then, to hide the twist bone, press **H** on the keyboard to display the Select From Scene dialog. In the **Display** toolbar, click the **Display Bones** button. Then, in the **Find** field, type ***Twist** and press **Enter** to select all the Twist bones. Right-click again and choose **Hide Selection**.

4 **Rename the biped objects**

Before you go any further, it is a good idea to rename the biped object to match our character's name.

- Select any part of the biped; then go to the **Motion** command panel.

Note: *The Motion command panel has the Biped rollout only when you have part of the biped selected.*

- Expand **Modes and Display** from the **Biped** rollout.
- Change the **Name** to *LiuJing*.

By changing the name with this technique, you add a prefix to all the biped objects in one single step.

Match the biped to your character

Now that the basic structure of the biped has been created and named, you can match the biped body parts to you character's body using the transform tool.

1 Match the biped to your character

- Enter **Figure Mode** by clicking its button in the **Biped** rollout.

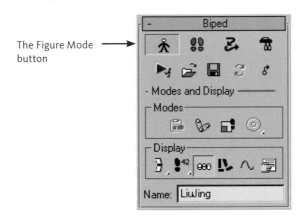

The Figure Mode button

The biped rollout

2 The center of mass

When positioning the biped inside your mesh, you should start with the *center of mass*, which is the parent of all objects in the biped hierarchy.

- In the Track Selection rollout click the Body Vertical button. This will select the center of mass (COM) object previously called *Bipo1*, now renamed as *LiuJing*.

- **Move** the center of mass in line with the hips of the character geometry.

- Press **Page Down** to move down the hierarchy to the Pelvis.

Note: *Use both the front and left views to position the biped bones in the geometry.*

- **Scale** the *Pelvis* so that the legs fit properly in the mesh.

Tip: *The skin envelopes that will be created later are based on the size of the bones in the skeleton. If the bones are too skinny, the envelopes will need later editing to work correctly. It's a good idea to make the biped bones slightly smaller than the mesh they will deform.*

Lesson 08: Creating the Skeleton

Project 02

3 **Symmetrical edits**

To make sure that each leg and arm is transformed symmetrically, two different techniques can be used.

- Select the bone that you want to modify.

- In the **Track Selection** rollout, click on the **Symmetrical** button to add the opposite bone to your selection.

- Transform the two bones at the same time.

 OR

- Go to the **Copy/Paste** rollout.

The Copy/Paste rollout

- Select the bones that you want to modify.

- Click on the **Create Collection** button. This starts a new collection.

- Click on the **Copy Posture** button.

 A snapshot of the bone transformation will be shown in the preview area.

- Click on the **Paste Posture Opposite** button.

> **Tip:** *It's better to work on one side of the biped and paste all the transformations at the end to avoid missing any transformations.*

4 **Matching the Legs**

- **Select** the left thigh bone, called *LiuJing L Thigh.*

- **Rotate** the thigh until the foot bones match the foot geometry.

Note: *When you rotate the thigh, the foot bones do not rotate on their Y axis, so the foot always stays flat on the floor.*

- **Scale** the thigh until the end of the bone is located in the middle of the knee.

Tip: *You can scale the bone on its Y and Z axes. It will not affect the position of the bone. This is only for the visual look to get a better view of the proportions of your character when animating with the biped and the geometry hidden. It will also help in the skinning step in the next lesson.*

- When you are satisfied with your pose, check the alignment in all viewports to make sure that the skeleton is positioned correctly in the geometry.
- **Select** the left calf bone called *LiuJing L Calf.*

Note: *Use the* **Page Up** *and* **Page Down** *keys to cycle through the nodes in a hierarchy.*

- **Rotate** and **scale** the calf until its opposite extremity matches the ankle rotation pivot.
- **Rotate** and **scale** the foot until its opposite extremity matches the toe's rotation pivot.
- **Scale** the toe until it is big enough to cover the extremity of the foot.

Note: *The head, toes, and fingertips should extend slightly beyond the mesh. This will help during the skinning process.*

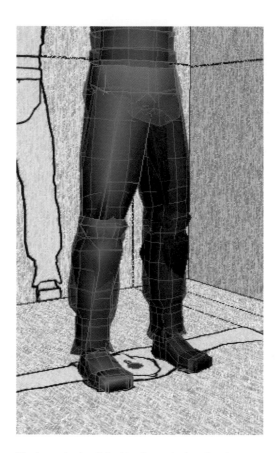

The lower body of the biped matched to the character

5 **Matching the spine**

- **Select** the two *UpperArm* bones on either side of the body.

- **Rotate** these bones up to form a *T-stance* matching the geometry.

 At this point, the shoulders are not in a correct position, making it impossible for the arms to match the geometry.

- **Select** the four bones representing the spine of the character.

- **Rotate** them using the left viewport to match the curve of the character's spine.

- **Scale** these bones using the front viewport until the clavicles match the shoulders of your model.

The spine bones after being scaled

6 **Matching the arms**

- **Rotate** and scale the clavicle, the upper arm, the forearm and the hand bone until they match the geometry articulations seen in the front and top viewports.

The biped arms matching the geometry

- **Select** the whole arm by double-clicking on the clavicle.
- **Copy** the arm posture.
- **Paste** this posture on the opposite arm.

Lesson 08: Creating the Skeleton

7 Matching the hand

- **Repeat** the previous steps to match the hand, thumb, and fingers to the geometry. This will take some time; be patient and you will be rewarded.

The biped hand matching the geometry

8 Matching the head

- **Repeat** the previous steps to match the head to the geometry.

The neck and the head bone with the reference point of the rotation pivot

- **Match** the ponytail bones to the geometry.

The ponytail bones

9 **Copy the posture**

- Select all the bones that you have modified which need to be symmetrical.

- Click the **Create Collection** button.

- Click the **Copy Posture** button.

 A snapshot of the bone transformation will be shown in the preview area.

- Click on the **Paste Posture Opposite** button.

Note: *You can delete the Copy Collections that you created earlier, with the Delete Collection button.*

Lesson 08: Creating the Skeleton

10 Setup the biped

Once you have successfully positioned a skeleton inside your character mesh, you can change biped features to finalize the biped set-up.

- Exit the **Figure Mode** by clicking on the Figure Mode button again.
- Select all the bones of the biped by **double-clicking** on the *LiuJing* center-of-mass bone.
- Expand the **Quaternion/Euler** rollout.

This rollout contains options to switch between Euler or Quaternion controllers on biped animations. These choices offer alternative ways to control an animation in the Curve Editor.

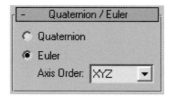

The Quaternion/Euler rollout

- Make sure the Euler option is selected.

Using the Euler controller is an efficient way to animate your biped because you can use Bezier tangents to change the interpolation of your XYZ curves. Quaternion curves do not have tangents.

The final biped and geometry

11 **Save your work**

 • **Save** your scene as My*08-skeleton_01.max*.

Conclusion

You now have greater experience in creating a biped skeleton and navigating skeleton hierarchies. You have learned how to match the biped bones to your geometry, and you have transferred postures to keep your biped modifications symmetrical.

In the next lesson, you will bind the character's geometry to the biped and explore different techniques and tools used for character rigging.

Lesson 09
Skinning

Skin modifier

The Skin modifier is a skeletal deformation tool that lets you deform one object with another object. Applying the Skin modifier and then assigning bones within the modifier gives each bone a capsule-shaped "envelope." Vertices of the modified object within these envelopes move with the bones. Where envelopes overlap, vertex motion is a blend between the envelopes.

By default, each vertex that's affected by a single bone is given a weight value of 1.0, which means it's affected by that bone only. Vertices within the intersection of two bones' envelopes have two weight values: one for each bone. The ratio of a vertex's weight values, which always totals 1.0, determines the relative extent to which each bone's motion affects the vertex. For example, if a vertex's weight with respect to bone 1 is 0.8 and its weight with respect to bone 2 is 0.2, the motion of bone 1 will have four times as much influence on the vertex as will the motion of bone 2.

The initial envelope shape and position follows the longest axis of the biped bone object. To make it easier to understand, you will learn the basics on a cylinder before you start skinning the character.

1 **Set-up the scene**

- If you still have the previous scene open, do a **File** → **Reset**.
- On the **Create** command panel, under **Standard Primitives**, click the **Cylinder** button.
- In the *top* view, create a cylinder, and then set the object parameters to be **0.1m** for the **Radius** and **1m** for the **Height**.
- On the parameters rollout, set **Height Segments** to **20**.

 This provides enough mesh detail for a smooth surface deformation.

- On the **Create** panel, under **Systems**, click the **Bones** button.
- Make sure the **IKHISolver** is enabled in the **IK Solver** list and turn on **Assign To Children**. (This will turn on **Assign To Root**.)

 Doing so will automatically create an IK handle for the bone animation.

- In the *front* viewport, click successively three times: At the bottom-right corner of the cylinder, in the middle of the cylinder, and at the top-right corner of the cylinder.
- **RMB** to exit the bone creation mode.

The bone setup

Note: *This scene can be found in the support_files as 09-skinning_01.max.*

Lesson 09: Skinning

- **Select** the cylinder.
- On the **Modify** command panel, choose **Skin** from the **Modifier List**.
- On the **Skin** modifier's **Parameters** rollout, click **Add** and use the **Select Bones** dialog to select the three bones you have just created.
- In the *front* viewport, select the bone end effector *IK Chain1* and move it around. If for some reason the IK handle isn't visible in the viewport, select it by pressing the **h** key to display the **Select From Scene** dialog; then click **Display All** and choose the **IK Chain1**.

The cylinder deforms to follow the bones.

The parameters rollout of the Skin modifier

The cylinder deformation

2 Edit weights with envelopes

- To adjust envelopes and refine the surface deformation, select the Cylinder again; then, in the Modify panel, click on the **Edit Envelopes** button from the **Parameters** rollout and click on the bone in the viewport to edit its envelope.

- Use the **Edit Envelopes** control points to resize the envelopes and change vertex weights.

The envelopes of the bottom bone and the upper bone

Lesson 09: Skinning

- In the *front* view, select the bone end effector *IK Chain1* and move it around.

 The cylinder deformation will now look better, as the vertex influences have been modified by the bone envelopes.

- Experiment with the different control points of the envelopes to see how you can adjust them. In addition to scaling the ends of the envelope by moving the outer control points, you can reposition the end of the envelope by clicking the inner control points as well. This is important when you have bones that are wider than they are long, and the envelopes have built themselves in the wrong direction.

The new cylinder deformation

Painting weights

Modifying the influences of each bone on each vertex can be a tedious task, but you can use the *Paint Weights* tool to paint the weights of the vertices directly on the geometry in the viewport. This makes it easier to visually edit the influence of bones on the geometry. Painting the weight of the vertices must be done after you change the envelopes, because the envelope will not affect the vertices after they are painted.

1 Changing the weights of the influences

- Enter the **Edit Envelopes** level of the Skin modifier.

- In the **Weight Properties** option box of the **Parameters** rollout, click the **Paint Weights** button.

 You can start painting the weight influence right away in the viewport. Your cursor will change into a brush that will follow the skinned geometry.

- **Press+drag** on the middle of the cylinder to change the influence of the middle vertices.

 *At this time, you can only change the middle vertex weight value because the **Paint Blend Weights** option under the **Paint Weight** button is active by default. When this option is on, the brush paints values by averaging the weights of neighboring vertices.*

- You can customize the brush size, strength, and other settings using the **Painter Options** button next to the **Paint Weights** button.

The Painter Options dialog

Tip: *You can also use negative **Strength** values to remove weight influences.*

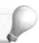

Lesson 09: Skinning

Deformer gizmos

The *Gizmos* rollout allows you to deform the mesh according to the angle of the joint, and to add gizmos to selected points on the object. The rollout consists of a list box containing all the gizmos for this modifier and a drop-down list of the current types of gizmos to add to the modifier.

1 **Create a simple animation**

- Switch to **Auto Key** mode by pressing the **n** hotkey.
- Go to frame **25**.
- Select the bone end effector and move it down until the cylinder bends enough to make the deformation look broken.
- Deactivate the **Auto Key** mode by using the **n** hotkey.
- Go back to frame **0**.

2 **Joint Angle Deformer**

- Select the Cylinder again.
- In the **Select** option box of the **Parameters** rollout, turn on **Edit Envelopes**, and then activate the **Vertices** option to make the vertices selectable.
- Select the upper bone (Bone02) of the cylinder that will drive the deformation.
- Select all the vertices in the middle of the cylinder that you want to affect.
- Select the **Joint Angle Deformer** from the **Gizmo** drop-down list.
- Click the **Add** button under the drop-down list.

 *Once you click **Add**, you can see the joint angle deformer gizmo in the viewport around the cylinder, and the **Gizmo Parameters** rollout appears under the **Gizmos** rollout.*

The joint angle deformer on selected vertices

3 Modify the bended influence

- Go to frame **25**.

You will see the deformation gizmo follow the cylinder as it bends.

- From the **Gizmo Parameter** rollout, click on the **Edit Lattice** button.

- In the viewport, select the control points of the lattice and **move** them until the deformation looks good.

Improved deformations using the joint angle deformer

Note: *This scene can be found in the support_files as 09-skinning_02.max.*

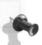

Project 02

4 Adjust the bended influence curves

- Use the **Edit Angle Keys Curves** from the **Gizmos** parameters rollout to bring up a curve editor that lets you manipulate the shape of the lattice at a particular angle.

 This graph reflects the position vs. angle of curves of the currently selected points.

The joint graph of the gizmo control points

Note: *The red curves are the X-axis, green curves are the Y-axis, and blue curves are the Z-axis.*

5 Available angle deformers

There are three deformers available:

- The **Joint Angle** deformer has a lattice that can deform vertices on the parent and child bones.

 This deformer is great for smoothing out a bending deformation.

- The **Bulge Angle** deformer has a lattice that affects only the vertices on the parent bone.

 This deformer is great for creating a bulging muscle effect.

- The **Morph Angle** deformer works on vertices of the parent and child bones.

 This deformer is great for achieving a particular shape as the bones deform.

Keep these distinctions in mind when you need to further deform vertices when skinning a surface.

Skinning the fighter

Because your character is mostly composed of deformable skin objects, you will bind its entire geometry using smooth binding.

1 **Scene file**

• **Open** the file *08-skeleton_02.max* from the last lesson.

• **Save** the file right away as *09-skinning_03.max*.

2 **Attach the eyes**

Because the eyes need to be animated with rotations, you can attach them directly to the bone structure by linking them to the head bone.

• **Select** both eyeballs (Eye Right and Eye Left).

• In the Schematic View, **link** the eyes to the *LiuJing Head* biped bone.

The eye objects linked to the LiuJing Head biped bone

3 **Skin the body**

• Unhide the twist bones that were hidden earlier.

• **Select** the body geometry of the fighter.

• Add a **Skin** modifier.

• Click on the **Add** button in the parameter rollout of the Skin modifier.

Lesson 09: Skinning

- **Select** the following bones from the **Select Bones** browser:

Pelvis	L+R Clavicle	L+R Finger01	L+R Finger31
Spine	L+R UpArmTwist	L+R Finger02	L+R Finger32
Spine1	L+R UpArmTwist1	L+R Finger1	L+R Finger4
Spine2	L+R UpArmTwist2	L+R Finger11	L+R Finger41
Spine3	L+R ForeTwist	L+R Finger12	L+R Finger42
Neck	L+R ForeTwist1	L+R Finger2	L+R Thigh
Head	L+R ForeTwist2	L+R Finger21	L+R Calf
Ponytail1	L+R Hand	L+R Finger22	L+R Foot
Ponytail11	L+R Finger0	L+R Finger3	L+R Toe0

A total of 63 biped bones will be include in the Skin modifier.

- **Hide** the twist bones.

Note: *The twist bones are only used to better deform the skin. They will be twisted automatically during the animation process.*

4 Adjust the envelopes

- Go to the envelopes sub-object selection level of the Skin modifier.

- Change the envelopes' radius using their control points to make a smooth deformation between the envelopes.

You can activate the option called **Color All Weights** *from the* **Display** *rollout to see the complete weighting value for the entire body.*

The body and weighting influences

5 **Testing the skinning**

The first step of skinning is done, so it is a good time to test how the body deforms. You can animate each bone one by one to see each deformation between two bones or, for this exercise, load a motion capture file from the support files, containing a stretching animation test.

- **Select** any part of the biped.

- Go in the **Motion** control panel and expand the biped rollout.

- Click on the **Load File** button located under the **Footstep mode** button.

This will bring up the Load Animation browser.

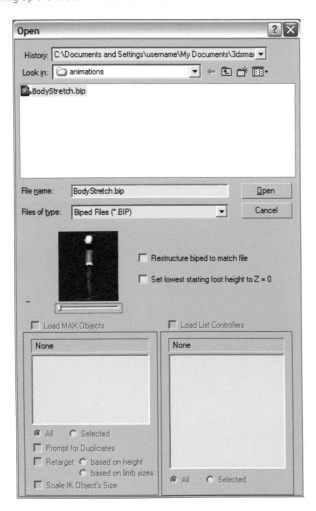

The open animation window

Lesson 09: Skinning

- Disable the option **Set lowest starting foot height to Z = 0**.
- Go to the *project2/sceneassets/animations* folder of the *support_files* and click on the *BodyStretch.bip* file.

 A preview of the animation is now visible in the preview area. You can scroll in the animation using the bar below the preview area.

- Click on **Open** to load the animation on your character.
- **Playback** the animation to see the character come to life.

> **Note:** *If you see that some vertices are floating in the viewport after loading the animation, it is because these vertices don't have any influence on any bone. You will need to give them weight value by painting to correct the problem.*

6 Paint the weights

You can now paint the weight values directly on the body at any point of the animation or you can switch to the **Figure Mode** to continue the painting while in T-stance.

- In the **Weight Properties** option box of the **Parameters** rollout, click on the **Paint Weights** button.
- Concentrate on refining the weights on one side of the body.
- Use the Mirror Parameters rollout to copy the weighting values from one side of the body to the other side.

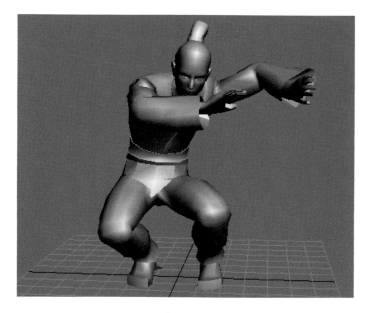

The final skinning

> **Tip:** *Sometimes it's easier to use the Weight tool, rather than painting the skinning weights. In the Parameters rollout, make sure you have Vertices turned on in the Select group; then choose the Weight Tool button in the Weight Properties section. It's the button with the icon of a wrench. The Weight tool dialog lets you select vertices, and see precisely which bones are weighted to those vertices, and the values for each. You can easily set the weights numerically here, which is more precise than using the painting technique.*

7 **Deleting the animation**

To delete the animation, do the following steps:

- **Select** all the biped parts.
- On the Animation menu, choose **Delete Selected Animation**.
- Go to the **Figure Mode** to restore the original pose.
- Exit the **Figure Mode**.

8 **Save your work**

The completed version of the skinned fighter can be found in the support files as *My09-skinning_04.max*.

Conclusion

You have now explored the various skinning techniques required to skin a character to its skeleton. You will put a lot of time into the skinning stage of character rigging, but that will allow you to create the best-looking animations and deformations possible.

In the next lesson, you will learn about the Morph modifier, which will be used for facial expressions.

Lesson 09: Skinning

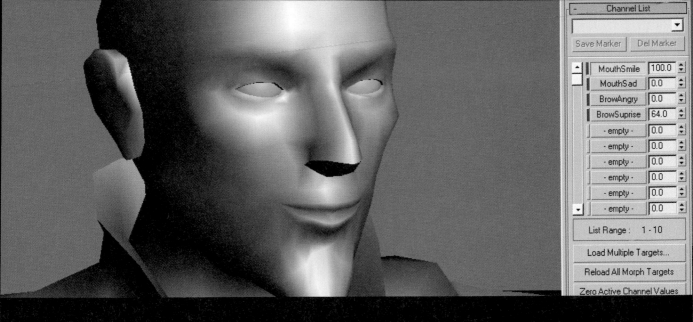

Lesson 10
Morph Targets

Sculpting a surface

The *Paint Deformation* tool lets you push, pull, or relax vertices by dragging the mouse cursor over the object surface. When you have an object selected, the Paint Deformation tool can paint and deform all vertices in the object. When you have vertices selected on an object, only those vertices can be deformed.

To try out the Paint Deformation tool and options, you will use the tool on a sphere to get a feel for it. Once you are familiar with the tool, you will paint directly on the fighter character geometry.

1 **Make a test sphere**

 • In a new scene, create a **GeoSphere** from the **Standard Primitive** submenu of the **Create** command panel.

 • Set the **Radius** value to **1m**.

 • Set the **Segments** value to **20**.

 • Use the **RMB** on the sphere to bring up the Quad-Menu.

 • Select **Convert To:** → **Convert to Editable Poly.**

2 **Use the Paint Deformation tool**

 • Expand the **Paint Deformation** rollout for the sphere.

 The Paint Deformation tool has three modes of operation: Push/Pull, Relax, and Revert. To paint on your object, first choose a mode, then change the settings as necessary, and then **press+drag** *the cursor over the object to paint the deformation.*

The Paint Deformation rollout

3 Painting on an object

- Click on the **Push/Pull** button to activate this painting mode.

- Move your cursor over the sphere geometry.

 The cursor icon changes to a vector line surrounded by a circular outline. The vector line indicates how much the surface will be pushed or pulled, while the outline indicates the brush radius. The brush icon is context-sensitive and will change depending on the different tool settings.

- **Press+drag** on the *sphere* to paint directly on the surface.

A simple pull stroke on the sphere

4 Paint another stroke

- **Paint** a second stroke over the first stroke to see how the deformations are added.

The second pull stroke

The sculpting modes

You will now explore the other painting modes to see how they work.

The **Push/Pull** mode moves the surface's vertices in the normal direction of each vertex. 3ds Max will use a vertex's original normal for the direction of deformation as long as you keep drawing a single stroke. You can also opt to use the altered normal direction for a more dynamic modeling process, or even deform along a specific world axis.

The **Relax** mode normalizes the distances between vertices by moving each vertex to a position calculated from the average of its neighbors.

The **Revert** mode lets you gradually reverse the effects of Push/Pull or Relax to the original vertex position.

1 **Push on the surface**

- Make sure you are in the **Push/Pull** mode.
- Change the **Push/Pull Value** to a negative value of **−0.1m**.
- **Paint** another stroke on the sphere.

Pushing the vertices of the sphere

2 **Smooth out the results**

- Switch to the **Relax** mode.

- Change the **Brush Size** to **0.5m**.

 This increases the size of your brush, and you can see that the outline has grown larger. This is the brush feedback icon.

- Click on the **Brush Option** button to bring the **Painter Option** setting window and keep it open.

Note: *This is the same settings window as the one used to paint the weight value on the skinning modifier in the previous lesson*

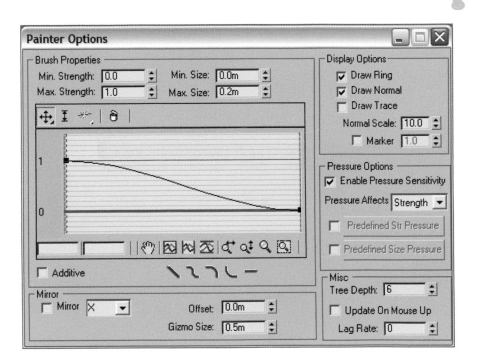

The Painter Options windows

Tip: *The Paint Deformation tool works more intuitively with a tablet and stylus, since the input device mimics the use of an actual paintbrush.The tool detects stylus pressure and uses it to control the strength or the size of the brush.*

Lesson 10: Morph Targets

- Activate the **Additive** checkbox in the **Brush Properties** option box.

 The Additive option makes a single stroke to deform the same area more than once, thus multiplying the effect of the brush.

- Change the **Brush Strength** to **0.5.**

- **Paint** over the sphere to smooth out the surface.

Smoothing a surface

3 **Erase the brush strokes**

- Switch to the **Revert** mode.

- Change the **Brush Size** to **0.7m.**

- Change the **Brush Strength** to **1.**

- **Paint** over the strokes to revert to the original sphere.

Revert half of the original sphere.

4 **Mirror tool**

- Use the **Revert** mode to bring back the original shape of the sphere.
- Switch to the **Push/Pull** mode.
- Change the **Push/Pull Value** to **0.1m** to pull the vertices.
- Change the **Brush Size** to **0.3m.**
- Activate the **Mirror** checkbox inside the **Painter Options** window.

> **Note:** *This check box has a drop-down list with all the different mirror axes you can choose from.*

- Move the mouse cursor over the sphere geometry.

 There are now two brush icons over the sphere, separated by the defined mirrored axis.

- **Paint** on the sphere to see the mirror effect in action.

Sculpting the fighter

You will now use the Paint Deformation tool to create facial expressions for the fighter. You will first duplicate the fighter's body in order to have multiple copies to use for the morpher modifier.

1 **Scene file**

- Continue with your own scene file from the previous lesson.

 OR

- Continue with *09-skinning_04.max.*

2 **Duplicate the fighter**

- **Hide** all the biped bones from the viewport.
- **Select** the fighter geometry object.
- Press **Ctrl+v** to **Clone** the fighter as a copy.
- **Rename** this new object *MouthSmile.*
- Delete the skin modifier from the modifier stack.
- **Move** the new object **1m** next to the fighter in the *front* viewport.
- Enter the **Polygon** sub-object selection level.
- **Select** the polygons that are part of the character's head.
- On the modify panel click the **Hide Unselected** button in the **Edit Geometry** rollout.

 This will hide all the polygons of the body, leaving only the head visible in the viewport.

- Exit the **Polygon** sub-object selection level.
- Create three new copies of the head as shown here:

The four new heads to be used for facial expressions

- **Rename** the other three heads as follows:

 MouthSad;
 BrowAngry;
 BrowSuprise.

Tip: *It is good to duplicate the other objects, such as the eyes, since you will be able to use them as a reference for when you model the morph targets. Never modify objects other than the one you're deforming.*

3 Sculpt the smile shape

Use the Paint Deformation tool to create a smile expression.

- Go to the Perspective viewport.
- Select the *MouthSmile* head object and go to its **Paint Deformation** rollout.
- Change the **Push/Pull Direction** to the **Z** option.

Note: *In the previous test sphere example, you were painting using the normals of the surface as the direction to be pushed and pulled. In this case, you will pull along the **Z axis**, which will move the vertices up.*

- Change the **Brush Size** to **0.01m**
- Change the **Brush Strength** to **0.01**
- Activate the **Additive** option from the **Brush Options** window.
- Make sure that the **Mirror** feature is activated and set to the **X** axis.

 This option allows you to create the complete shape by sculpting only one side of the geometry.
- **Paint** directly on the model to get a morph target similar to the following:

The MouthSmile shape

Tip: *You can also paint on other areas such as the cheek to make the cheek rise when smiling. Doing so will improve the visual quality of the expressions and mimic the behavior of facial muscles.*

4 **Sculpt the other shapes**

- **Repeat** the previous steps to sculpt the three other shapes and any other shape you want.

Tip: *Beside using the painting tools to transform the geometry, you can enter the vertex subobject mode and move the vertices one by one, or move them using the Soft Selection tool.*

The MouthSad shape *The BrowAngry shape* *The BrowSuprise shape*

Tip: *You can also create a blink facial shape, but make sure to cover the eyeballs properly.*

The Morpher modifier

In order to make character animation more realistic, you will need facial animation. This will be done using a deformer that will blend between the original geometry and the expression morph targets that you just created. That kind of deformer is called the *Morpher modifier*. Morpher deformers are very useful in 3D, especially to animate facial expressions on characters, but they can also be used for plenty of other things you may think of that require specific geometry shapes. The dripping of candle wax and the melting of a clock are both good examples of Morpher modification.

1 **Creating the deformer**

- **Select** the original *Body* object.
- From the **Modifier** drop-down list, select the modifier named **Morpher**.
- Expand the **Channel List** rollout.
- Click on the **Load Multiple Targets...** button.

 A browser will appear with a list of all morph targets available.

Note: *All morph targets must have the same number of vertices and vertex order. If you change the number of vertices on a target, this target will not be available from the list.*

- **Select** every available target from the list.
- Click **Load** to load the four morph targets.

You now have four different morph targets assigned to four different channels.

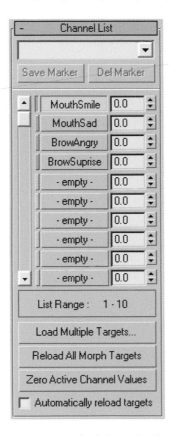

The four morph targets loaded into the Channel List

- You can hide the morph target object used to create the base topology.

Lesson 10: Morph Targets

2 **Testing the deformer**

- To see the morph target deforming the mesh topology, use the spinner button next to the morph target value field.

- Experiment on your own, blending more than one target at a time to see the effect.

A very mad fighter

3 **Adjusting the morph targets**

You can still change the morph target geometry as needed.

- Make modifications on any of the morph target geometry.

- Return to the original body object.

- In the **Channel List** rollout, click the **Reload All Morph Targets** button.

Tip: *You can use the Automatically reload targets option in the Channel List rollout to allow targets to be updated dynamically by the Morpher modifier. However, there is a performance penalty when using this option.*

4 **Delete targets**

When all your shapes are final and approved, you can delete the morph target objects from your scene as they are no longer needed.

- Select the duplicated head morph targets.
- Press the **Delete** hotkey to dispose of them.

Note: *When you delete morph targets, the modifier stores the blend values internally instead of using the geometry in the scene. If you want to adjust a target later on, you will need to recreate the morph targets and then recreate the morph modifier. To do so, activate an expression on the model; then copy it, collapse the modifier stack, change the new mesh, and replace the old object with the new one in the Morpher modifer.*

5 **Save your work**

- **Save** your scene as *My10-morpher_01.max*.

Conclusion

You are now more familiar with the very useful Morpher modifier, as well as the Paint Deformation tool. You now have the skills to create extremely powerful deforming animations, such as lip-synching, facial expressions, and reactive animations.

In the next project, you will complete the fighter model by applying textures to it. You will learn more about the materials and the mapping techniques available in 3ds Max.

Lesson 10: Morph Targets

IMAGE
GALLERY

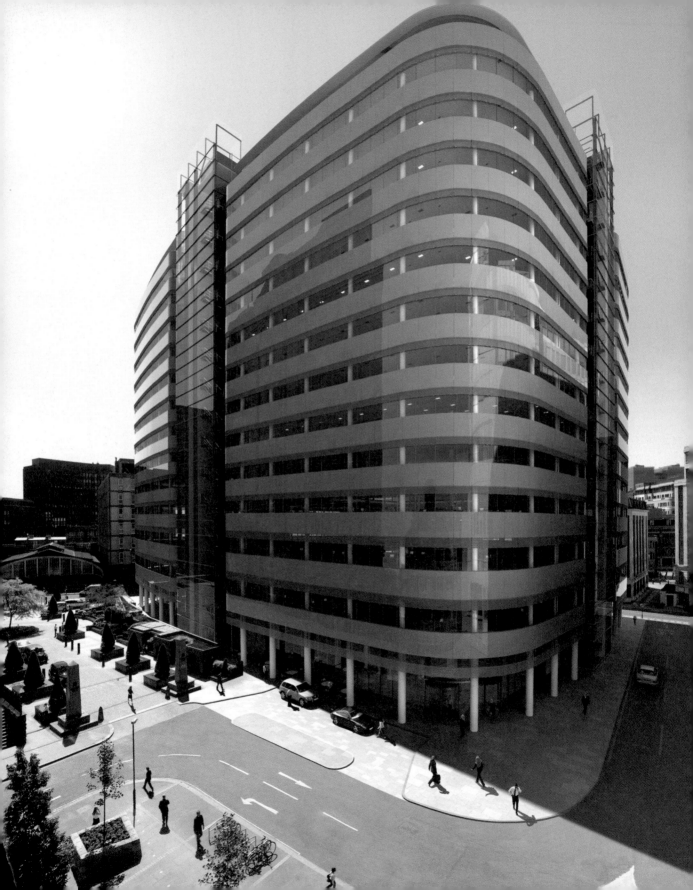

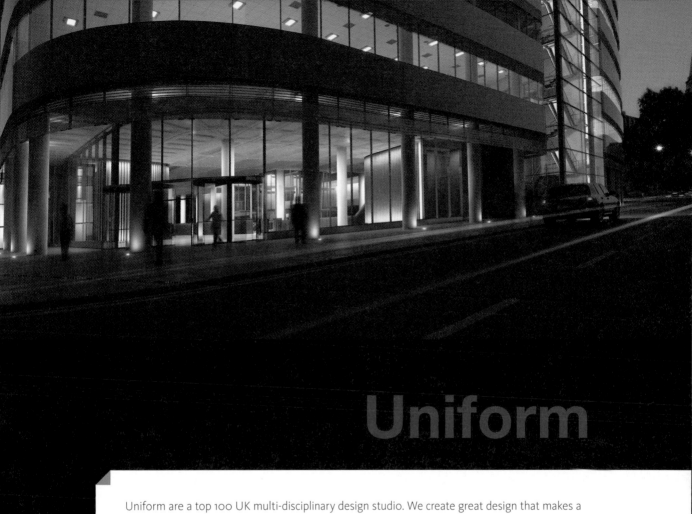

Uniform

Uniform are a top 100 UK multi-disciplinary design studio. We create great design that makes a difference. As well as making our clients more successful, it makes us happy too, we love what we do and we think it shows. Since the company was founded in 1998 by three friends who met at University in Liverpool, the company has grown to a team of 23. Uniform work on local, national and international projects varying in scale from bespoke print projects to national and international campaigns, films and brand development projects for clients in the fashion, architecture, creative, broadcast and leisure sectors. Everyone in our studio shares our passion to make a difference, creating original, intelligent, effective solutions to our clients design challenges. Whether it's branding strategy, brochures, ad campaigns, identities, short films, commercials or animations, our integrated approach is what makes us unique. We think this could be the start of something beautiful.

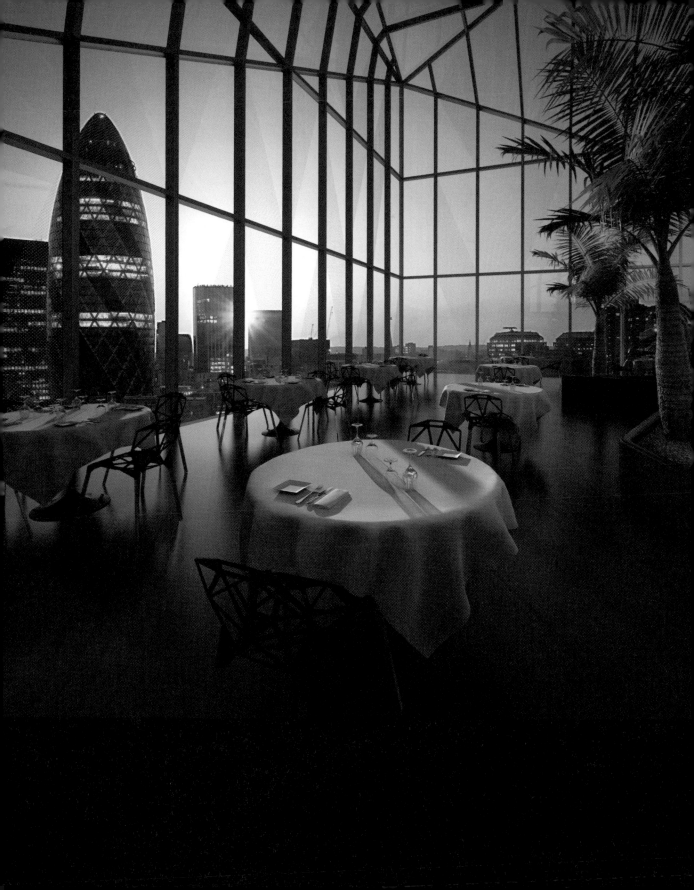

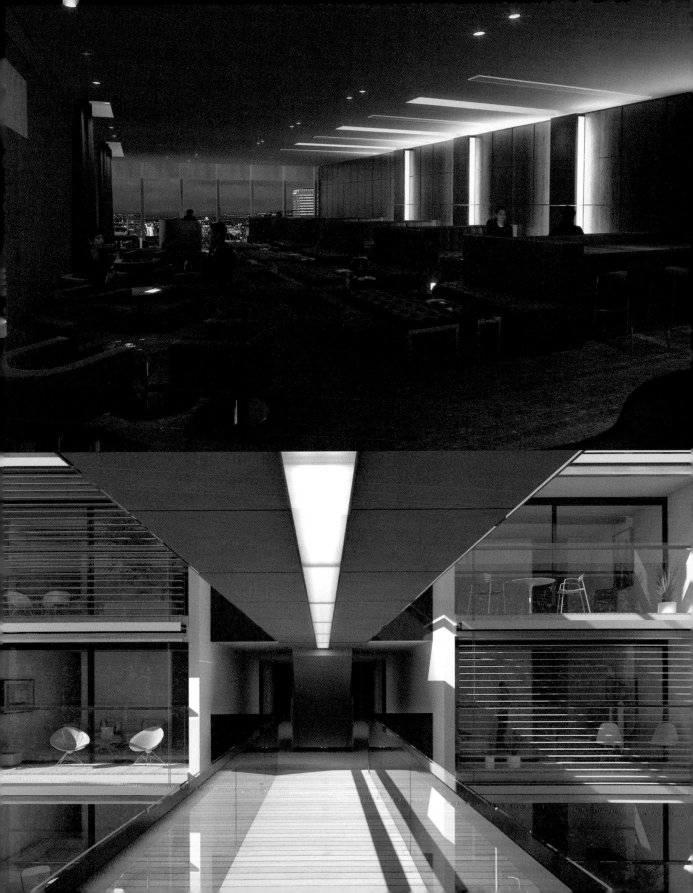

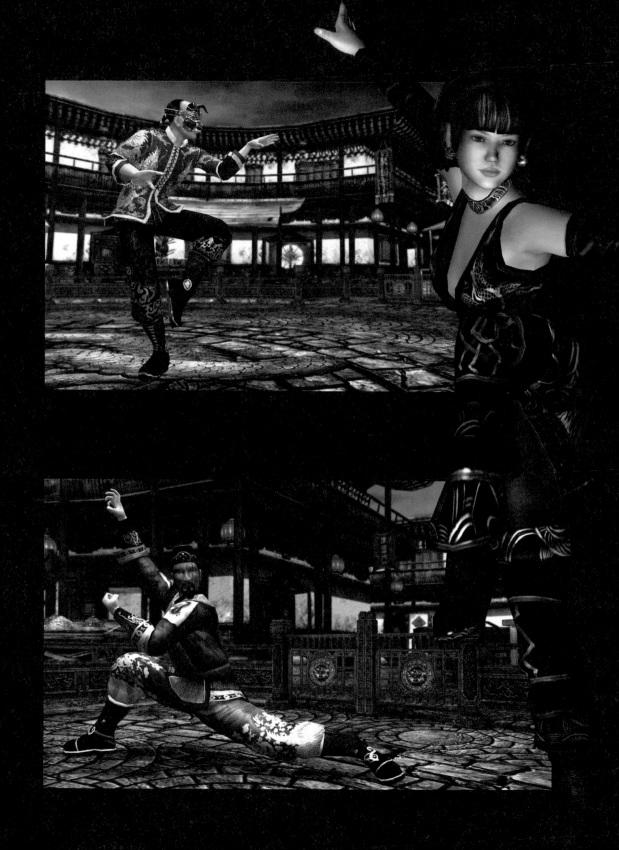

Bedlam is a fully-funded, publisher-owned flagship development studio devoted to the creation of AAA next generation games based on original intellectual properties.

The studio was formed in late 2005 by a seasoned group of industry professionals from top-tier companies such as Rockstar, Electronic Arts and Ubisoft who are united in their belief that games can be developed differently.

Bedlam is devoted to the proposition that (i) the most talented, passionate and focused team; (ii) empowered, respected and supported with the right tools; (iii) provided with an unparalleled work environment; and (iv) guided by intelligent design, careful planning and straightforward stakeholder relationships - will deliver the best possible game to consumers.

ASSASSIN'S CREED

UBISOFT™

Ubisoft is a leading producer, publisher and distributor of interactive entertainment products worldwide and has grown considerably through a strong and diversified lineup of products and partnerships. Ubisoft has offices in 23 countries and sales in more than 50 countries around the globe. It is committed to delivering high-quality, cutting-edge video game titles to consumers. Ubisoft generated sales of 680 million Euros for the 2006-07 fiscal year. To learn more, please visit www.ubisoftgroup.com

Ubisoft, which employs over 1,800 creators in its Montréal and Québec studios has developed and launched such successful series as *Prince of Persia*®, *Tom Clancy's*® *Rainbow Six*, *Tom Clancy's*® *Splinter Cell*, and *Far Cry*®. The Montréal studio – the most important creative force in the Ubisoft Group and the second largest in world – is currently working to produce such promising titles as *Assassin's Creed*™, *Tom Clancy's Splinter Cell*® *Conviction, and Far Cry*® *2*.

BioWare Corp. is an electronic entertainment company which develops computer, console, handheld and online video games focused on rich stories and memorable characters. Since 1995, BioWare has created some of the world's best-selling titles including the award-winning Baldur's Gate™ and Neverwinter Nights™ series, as well as the 2003 Game of the Year, Star Wars®: Knights of the Old Republic™. Original BioWare-created IPs include the 2005 RPG of the Year, Jade Empire™, with next-generation titles Mass Effect™ and Dragon Age™ currently in development. Mass Effect will ship to retailers throughout North America on November 20, 2007. The game has received more than 50 awards, including the 2007 Game Critics Awards for "Best Console Game" and "Best RPG" at the Electronic Entertainment Expo. With studios in Edmonton, Canada, and Austin, Texas, BioWare is also hard at work on a new title for the Nintendo DS™ based on Sonic the Hedgehog, as well as several unannounced projects including a massively multiplayer online game. For more information on BioWare, visit www.bioware.com

Image courtesy of Bedlam Games

Project 03

In this project, you will learn more advanced techniques for using the Material Editor to create complex materials and to apply them to 3d objects. Your will then see the different types of materials and learn when you should use them. Finally, you will learn about the different types of maps available, unwrap mapping coordinates, and ultimately texture your character.

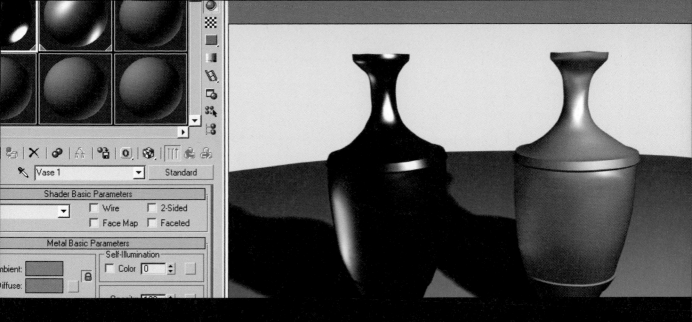

Lesson 11
Materials

Introduction to materials

When you look around, materials are everywhere, from the floor to the sky and everything in between. A material in 3D graphics is the combination of all the elements that make up the look and feel of a surface. Some materials can be simple, like a colored plastic ball, or more complex like an old wooden chest. Some materials are not even photorealistic. For example, a cartoon cell is made up of solid colors and lines, and a photocopy is a simple monochrome image. Whatever your need, you can find a material to fill it. Real or imaginary, materials make up the visible world you live in.

The purpose of materials

In 3ds Max software, materials serve many purposes and can be used to portray different types of surfaces. For example, a steel urn has a very different look than the same shape made of clay. Materials also help impart an object's age, such as the difference between freshly cut, polished wood and a board that has been sitting on the beach for years. Even though the two objects are made of wood, there are visible differences that provide hints as to the age of the item. Generally materials help create the illusion that the sculpted mesh geometry isn't simply a certain color, but rather that it is made of something with which you are familiar, like glass, metal, wood, fabric, etc. Materials also can provide the detail that would be too costly to create as geometry.

The importance of materials

A well-made material can make a difference in telling the story of an object or scene element. A scratch on the surface of a desk can tell a tale of what happened to the desk, who owns it, and what it's used for. While a simple scratch can tell a tale, the importance of a well-made material is visible to all who see the final image. Whether you are creating a photorealistic environment or taking a flight through a world of fantasy, the materials you use will make the difference between a "pretty good" image and one that really sells your idea.

Materials and lighting

Materials in 3ds Max software and in the real world have one thing in common: without light, they do not exist. When creating a material, you must think about how it will look under various lighting conditions, as well as how the light will interact with the material. Is the material shiny or dull? Is it reflective or transparent? The answers to these questions all depend on lighting and the material definitions; these two systems work hand in hand to create the final effect.

Set up your project

Since this is a new project, you must set a new directory as your current project directory.

1 **Set the project**
 • Go to the **File** menu and select **Set Project Folder...**

A window opens, pointing you to the Max projects directory.

- Click on the folder named *project3* to select it.

- Click on the **OK** button.

This sets the project3 directory as your current project.

OR

- If you did not copy the support files to your drive, create a new project called *project3* and then copy the support files into the default directories.

2 **Make a new scene**

You will now load the startup scene *11-Materials_01.Max* from the *support_files*.

- Select **File → Open...** .

- **Load** the file *11-Materials_01.Max* in the *project3/scenes* folder.

This scene includes two simple vase objects on a plane with basic lighting and a camera.

3 **Open the Material Editor**

- Press **m** on the keyboard to open the Material Editor. You can also launch the Material Editor by clicking the Material Editor icon on the main toolbar, or on the menu bar choosing **Rendering → Material Editor**.

Material samples

The Material Editor displays a collection of material samples. Depending on your present configuration you will see 6, 15, or 24 material sample slots. These slots are temporary editing places for you to design materials. Materials can be stored in a library, or on objects in the scene; you aren't limited in the number of materials by the number of sample slots.

There is one fundamental thing to understand about materials in 3ds Max. The materials can exist in multiple places with multiple names, independently of each other. You can have several materials with the same name in the Material Editor, with completely different characteristics. You can have a material in the scene, in the Material Editor, and in a material library—all with completely different characteristics.

The material sample window provides more than just a method of visualizing the current material; it also provides the status of each material in the editor. As your scenes grow, these indicators become more and more important, telling you the status of your material in relationship to the scene. When you assign a material to an object in a scene, the material sample slot displays small triangles in each corner. These triangles indicate whether a material is assigned to an object in the scene and if it's assigned to the currently selected object. Gray triangles indicate the material has been assigned to objects in the scene, and white triangles indicate the material has been assigned to an object currently selected in the viewport.

Project 03

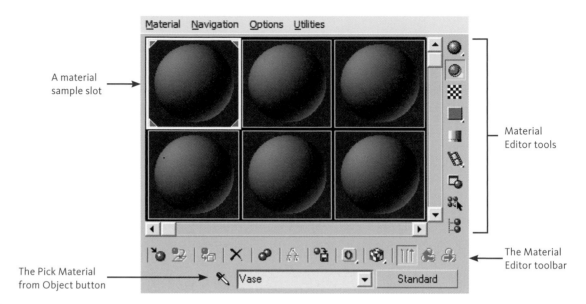

A material
sample slot

Material
Editor tools

The Pick Material
from Object button

The Material
Editor toolbar

The main Material Editor menu

1 **Changing the material sample object**

The default object in the sample slots is a sphere, but not every object you will be working
with is spherical. In many cases, the sphere works well. However, you might want to use a
different shape, such as when you are working on a coffee mug or a floor.

- **Click+hold** on the **sample type** button located on top of the vertical Material Editor
 toolbar to see the available sample type.

 You can choose from three standard types of shapes.

- Click on the **Cylinder Object** button to change the sample into a cylinder.

- **Repeat** to try the cube sample shape.

2 **Create your own sample object**

You can also create your own custom sample object that can be seen into the sample window
indicator.

- The scene you create should contain a single object that fits into an imaginary cube that is
 100 units on each side or 1 meter on each side if you are using the metric unit system.

- If the object is of a type that doesn't have a **Generate Mapping Coords** check box, apply
 a **UVW Map** modifier to it.

- **Save** the scene in a MAX file.

Note: *A scene with a vase object has already been created and saved in a MAX file called vase.Max in the support files. You can use this file for this lesson.*

- On the Material Editor menu bar choose **Options** → **Options** to open the Material Editor options dialog.

- Click the **File Name** button in the **Custom Sample Object** group box, and choose the *vase.Max* file.

When you specify the file, a new button is displayed at the right of the Sample Type flyout. This button, which shows an object with a question mark, displays the sample object file.

- **Activate** the sample slot in which you want to see the custom object, and then choose the button at the far right of the Sample Type flyout.

The Sample Type flyout

Tip: RMB *on the sample window indicator and select the Drag/Rotate option to be able to rotate around the vase. After you rotate it, RMB again and change back to Drag/Copy*

3 Changing the sample setting

Other settings are available in the sample window indicator. Buttons for all of these settings are located in the vertical toolbar on the right side of the Material Editor. The two most important settings are the Backlight and the Background. Test these settings on different types of samples.

- Turning on **Backlight** adds a backlight to the active sample slot.

Backlight is especially useful whenever you are creating metal and Strauss materials. It lets you see and adjust the specular highlight created by glancing light, which is much brighter on metals.

- Turning on **Background** adds a multicolored checkered background to the active sample slot.

The pattern background is helpful when you want to see effects of opacity and transparency.

> **Tip:** *Double-click on the sample window indicator to create a floating window that can be resized to any scale.*

ActiveShade

ActiveShade gives you a preview rendering that can help you see the effects of changing lighting or materials in your scene. When you adjust lights or materials, the ActiveShade window interactively updates the rendering. There are two ways to display the ActiveShade window, but only one such window can be active at a time. If you choose an ActiveShade command while an ActiveShade window is already active, a prompt will ask whether you want to close the previous one.

1 **ActiveShade Viewport**

The ActiveShade rendering appears in the active viewport.

• **RMB** the viewport label, and choose **Views**, and then **ActiveShade**.

The ActiveShade rendering in the viewport

> **Note:** *You cannot make a Maximized viewport an ActiveShade window, or Maximize an ActiveShade window.*

2 ActiveShade floater

The ActiveShade rendering appears in its own window.

- Choose **Quick Render (ActiveShade)** from the **Quick Render** flyout.

The Quick Render (ActiveShade) button

The Quick Render (ActiveShade) button

> **Tip:** *You can drag and drop materials from the Material Editor to ActiveShade windows and viewports, as you can with other viewports.*

Viewport lighting and shadows

The same type of functionality you just saw in Active Shade is also available in the standard 3ds Max viewport when Smooth and Highlight mode is active. The Perspective viewport can now display real-time display of shadows, unavailable in previous versions. To try it out do the following:

- In the **Front Viewport** select the *Direct Light 01* object.
- RMB on the object and choose **Viewport Lighting** and **Shadows** on the display quad. On the secondary menu that appears, choose Viewport **Shading** → **Best**.
- Then choose **Enable Viewport Shadows Selected**.
- Make sure that **Cast Shadows** is turned on for the light; this option is also found on the Tools 1 quadrant.
- Move the *Direct1* light and watch the viewport shadows update interactively.

Material types

Materials are all around you. Some are simple materials like a red plastic ball, while others are much more complex, like the water on ocean waves. Autodesk 3ds Max software offers different types of materials that can be used for multiple purposes. The materials fall into two major categories: single materials and multiple materials. A single material is a material that works on its own, such as the Standard material. Multiple materials use several different materials together. Multiple materials can blend or mix these materials together on a surface, or can be used to place different materials on different faces on the same object. They can be used to put one material on the top of the object and a different material on the bottom, or on the front and back of a single polygon.

In 3ds Max, there are two ways to choose a material type: you can click the **Get Material** button in the lower toolbar of the Material Editor or click the **Material Type** button to the right of the material name. Either option brings up the Material/Map Browser; however, they retrieve a material in different ways: The Get Material button replaces the material currently in the active slot with the new material. If the replaced material is assigned to an object in the scene, it's not affected. Only the material definition in the editor is replaced, so you can create a new material for another object. By contrast, if you have a material assigned to an object in your scene and you click the Material Type button, you replace the old material with the new one on all scene objects

Get Material ⟶ ⟵ Material type

The two buttons to create a new material

Standard material

While each material in 3ds Max serves a different purpose, they share many of the same parameters. Learning the default standard material will help you understand other material types in 3ds Max. The Standard material type is extremely flexible; you can use it to create an unlimited variety of materials.

The Standard material uses the Shader Basic Parameters and Blinn Basic Parameters rollouts. The Standard material provides an assortment of shaders for controlling how the surface looks. A shader is a mathematical formula that defines how a surface is affected by light. You can choose from eight shaders available in the Shader Basic Parameters rollout. Although the Standard material has several common parameters, each shader has its own specific parameters. When you choose a shader, the Basic Parameters rollout controls change accordingly.

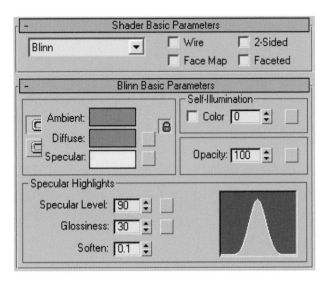

The basic rollouts of the Standard material

Shader types

The list of shaders presents you with eight different choices. The Blinn shader is the default.

The eight different shaders for the standard material

- Change the shader type from Anisotropic to Metal and see the difference on the vase in the ActiveShade viewport.

Anisotropic

The *Anisotropic* shader creates surfaces with elliptical highlights. These highlights are good for modeling hair, glass, or brushed metal. Anisotropy measures the difference between sizes of the highlight as seen from two perpendicular directions. When anisotropy is 0, the highlight is circular. When anisotropy is 100, in one direction the highlight is very sharp; in the other direction it is controlled solely by Glossiness.

The Anisotropic shader

Blinn

Serving as a basic all-purpose shader with a round highlight, *Blinn* can be used for a wide range of materials, from rubber to stone to highly polished surfaces. With Blinn shading, you can obtain highlights produced by light glancing off the surface at low angles.

The Blinn shader

Metal

Metal shading provides realistic-looking metallic surfaces and a variety of organic-looking materials. Metal shading has a distinct curve for specular highlights. Metal surfaces also have glancing highlights. Metal materials calculate their own specular color, which can vary between the material's diffuse color and the color of the light. You can't set the specular color of a metal material.

The Metal shader

Multi-Layer

The *Multi-Layer* shader is similar to the Anisotropic shader, but it has a set of two specular highlight controls. The highlights are layered, letting you create complex highlights that are good for highly polished surfaces, special effects, and so on.

The Multi-Layer shader

Oren-Nayar-Blinn

The *Oren-Nayar-Blinn* shader is a variant of the Blinn shader. It contains additional "advanced diffuse" controls, Diffuse Level and Roughness, that you can use to give the material a matte effect. This shader is good for matte surfaces such as fabric, terra-cotta, and so on.

The Oren-Nayar-Blinn shader

Phong

Phong shading smoothes the edges between faces and renders highlights realistically for shiny, regular surfaces. This shader interpolates intensities across a face based on the averaged face normals of adjacent faces. It calculates the normal for every pixel of the face.

The Phong shader

Strauss

The *Strauss* shader is for modeling metallic surfaces. It uses a simpler model and has a simpler interface than the Metal shader.

TheStrauss shader

Translucent

Translucent shading is similar to Blinn shading, but it also lets you specify translucency. A translucent object allows light to pass through, and also scatters light within the object. You can use translucency to simulate frosted and etched glass.

Translucency is inherently a two-sided effect: with the translucent shader, backface illumination appears on front faces. To generate translucency, both sides of the material receive diffuse light, though only one side is visible in renderings and shaded viewports unless you turn on 2-Sided (in the Shader Basic Parameters rollout).

For specular highlights, you have a choice: to model materials like translucent plastic, you can choose to have highlights on both sides; to model materials like frosted glass, which is reflective on one side only, you can choose to have highlights on only one side. This is controlled by the Backside Specular toggle in the translucent highlight controls.

The Translucent shader

Lesson 11: Materials

Note: *Do not use shadows with the Translucent shader. Shadows can produce artifacts at the edges of translucent objects.*

Raytrace material

Like the Standard material, the *Raytrace* material lets you use Phong, Blinn, Metal, Anisotropic, and Oren-Nayar Blinn shaders, but it also generates physically accurate reflections and refractions. Because of this, raytraced materials take longer to compute. Ray tracing is a form of rendering that calculates rays of light from the screen to the lights in a scene. The Raytrace material type uses this capability for additional features, such as luminosity, extra lighting, translucency, and fluorescence. It also supports advanced transparency parameters such as fog and color density.

The Raytrace material

Architectural material

The *Architectural* material provides the greatest realism when rendering with photometric lights and radiosity, enabling you to create lighting studies with a high degree of accuracy. The settings for this material are physical properties. The templates rollout includes a drop-down list of preset materials. The templates give you a set of material values to get your material started, which you can then adjust to improve the material's appearance.

The Architectural material with (left) the water and (right) the metal presets

Ink'n Paint material

The *Ink'n Paint* material type differs from the other materials in that it's designed to render nonphotorealistic, cartoon-shaded images. It provides you with a great amount of flexibility for creating a unique style for your images and animations, creating anything from a simple hidden-line rendering to a complex, multicolored, cartoon-shaded image.

The Ink'n Paint material

mental ray Arch & Design material

In the first lesson you used an Arch & Design material with the mental ray renderer. The Arch & Design material type provides powerful templates that let you create materials for use with the physically based system that mental ray 3.6 uses for photorealistic rendering. Here is an example with a physically based glass, chrome and ceramic tile materials applied to the vase objects.

The Arch & Design material

New to 3ds Max software is the ability to see the Arch & Design material maps in the viewport. If you have the mental ray renderer selected, you can see and choose these materials in the Material Editor and apply them to the objects in the viewport. The Show Map In Viewport icon on the Material Editor lower toolbar now has a flyout that lets you choose Show Hardware Map in Viewport.

Conclusion

In this lesson, you learned about materials and their purpose, why they are so important, and how they can be used. You have also learned how to use the Material Editor to build simple materials and use the various tools available to you. After experiencing the different types of material and shader types, you should now be comfortable creating materials from scratch using the Material Editor.

In the next lesson, you will learn more about the different types of maps that you can add to create more complex materials.

Lesson 12
Maps

In this lesson, you will learn about creating and using the different types of maps available in Autodesk® 3ds Max® software. You will also learn about what maps are used for and how to apply them to objects.

In this lesson you will learn the following:

- What maps are and their purposes ;
- The difference between textures and maps ;
- About procedural maps ;
- The most common map channels;
- How to display and mix maps.

Maps defined

When you look at an old wooden desk or a newly polished wooden floor, you are looking at the texture of the surface. For example, the difference between burl oak and knotty pine is the texture of the wood itself. In 3ds Max, you can use image maps and procedural maps in a material to create textures for an object. These can create an infinite variety of textures and looks for the rendered object. The images you assign to materials are called maps. These maps can be 2D or 3D, they can be digital images (standard bitmaps) or synthetic (procedural maps), or they can be compositing or masking systems. Maps increase the realism in a material.

A texture, however, is not just a map; textures can be simple, like the glass used in a bottle, or they can be very complex, like an old weathered pine fence. Whether you need to create high-tech, sci-fi scenes or photorealistic real-world scenes, the texture of every surface can make or break the illusion.

Textures defined

By definition, a texture is the distinctive physical composition of an element with respect to the appearance and feel of its surface. Essentially, it's what you see when you are looking at something.

A real-world example of cracked, dried mud

In 3ds Max, the texture is the end result of a material; whether the material uses maps or not does not matter. 3ds Max provides you a variety of maps that let you create textures that can be applied to objects for any purpose. Materials can define categories of textures. For example, you can create a wood material with properties that are common to various types of wood; however, wood is not a texture. If you were to ask someone to create *wood*, they might not know what type of wood to create. That's where the texture of a surface comes in. If you tell someone to create highly polished burl oak, they will be able to deliver what you want.

Note: *You can load the scene named 12-maps_01.max from the support files to experiment with the various topics explored in this lesson.*

Bitmaps vs procedural

Textures in 3ds Max can be simulated without maps; however if you want to add any detail or other texture definition to the surface, a map is the way to do it. 3ds Max provides two types of maps that can be used in a material definition: a bitmap and a procedural map. Although the results can be similar, they function very differently.

Bitmaps

A bitmap is a two-dimensional image made up of individual picture elements (pixels) in a rectangular grid. The more pixels in an image, the higher its resolution (size) and the closer you can look at it without noticing the pixels. The size of the bitmap becomes important as you create animation where the camera moves close to a material containing a bitmap. A small- or medium-size bitmap works for objects that are not too close to the camera. A larger bitmap might be needed if the camera zooms in on part of an object. The following example shows what happens when the camera zooms in on an object with a too-small bitmap compared to a larger one.

A large bitmap file on the left compared to a small bitmap file on the right

Note: *Using a higher-resolution bitmap would reduce the amount of pixelation. Be careful, because higher-resolution bitmaps require more memory and take longer to render.*

Procedural maps

Unlike bitmaps, which are digital images usually created by camera, scanner or paint programs, procedural maps are derived from simple or complex mathematical equations. One advantage to using procedural maps is that they do not degrade when you zoom in on them. You can set up procedural maps so that when you zoom in, more detail is apparent.

An overview of the block

This example was created using a procedural Cellular map. A closer look reveals more details on the block granite texture.

A closer look at the block

The flexibility of procedural maps provides a variety of looks. 3ds Max includes different procedural maps, such as *Noise*, *Tiles*, *Checker*, *Marble*, and *Gradient*. The advantage to procedural maps is they can be 3D. That means they fill 3D space as if it were solid. While bitmap maps require specific mapping coordinates in order to be rendered correctly, 3D procedural maps do not need them because they occupy the whole 3D scene. The only control you have is the angle of the whole map, which you can change in its coordinates rollout.

Map types

When creating simple or complex mapped materials, you use one or more of the map types available in the Material Editor. You can use a bitmap or procedural map as the diffuse color, bump, specular, or any other available component of a material. You can use maps individually or in combination to get the look you want. Available map types vary among different shaders and materials, but several map types are relatively common. You can typically access a map type in any of several ways.

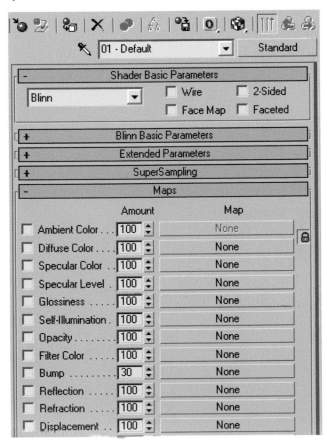

The different map channels of the Blinn shader

Accessing map types

To choose a map, click one of the small square buttons on the Basic Parameters rollout for the shader or material. These map boxes appear next to the color swatches and numeric fields. However, not all map buttons are available in the Basic Parameters rollout. To access all map buttons, use the **Maps** rollout.

Map channels

While many map channels are available for use, you will focus here only on the commonly used types.

Diffuse Color

One of the most frequently used map types; it determines the visible surface color of an object.

Specular Color

Determines the color of the specular highlight on a material. Using a map or changing the specular color provides a variety of special surface effects.

Specular Level

Using a map in this channel varies the specular level based on the grayscale value of the map. With this feature, you can add surface dirt, smudges, or scuff marks to a material.

Glossiness

Affects the size of the specular highlight; lower values spread it out while larger values sharpen it and make the highlight smaller. You can create a variety of surface types, from flat to shiny, in the same material.

Opacity

Determines the opacity or transparency of a material based on the grayscale values of the map. White is opaque and black is transparent. Opacity also presents several other options; it can be rendered with a filter color, as additive or subtractive.

Bump

The effect of bump-mapping on an object can be dramatic. Bump maps create the illusion of sunken and raised portions of a surface by setting a positive or negative value in the amount area. This effect allows you to fake geometry such as a rocky surface or dents.

Reflection

Use this parameter to create reflective materials, such as mirrors, chrome, shiny plastic, etc. Often you will use a Raytrace reflection map in this channel.

Creating maps

When you click on an empty map channel, the Material/Map Browser offers you different map types to choose from. By default, it shows all the available maps but you can view them by category using the category selector in the lower-left corner of the browser.

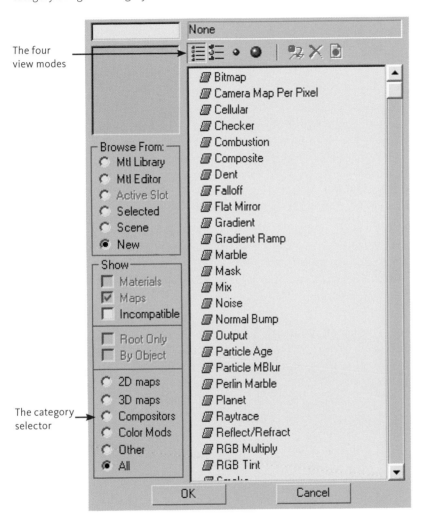

The Map Browser

Displaying maps

Show end result

The *Show End Result* button, located in the toolbar of the Material Editor, lets you look at the material at the current level instead of seeing the end result of all the other maps and settings. When you click this button to turn the end result off, the sample slot shows only the current level of the material. This tool is useful when you are working with compound materials. It would be difficult to see exactly what effect you are creating on a particular level if you didn't have the ability to turn off the end result display of the other levels.

Display all maps in viewport

In the previous exercise, you learned how to display maps in viewports by turning on the Show Map in Viewport button. This tool helps you get a better idea of what your scene looks like before you commit to a render. It also helps you adjust the bitmap, fitting it to the object you're applying it to. You typically turn this option on or off one map at a time. However, you may elect to use this tool globally, affecting all maps in the scene simultaneously. You can find such options in the **Global Maps** In **Viewport** setting, located in the main Views menu.

Sometimes the viewport display of a bitmap will appear at a lower resolution then it should be. In the first lesson you changed this by going to the menu bar and choosing **Customize → Preferences** and then, in the **Viewports** tab, choosing **Configure Driver**. In the Configure Direct3D dialog, the Match Bitmap Size as Closely as Possible checkbox in the Appearance Preferences group can be turned on for the Texture Size setting.

Note: *Keep in mind that enabling all maps simultaneously may affect the performance of your system.*

Mixing maps

While simple materials sometimes suffice, most materials in the real world are fairly complex. Look around you; examine the texture of objects and surfaces in the real world. As you can see, virtually no surface has a simple texture. Some surfaces contain multiple layers and others are intricately designed. These aspects of material creation are important to keep in mind while working in the Material Editor.

Several available map types allow you to use several maps together. With the Mix and Composite maps you can combine multiple maps to generate a new map image. In addition, procedural 2D and 3D maps can use multiple maps in order to create textures that mimic real-world textures.

Note: *Explore the materials of the scene to see some examples of map combinations and how maps can be mixed together.*

Conclusion

In this lesson, you learned about different map channels and their purpose for creating complex materials. You have learned the difference between a bitmap and a procedural map and what the advantages of each one are. Now that you have some experience with the different types of maps and how to mix them, you should be comfortable creating materials from scratch using different map channels.

In the next lesson, you will learn about the mapping coordinates of complex geometrical objects and how to unwrap UVs to prepare the surface to receive a 2D bitmap.

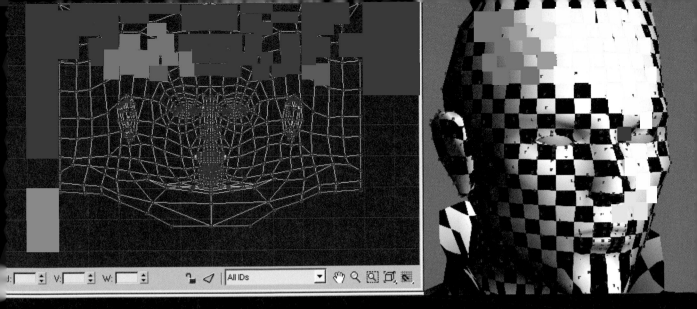

Lesson 13
Unwrapping UVs

UVs determine how textures appear on the surface. Mesh object surfaces, because of the arbitrary nature of their topology, do not have predictable UVs. Before you can texture a mesh object surface, its UVs must be properly set up. In this lesson, you will unwrap LiuJing's geometry.

In this lesson you will learn the following:

- Basic workflow for texturing mesh object surfaces;
- How to project UVs;
- How to relax and unfold UVs;
- How to cut and sew UVs.

Texturing mesh object surfaces

In this exercise, you will unwrap the UVs of LiuJing, the character from the previous project.

> **Note:** *Your results throughout this lesson may vary depending on your model.*

1 **Open scene file**

 - Navigate back to the *Project 2* folder, then to the *scenes* directory**.**

 - **Open** the scene from the previous project, called *10-morpher_01.max*.

 - **Save** the scene as *My13-unwrap_01.max*. Save this in the *Project 3/scenes* folder.

2 **Add the Unwrap modifier**

 - Select the *Body* object.

 - Move the Morpher modifier in the stack so it is under the Skin modifier in the stack. To do so, just drag and drop the Morpher to its new position.

 - Select the Skin modifier at the top of the stack, and add the modifier called **Unwrap UVW**. This modifier should sit above the Skin and below the Morpher in the stack.

3 **View the UVs**

 - In the **Parameters** rollout of the **Unwrap UVW** modifier, click the **Edit** button to check the layout of its UVs in the Edit UVWs window.

 At this time, the UVs do not provide good coordinates for applying a texture.

The default UVs of LiuJing displayed in the Edit UVWs editor

4 **Assign a new material to LiuJing**

- Open the Material Editor and assign a new default material to the *Body* surface.

- **Rename** that material to *LiuJing Body*.

- Click on the **Map** button for the diffuse channel.

- Click on the **Checker** map from the Material/Map browser and click **OK** to create the map.

- Click on the **Show Map in Viewport** button to view the Checker map in the viewport.

The checker texture should now appear on LiuJing, but because of the poor UV layout, the checker looks irregular.

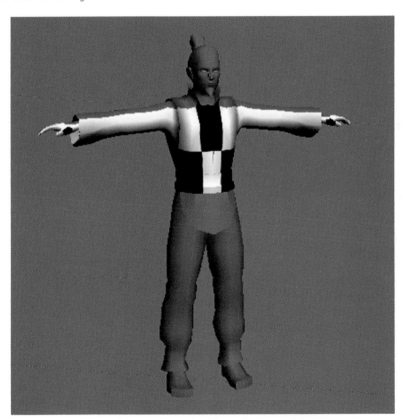

Irregular texture placement due to poor UVs

5 **Change the checker's Repeat values**

- Expand the **Coordinates** rollout of the checker map.

- Change both **Tiling U** and **V** values to **20**.

You should now see a smaller checker pattern on your character.

6 **Apply a planar projection to the body**

- Expand the Unwrap modifier and go to the **Face** sub-object.
- Select all the faces of the *Body* using the **Ctrl+a** hotkey.
- In the **Map Parameters** rollout of the **Unwrap UVW** modifier, click on the **Planar** button to activate the planar projection mode.
- In the same rollout, click on the **Align Y** button.

 Doing so will rearrange the surface's UVs by projecting new UV coordinates in the Y direction.

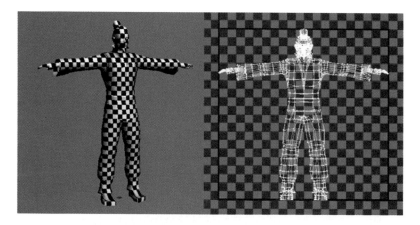

LiuJing's UVs using planar mapping

- Click again on the **Planar** button to exit that mode.

Unwrap the UVs

In order for the UVs to be properly unwrapped, you must first cut the UVs into UV elements, which will define the different parts of the body, such as the head, arms and legs. The elements should be able to lie relatively flat when unfolded, without overlapping, much as a cloth pattern is laid flat for a piece of clothing prior to sewing.

The location of the UV cuts requires some planning to obtain the best unwrapping results. The better the UV cuts, the better the correlation between the original polygons and their corresponding UV mesh. In addition, you should anticipate that the polygon edge cuts will result in texture mismatches along those edges and plan their locations on the model accordingly so they are less visible. For example, you can make edge cuts under the arms or on the back of the legs of a character.

1 **Unwrap the head**

- Select all the faces that make up LiuJing's head and neck, but without the hair faces.

- On the **Map Parameters** rollout, click the **Cylindrical** button.

 A cylindrical mapping gizmo appears, but its size and orientation are incorrect.

- Click on **Align Z** to adjust the gizmo over the head.

 Take a look at the vertical green edge on the side of the head. This edge is called the map seam and represents the edge that will be used to unwrap the map. The gizmo also has a green edge to represent where it will cut the edges.

- In the Edit UVWs Editor, click on the **Filter Selected Faces** button located in the middle of the lower tool bar to get rid of the other element UVs in the editor.

The face UVs after using the cylindrical unwrap method

- In the Perspective viewport, rotate the gizmo on the **Z** axis until the map seam is at the back of the head to form a perfectly symmetrical layout in the Edit UVWs editor.

- In the **Map Parameters** rollout, click the **Fit** button to give the cylinder gizmo the right proportions to fit all around the head.

The face UVs after the map seam is placed at the back of the head

- Click the **Cylindrical** button to exit that mode.

2 Get better results

As you can see, unwrapping a UV element is quite simple, but when you look at the previous image, you can see that the chin area overlaps the neck area. The same thing happens in the ears and nose area. This is not recommended, since the texture will show up on two parts of the face at a same time. For instance, the chin texture will also appear on the neck.

You will now have to move the UVs of the goatee into a new position.

- Change to the **Vertex** sub-object level mode.

Tip: *You can use the buttons located in the Selection Modes section of the editor's lower option menu to change between the vertex, edge, and face modes.*

- Select the vertex at the end of the goatee.

Note: *You can select objects in both perspective view and the Edit UVWs editor.*

- Activate the **Soft Selection** mode and change its falloff value to **5.5**.

 The Soft Selection tool works in the same way with UV's as it does with editable mesh vertices.

- **Move** the goatee vertices until no vertices or edges overlap.

Note: *You can move the vertices one by one, without using Soft Selection mode, to get more control.*

3 Check overlap faces

To make sure there are no overlapping faces in the UV layout, you can render the UVs to see exactly where the overlapping faces are.

- Change to the **Face** subobject level mode.
- Activate the **Select Element** option below the three sub-object selection mode buttons.
- In the Edit UVW's window, select any faces on the head to select the whole UV element.
- Click on the **Filter Selected Faces** button to isolate the head element.
- Make sure that the head element is located inside the *0–1 UV space,* represented by a dark blue square border in the **Edit UVWs** editor.
- If your element is bigger than the 0–1 UV space, just **scale** it down and **move** it inside the *0–1 UV space*. You can use the **Freeform Mode** tool on the upper **Edit UVWs** toolbar to scale and move in one operation

Note: *The 0-1 UV space will be covered in more detail in the next lesson as we texture the model.*

- In the main menu of the **Edit UVWs** editor, select **Tools** → **Render UVW Template...**

The render UVs dialog

- In the Render UVs dialog, change the **Fill Mode** to **Solid** and make sure that the **Show Overlap** option is activated.

- Click on the **Render UV Template** button to see the overlapping faces in your element.

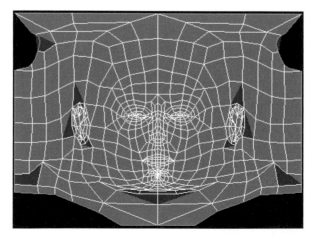

The UV template shows the overlapping edges in red

- **Move** the vertices of the overlapping faces to fix the problem.

Tip: *Don't worry if you get overlapping faces around the ears. The area behind the ears will be mostly hidden at all times.*

Now that the head UVs have been properly unwrapped, they are in much better shape for supporting textures.

The final head UVs with the checker texture on it

4 **Save your work**

- **Save** your scene as My13-unwrap_01.max.

Cut and unwrap the rest of the body

Now that you have more experience unwrapping mesh geometry, you can unwrap the rest of the body. The following steps are similar to what you have done on the head, but there are areas where the unwrapping will be more complex, such as the fingers and toes.

1 **Unwrap the arms**

The arm UVs should be cut on the inside of the shirt and at the wrist using the cylindrical method. The cut along the arm should be located underneath the arm so that the seam is less visible. The hands will be in separate UV elements.

The arm map seam

The arm UV element

Note: *When unfolding the two arms, you may get different resulting UV layouts. This is normal, but you should try to edit the resulting UVs in order to keep the symmetrical parts of the body in a symmetrical UV layout. Doing so will help when you texture the geometry, since both arms will be similar.*

2 Weld vertices

The green lines around the UV elements represent the border where the UV cut has been made and should be a continuous green line. If there are green lines that are located on the inside of the UV element, it is because you have unwelded vertices. You should weld those vertices before going on and relaxing the UVs.

- Select all the vertices located on the green line.

- In the Edit UVs editor menu, select **Tool** → **Weld Selected**.

 This will weld all the vertices together to get a continuous contour green line.

3 Relaxing UVs

- Select all the vertices of the arm element.

- Select **Tool** → **Relax...**

 The Relax tool offers an advanced toolset for modifying the spacing of selected texture coordinates parametrically, for the purpose of eliminating or minimizing distortion in texture maps. The option window provides three different methods for relaxing vertices. You can use Relax to separate texture vertices that are too close together or to resolve overlapping areas.

- Activate the **Keep Boundary Points Fixed** option.

- Click **Apply** to relax the inside vertices.

The arms UV after using the Weld and Relax tools

Lesson 13: Unwrapping UVs

4 Unwrap the jacket

The simplest solution for unwrapping the jacket is to cut vertically under both arms using the cylindrical method, aligned to the X axis. This solution will allow the UVs to be unwrapped without any seams visible on the shoulders. Use the Relax tool to rearrange the inside vertices. Change the relax method and the number of iterations to get different results.

The jacket map seam

The jacket UV element

5 Unwrap the belt

To unwrap the belt, use the cylindrical method aligned to the Z axis. Put the map seam behind the back. Scale the UV element to get the belt's correct proportions.

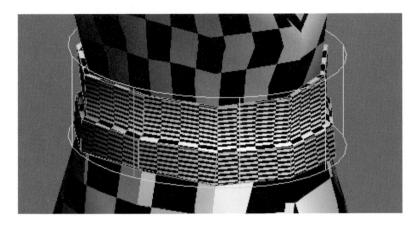

The belt map seam

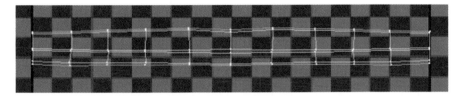

The belt UV element

6 Unwrap the hair

To unwrap the hair, use the cylindrical method. Align the gizmo around the hair and put the map seam behind the head. Scale the UV element to get the hair's correct proportions.

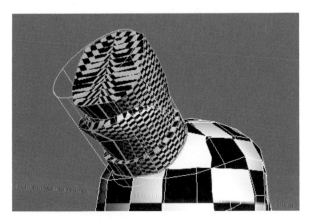

The hair map seam

Project 03

The hair UV element

7 Unwrap the hands

The hands are a little trickier since they cannot be unwrapped as easily. The simplest way to unwrap them is to cut the hand in half horizontally. You will then have a top and bottom UV element for each hand.

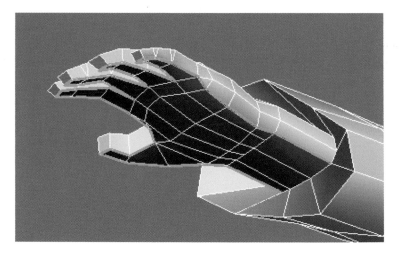

The bottom polygons of the hand used to create the UV

You should now select each shell's faces and assign planar mapping in the Z axis. Once that is done, it is easier to unwrap the element using the Relax tool.

The hands' UV elements

Tip: *It is sometimes faster to move UVs by hand than attempting to use automated tools.*

8 **Unwrap the jacket bottom cloth**

To unwrap the cloth at the bottom of the jacket, use the planar method aligned to the Y axis. Scale the UV element to give this cloth the correct proportions.

The jacket bottom cloth UV elements

Tip: *With a checker texture, you should attempt to make all the squares similar on every part of the geometry. There are exceptions, for instance in the face, where you need more resolution (smaller checkers), so the texture will look good for closeups of the head.*

Lesson 13: Unwrapping UVs

9 **Unwrap the pants**

The pants would be difficult to map using conventional mapping methods without getting smearing and stretching of pixels. It is best to use Normal Mapping in such a situation.

- Select all the faces that cover the pants.
- In the **Edit UVs** editor menu, select **Mapping** → **Normal Mapping...**
- In the Normal Mapping dialog, remove the **Align By Width** option.
- Select the **Back/Front mapping** method and click **OK** to unwrap the pants.
- **Move** the green line vertices outside the elements.

There might be some faces that are not attached to their proper places.

- Select the faces that should be relocated.

When you select a face, the corresponding edges on the other pant element are highlighted in blue.

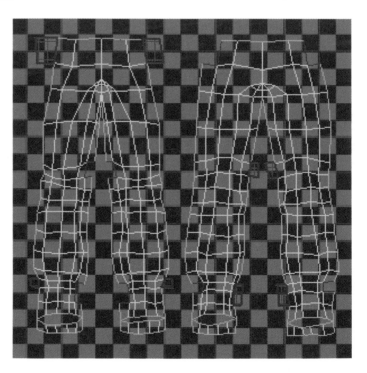

Incorrectly attached faces

- In the **Edit UVs** editor menu, select **Tool** → **Break** to break the face out of the element.
- **Move** the broken faces one by one to their respective positions, highlighted by blue edges.

 The faces will not fit perfectly into the new element but try to place them as closely as possible.
- Select the edges of the face that match with the new element.
- Go to the editor's main menu and select **Tool** → **Stitch Selected...**
- In the **Stitch Selected** dialog, disable **Align Clusters** so that you align only the faces and not the elements.
- Change the **Bias** value to **1** to give the edges of the face the orientation of the element edges.
- Click on **OK** to stitch the face to the element.

Note: *It is possible that edges will not be completely welded to the new UV element. In that case, weld the vertices after the stitch operation using the Weld tool.*

- **Repeat** for all the other faces.
- Rearrange the contour vertices to form a rectangular shape similar to the following image.

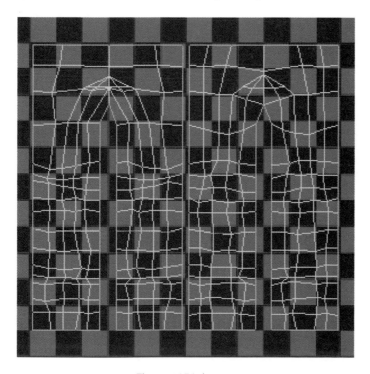

The pant UV elements

10 Unwrap the shoes

The shoes will be unwrapped in two passes. First you will use the planar method aligned to the Z axis to unwrap the faces under the shoes. Then, you will use *Pelt Mapping* to unwrap the rest of the shoes.

When using the Pelt Mapping tool, you start by defining pelt seams. Pelt seams are like map seams, but instead of creating a seam with a gizmo, you create it manually using a virtual *cut* line that will be used to unwrap the faces.

- In the **Parameters** rollout display group, turn on **Show Map Seam**.

 The green map seams can make the blue pelt seams difficult to see.

- In the **Map Parameters** rollout, click the **Point To Point Seam** button.

- Click the vertex behind the shoe at the floor level and click the vertex up to the end of the shoe.

- **Right-click** to accept the seam and **right-click** again to exit the point-to-point seam mode.

 You now have a pelt seam running along the shoes.

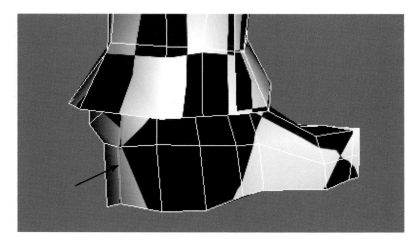

The shoe pelt seam

- Select all the faces making up the shoes except the one at the bottom of the shoe.
- On the **Map Parameters** rollout, click the **Pelt** button.
- A planar mapping gizmo appears in the viewport.
- Click the **Align Z** button to align the gizmo perpendicular to the Z axis.
- At the bottom of the **Map Parameters** rollout, click the **Edit Pelt Map** button.
- The Edit UVWs dialog appears if it was not open already along with the **Pelt Map Parameters** dialog.

Note: *The display of the geometry in the Edit UVWs dialog is slightly different from what you have seen so far. A circular stretcher is displayed. You will use this to simulate pelt mapping by stretching the geometry.*

- Position the cursor on one of the Stretcher control points. **Scale** the stretcher until it reaches the boundaries of the checker map.

- In the **Pelt Map Parameters** floating dialog, click the **Simulate Pelt Pulling** button.

- The faces are stretched out based on the pelt seams you created.

- Click the **Simulate Pelt Pulling** button again for additional stretching.

The shoe UV element after using pelt mapping

11 Final touches

Continue to refine each piece of the UV element. Make sure no faces were forgotten and take a closer look at your entire character in the viewport to confirm that the UVs are properly unfolded.

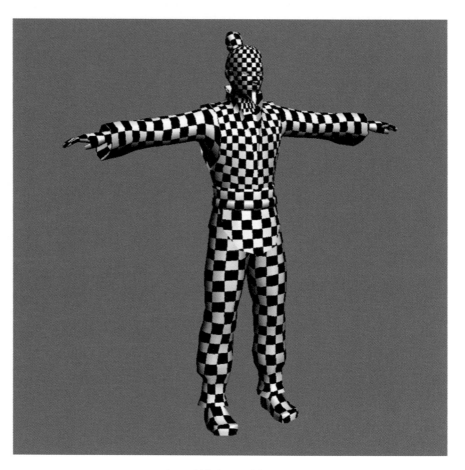

The unfolded UVs of the model

12 Save your work

- **Save** your scene as *My13-unwrap_02.max.*

Conclusion

You have just unwrapped a complete character! You learned about different tools to unwrap polygonal UVs such as planar mapping, cylindrical mapping, normal mapping and pelt mapping. You also learned about some tools to correct the UVs such as the Weld and Break tools, the Stitch Selected tool and the Relax tool. And finally, you learned about the 0–1 UV space, which will be very important for the next lesson while texturing the model.

In the next lesson, you will texture the model using the new mapping coordinates that you have just created.

Lesson 14
Texturing the Character

In this lesson, you will finalize the LiuJing model by texturing the geometry with a single texture map. You will learn how to prepare the model to receive its texture and also how to give your model extra detail using vertex coloring.

In this lesson you will learn the following:

- How to organize the UV for texturing;
- How to set the smoothing group manually;
- How to export UV maps;
- How to texture using a Gradient Ramp;
- How to transfer light onto vertex coloring;
- How to collapse modifiers into the model.

The 0–1 UV space

Now that the entire character's UVs have been unwrapped, you must place all the elements into the 0–1 UV space. The 0–1 UV space is visible in the Edit UVWs window and is defined by a dark blue square of the grid of the Edit UVWs editor.

When you load a bitmap texture, Max will normalize it to fit in the 0–1 space, thus making it square, regardless of its actual width and height.

Because you will use one big texture map for your entire character, it is better to place the character's UV shells in the 0–1 space so that you lose as little as possible of the texture map.

> **Note:** *When using the texture wrapping option, it is possible to place UVs outside the 0–1 square. Texture wrapping repeats the texture beyond the 0–1 UV space.*

1 **Open scene file**

- **Open** the scene from the previous lesson called *13-uv_01.max*.

- **Save** the scene as *14-texture_01.max*.

2 **Place all the elements in the 0–1 UV space**

- Use the **Select Element** option, located in the **Selection Modes** option group in the Edit UVWs editor, to select every face of an element in one click.

- **Move**, **rotate,** and **scale** to place the elements to optimize usage of the 0–1 UV space.

The UVs elements after being optimized

Note: *Because some of the body parts are symmetrical, like the hands, the arms, and the shoes, place these elements on top of each other to save more place. These elements will receive the same textures and thus be symmetrical in texture. Use the Mirror tool in the Tool menu to flip the UVs and match the corresponding UV element.*

Tip: *Keep in mind when organizing the elements that some elements need more texture space than others. For instance, the face needs more texture space than under the shoes.*

Finalize the smoothing group

Now that the UVs are correctly set up for the entire character, you will change the smoothing groups in order to get hard or smooth edges at the right locations on the model. In previous lessons, you had already modified the smoothing group but it was with an automatic function based on face angles. Now you will set edge smoothing manually to get more control over the final look.

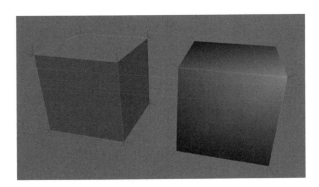

Hard vs. smooth polygonal edges

3 **Smooth the Head**

• Go to the Editable Poly subobject-level mode for the Body geometry.

Note: *When you change a modifier in the stack, you will see a warning message that a modifier in the stack depends on the topology. If you change the topology of the base editable poly object, like removing or adding polygons, the morph target will not work anymore because it uses the number of vertices to morph between the original and morph target models.*

Lesson 14: Texturing the Character

- Select all the polygons of the geometry.
- In the **Polygons: Smoothing Groups** rollout, click on the **Clear All** button to remove all the smoothing group information on the geometry.
- Select the polygons of the head and the neck.

> **Tip:** *To make the selection easier, in the Selection rollout, activate the Ignore Backfacing option. When this is on, selection of subobjects affects only those facing the camera. When it's off (the default), you can select any sub-object(s) under the mouse cursor, regardless of visibility or facing. If multiple subobjects lie under the cursor, repeated clicking cycles through them. Likewise, with Ignore Backfacing off, region selection includes all subobjects, regardless of the direction they face.*

- **Assign** the head and neck polygons to the smoothing group number **1** by clicking on the **1** button.

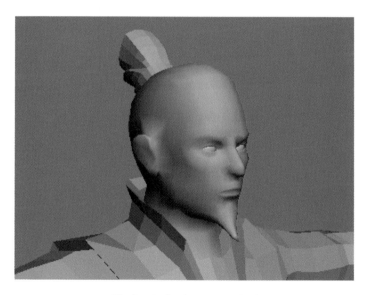

The head after being smoothed

> **Note:** *The smoothing group may produce strange results around the ears. This is due to the large angle between the polygons that separate the ear from the head. To solve this, you can give the ears a different smoothing group to get a better result.*

- Select the polygons behind each ear that are attached to the head.

The selected polygons behind the ears

- **Remove** the smoothing group number **1** by clicking on the **1** button and activate the group number **2** for these polygons.

 The smoothing group problem behind the ears has been solved but the polygons are no longer continuous with the rest of the ear. You will give the polygons that are inside the ear an additional smoothing group to smooth the complete ear.

- Select the polygons on the ears that lie around the polygons in smoothing group number 2.

The polygons that will receive an additional smoothing group

- Add the smoothing group number **2** to these polygons.

 The ear should now look correct and smooth.

4 Smooth the hair

The hair will be separated into three different smoothing groups: one for each hair section and another one for the ribbon.

The hair and the ribbon after being smoothed

5 Smooth the jacket

- Select the main surface of the jacket but don't select the polygons that form the inside of the jacket.

- Give these polygons the smoothing group number **6**.

The surface of the jacket after being smoothed

- Select the interior of the jacket and give it the smoothing group number **7**.

The interior of the jacket after being smoothed

- Select the polygons on the body that represent the shirt under the jacket.
- Give these polygons the smoothing group number **8**.

The shirt after being smoothed

6 Smooth the other parts

Now that you understand how to set smoothing groups on different parts of the character and how to simulate clothing seams like on the jacket, continue to set smoothing groups on the rest of the body.

The smoothed character

After setting all of the smoothing groups, make sure you deselect all the polygons before exiting the poly sub-object selection level mode. When you leave the sub-object selection level, the modifier will influence only the selected sublevel object.

7 Save your work

- **Save** your scene as *My14-texture_01.max*.

Create a texture map

1 **Export maps to paint the texture**

- From the Edit UVWs dialog, turn off the **Show Map** icon to hide the checker pattern.

- On the Edit UVWs menu bar, select **Tools → Render UVW Template**...

- In the Render UVs options, set the **Width** and **Height** value to **1024**.

- Set the **Fill Mode** to **Solid.**

- Make Sure **Show Overlap** is off, and **Seam Edges** is on.

- Click the **Render UV Template** button.

The render map window

- Click the **Save** icon, located in the top-left corner of the Render Map window.

- In the **Browse Image for Output** window, change the **Save as Type** option to **TIF Image file**.

- Change the folder to the *sceneassets/images* folder of your *project3* folder.

- Name your image **outUV** and click on the **Save** button.

 A TIF Image Control dialog will appear to let you set some features of the TIF format.

- Make sure that image type is set to **8-bit color** and enable the **Store Alpha Channel** option to be able to use that image as a layer in your paint software.

2 Paint the texture

- Open the UV snapshot image in a paint program to paint the character's texture map.

- When you are done painting the texture, substitute your painted bitmap for the diffuse color map instead of the checker and **load** your new texture.

- Here is the texture included in the support files.

The texture map included in the support files

Tip: *When you load the texture on your model, you can move some of the UVs' vertices to match the position of the texture to your model perfectly.*

The character with a texture applied

3 Texture the eyes

You can now take some time to texture the rest of LiuJing's geometry.

- **Assign** to the eyeballs a Standard **Phong** shader.
- **Rename** that material *LiuJing Eyes*.
- Change the **Specular Level** value to **25**.
- Change the **Glossiness** value to **40**.
- Select one eye and use the **RMB** on it to bring up the quad menu.
- Select the **Isolate Selection** tool.

Project 03

> **Note:** *The Isolate Selection tool lets you edit selected objects while hiding the rest of the scene on a temporary basis. After texturing the eye, click on the* **Exit Isolation Mode** *button on the floating window to unhide the rest of the scene.*

- **Map** the **diffuse** channel with a **Gradient Ramp** texture.
- Make the map visible in the viewport.
- In the **Coordinates** rollout, change the **V** angle value to **90**.
- In the **Gradient Ramp** parameters rollout, set the **Gradient Type** to **Tartan.**
- Click anywhere along the gradient bar to create additional flags.

 By default, three flags appear along the bottom edge of a gradient. Each flag controls a color. Each gradient can have any number of flags.

- **RMB** on any flag and select Edit properties to change the color of the gradient at the flags position.
- **Click+drag** any flag to adjust the position of its color within the gradient until you get the color you want.

The eye gradient bar

- Exit the **Isolation** mode.

Add vertex lighting to the model

Vertex colors are often used in the game industry. It's an easy way to create light effects on a texture. In this example, you will transfer the radiosity lighting solution into the vertex color of your model.

1 **Vertex paint modifier**
 - On the **Create** panel click the **Lights** icon. From the **Lights** submenu of the **Create** command panel, create a **Skylight** object anywhere in your scene.
 - Add the **VertexPaint** modifier to the *Body* geometry.
 - The **VertexPaint** paintbox will appear on the left side of your viewport.

The upper part of the VertexPaint window

2 **Radiosity lighting**

You will use the four top buttons in the window, which control the different vertex display modes.

- In the **Assign Vertex Colors** rollout of the **VertexPaint** modifier, change the **Light Model** to **Lighting Only** to paint only the light information on the model.

- Click on the **Radiosity Setup...** button from the same rollout.

The render scene window will appear in the Advanced Lighting panel.

- Change the lighting plug-in to **Radiosity**.

- Click on the **Start** button from the **Radiosity Processing Parameters** rollout to calculate the lighting information.

- Click on the **Assign** button in the **Assign Vertex Paint** rollout of the **PaintVertex** modifier to transfers the lighting to the vertex color of your character.

You can now display the vertex color in different modes using the four buttons of the PaintVertex window.

Note: *Now that the lighting has been transferred to the vertex color, you can delete the skylight and remove the Radiosity Advanced Lighting plug-in.*

- Click the button on the right to toggle the texture display off. Then select the button on the left, which is **Vertex Color Display Unshaded**. Your model should look like this:

The model with the vertex color only

3 Vertex color in renders

Vertex color can only be seen in the viewport. When you render the scene, the vertex colors are not used by the renderer. The only way to see the vertex color in the render is to include the vertex color map in the texture.

- Select the material used by the body geometry.
- Click on the diffuse map channel to enter the bitmap option.
- Above the **Coordinates** rollout, click on the **Bitmap** button, next to the **Map Name** field, to replace the diffuse map.
- Select the **RGB Multiply** map from the browser and click **OK**.

 When you replace a map, a dialog will appear, asking if you want to discard the old map or keep it as a sub-map.

- Click on **Keep old map as sub-map**.

 The bitmap has been placed as the Color #1 map.

- Click on the **None** button to add a new map on Color #2.
- Select **VertexColor** from the browser and click **OK**.

 The vertex colors are now visible when rendering your scene.

> **Tip:** *Because the vertex color map's default green and orange colors are diplayed in the viewport over the bitmap, it is hard to determine the real color of the map in the viewport. Choose the Bitmap map option in the Material Editor and click on the show standard maps in viewport button to activate the bitmap only in the viewport.*

Collapse the modifiers

Since this particular scene will be used later on in this book, you have to make sure that the modifiers Unwrap UVW and VertexPaint are collapsed in the Editable Poly object. Because you already have modifiers that you want to keep in the modifier stack, you cannot collapse the whole stack. You will only collapse the unwanted modifiers.

- Select the *Body* geometry**.**
- In the modifier stack area, **click+drag** the modifier Unwrap UVW between the Editable Poly base object and the Morpher modifier.

 This will change the order in which modifiers are executed over the Editable Poly object.

- Use the **RMB** on the UnwrapUVW modifier and select the **Collapse To** option.
- In the Warning: Collapse To dialog, select **Hold/Yes** to continue and collapse the Unwrap UVW modifier.

 It will collapse the stack, up to and including the Unwrap UVW modifier, into the Editable Poly object. Modifiers on the stack above the Unwrap UVW modifier are not affected, and you can still access them and adjust them individually.

- **Repeat** for the VertexPaint modifier.

4 **Save your work**
- **Save** your scene as My*14-texture_02.max.*

Conclusion

You just textured a complete character! During this lesson, you learned about 0–1 UV space, which is very important for any texturing task. You also learn how to export a UV template to paint a texture in separate paint software. Your character is now ready to be animated and rendered.

In the next project, you will learn about the basics of animation and the tools to create simple animation such as a walk cycle.

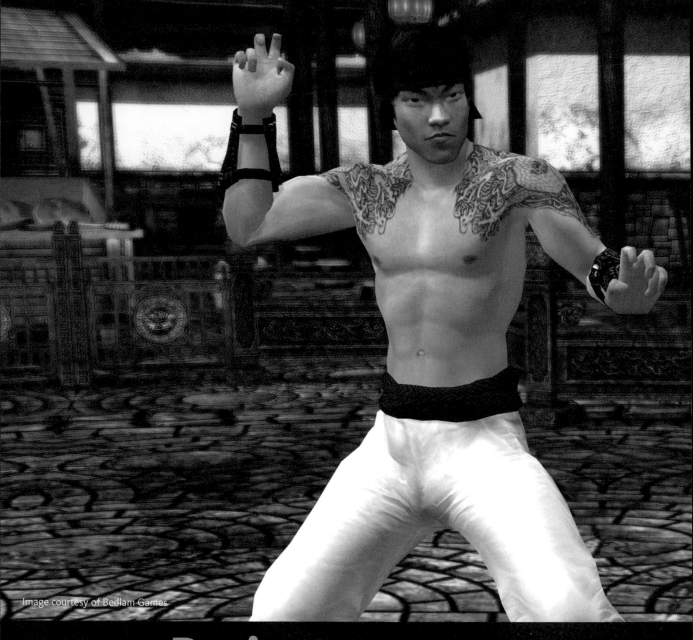

Image courtesy of Bedlam Games

Project 04

In this project, you will learn about the basics of animation with characters in Max. You will explore the main tools of the biped that will help you create animation for your character. You will also learn how to use the Animation Layer tool to modify your existing animations and how to mix them together.

Lesson 15
Walk Cycle

The fighter character is now ready to be animated. To create a walk cycle, you will build up the motion one part at a time. Starting with sliding the feet and moving the center of mass, you will then refine the position and rotation of the feet. When that is done, you will animate the upper body accordingly.

In this lesson, you will learn the following:

- How to prepare a character for animation;
- How to animate the character's legs and center of mass;
- How to animate the motion of the arms and head;
- How to refine a cycle using the Track View;
- How to export a clip file.

Animating a walk cycle

To create a walk, you will start with a single stride cycle. To create a cycle, you will need the start position and end position to be the same. There are several controls that need to be keyed, including the position of the feet, the roll of the feet, and the rotation of the pelvis. Before starting, you will change some of the character's properties to make the animation process easier.

> **Note:** *There is an automatic Footstep Mode as part of the Biped animation functionality that will create a walk cycle for you near instantly. Where's the fun there? Instead, this tutorial teaches the classic hand-animated method of generating a walk cycle.*

1 **Load the scene**

 • **Open** your final character from the last project.

 OR

 • **Open** the scene called *15-animtech_01.max* from the support files.

2 **Hide the helper objects**

 Helper objects play a supporting role and will not be keyframed or used during the animation process. For the biped, they are located at the end of each bone extremity, including the hand, the feet, the head, and the ponytail.

 • In the **Display** command panel, expand the **Hide by Category** rollout.

 • Click in the check box next to **Helpers**.

 This will hide all helper objects in your scene. The only way to bring back these objects is by deactivating the check box option. The standard unhide method will not affect helper objects that have been hidden using the Hide by Category rollout.

3 **Change bone transparency**

 At this time, the bone objects are opaque and are displayed over the model, making it difficult to see. You will make the bone objects semi-transparent for a better view of the character geometry.

 • **Select** all biped bone objects. On the main toolbar click the arrow to the left of the **Select Object** button and choose **Bone** from the drop-down list. Drag a selection rectangle around the entire character in the Perspective viewport, and this will select all the Bones.

 • Press **Alt+q** to enter **Isolation mode.** The biped skeleton is visible, and the mesh is hidden.

 • **RMB** on any biped object in the viewport to bring up the quad menu.

 • Select **Object Properties....**

 • In the **Rendering Control** option, change the **Visibility** value to **0.25**.

- Click **OK** to close the Object Properties window and change the visibility of the biped bones.

- Click the yellow Exit Isolation Mode button.

- On the main toolbar, change the **Selection Filter** from **Bone** back to **All**.

4 Freeze the character

Because you will only need to animate the biped, you will freeze the character geometry to avoid selecting it during the animation process. This step will also make it easier to select the bones that are under the geometry.

- Select the *Body* and the Eyes geometry.

- **RMB** to display the quad menu. Choose **Object Properties** on the **Transform** quad.

- Make sure the **Show Frozen in Gray** option from the **Display** properties rollout is deactivated to maintain the texture after freezing the object.

- Turn on **Freeze** in the **Interactivity** section of the **Object Properties** dialog.

Note: *On the Display panel, you can also click the* **Freeze Selected** *button to freeze the geometry objects.*

The character and the biped ready to animate

Animate the feet sliding

You will now key the horizontal position of the feet to establish their forward movement. This will result in a sliding motion of the feet, which will be refined later in the lesson. During this lesson, you will use some of the biped tools found in the rollouts of the Motion command panel to achieve the walk cycle.

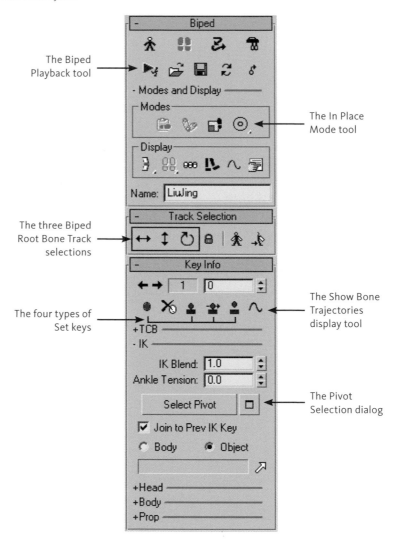

The main functions of the biped objects

> **Note:** *The animation values specified here depend on the scale of your character. To follow this lesson properly, either open the support file provided or adjust the values in your own model to compensate.*

1 **Set your time range**

 • Set the **Start Time** to **0**.

 • Set the **End Time** to **40**.

 This will give you a smaller time range to work with as you build the cycle. The cycle will be a full stride, using two steps of 10 frames each.

2 **Activate Auto Key**

 • Activate the **Auto Key** mode by pressing the **n** hotkey.

 From now on, if you move a bone, a key will be set for it at the current frame.

3 **Position and key the lower body start pose**

 You will key the starting position of the character in the position of a full stride.

 • Go to frame **0**.

 • Select the two foot bones.

 • Click on the **Set Planted Key** button from the **Key Info** rollout.

 • Select the *Center of Mass* and set the following:

 • **Move** along the **Y axis** to **0m**.

 • **Move** along the **Z axis** down the ground to **0.8m**.

 Notice that the foot stays in place because of the planted key.

 • **Rotate** in **Local Z** by **5** degrees to turn the body and head toward the left.

 • Select the *LiuJing R Foot bone*

 • Use the **Arc – Rotate** tool to rotate the left viewport and create a new User view. Zoom in on the feet in the viewport and change to Wireframe viewport shading.

 • *Expand the IK section of the Key Info rollout on the Motion Panel. Click on the **Select Pivot** button from the **Key Info** rollout.*

 • *Click on the lower middle button to change the pivot point to the back of the foot.*

 You will see a red dot under the foot that represents its pivot point.

 • Set the following:

> **Rotate** in **Local Z** by **10** degrees to raise the toes off the ground;
>
> **Move X** to **–0.1m**;
>
> **Move Y** to **–0.3m** to place the foot in front of the character.

- Select the *LiuJing L Foot* bone
- In the Key Info rollout of the Motion Panel, click the Set Sliding Key icon.
- and set the following:

 Rotate in **Local Z** by **−30** degrees;

- To move the foot, don't use the type-in transform fields. Instead use the transform gizmo in the viewport to drag the foot backward until the values are approximately the following:

 Move X to **0.132m**.

 Move Y to **0.335m**;

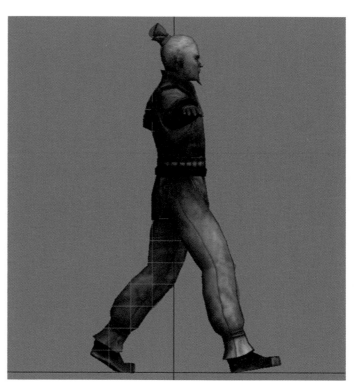

Lower body position

4 Position the middle step

- Go to frame **10**.
- Select the *Center of Mass* and set the following:

 Move Z position to **0.84m**;

 Move Y position to **-0.35m**;

 Rotate in **Local Z** by **−5** degrees.

- Select the *LiuJing R Foot* bone.
- **Rotate** in **Local Z** by **–10** degrees to bring the foot flat to the floor.
- *Change the pivot point of the feet to its original position* between the foot and the toes *using the* **Pivot Selection Dialog.**
- Select the *LiuJing L Foot* bone.
- **Move Y** to **-0.35m**;
- **Move Z** to **0.2m**;
- Click on the **Set Free Key** from the **Key Info** rollout.

 This will add a Free Key at frame 10. In a Free Key, the bone is unconstrained and can move easily.

- Select the *LiuJing L Toeo* bone.
- **Rotate** in **Local Z** by **–40** degrees.

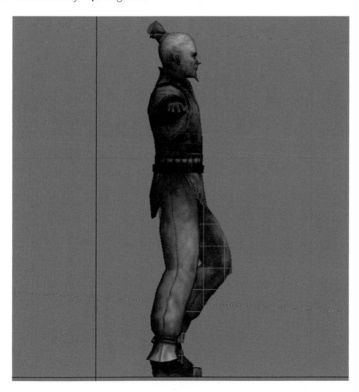

The middle step position

5 **Position the second step**

Because the second step will be using the same pose as the first step but with the other foot, you will copy the posture of the foot on frame 0 and paste it to the opposite foot at frame 20.

- Go to frame **20**.
- Select the *Center of Mass* and set the following:

 Move Z to **0.8m**;

 Move Y to **−0.7m**;

 Rotate in **Local Z** by **−5** degrees.

- Go to frame **0**.
- Select both legs from the thigh to the toes.
- Use the **Copy/Paste** rollout to create a collection and copy the posture.
- Go to frame **20**.
- Click on the **Paste Posture Opposite** button.

 Because the Copy/Paste tool does not transfer the planted key information, you must do that manually.

- Select the *LiuJing R Foot bone and set a* **planted key**.
- Select the *LiuJing L Foot bone and set a* **planted key**.
- *Change the pivot point of the foot near the heel.*

6 **Position the other middle step**

- Go to frame **30**.
- Select the *Center of Mass* and set the following:

 Move Z to **0.84m**;

 Move Y to **−1.05m**;

 Rotate in **Local Z** by **−5** degrees.

- Go to frame **10**.
- **Copy** the posture of the two legs.
- Go to frame **30**.
- **Paste** the posture with the **Paste Posture Opposite** button.
- Select the *LiuJing L Foot bone and set a* **sliding key**.
- *Change the pivot point of the foot to its original position.*

7 **Position the last step**

- Go to frame **40**.
- Select the **Center of Mass** and set the following.

 Move Z to **0.8m**;

 Move Y to **–1.4m**;

 Rotate in **Local Z** by **5** degrees.

- Go to frame **0**.
- **Copy** the posture of the two legs.
- Go to frame **40**.
- **Paste** the posture with the **Paste Posture** button.
- Select the *LiuJing L Foot bone and set a* **planted key**.
- **Play back** the animation to see the motion.

> **Tip:** *Use the In Place Mode feature located in the Biped rollout during the playback to see the animation loop without the translation of the character.*

Refine the heel rotation

So far, you have only rolled the feet; the legs do not have any "snap." You are now going to refine the animation of the foot rotations.

1 **Set a key for the right foot roll**

As you play back, you will notice that the feet don't pound on the ground after heel contact.

- Select the *LiuJing R Foot*.
- Go to frame **4**.
- **Rotate** in **Local Z** by **–7** degrees to make the foot hit the floor.

2 **Set a key on the left foot's roll**

- Select the *LiuJing L Foot*.
- Go to frame **24**.
- **Rotate** in **Local Z** by **–11** degrees to make the foot hit the floor.

3 **Play back the results**

> **Tip:** *You should always try to keep the required number of keyframes to a minimum and group them on the same frame if possible. Later in the animation process, the animation curves can become quite complex and having fewer keyframes makes it easier to modify.*

Animate the feet up and down

You will now key the vertical raising and lowering of the feet to establish the stepping action.

1 **Raise the left foot at mid-step**

Key the high point of the raised foot in the middle of a step.

- Go to frame **4**.
- Select the *LiuJing L Foot*
- **Translate** the foot about **0.05m** up along the **Z axis** to place it above the ground.

 This will sets a new key for the foot.

2 **Raise the right foot at mid-step**

- Go to frame **24**.
- Select the *LiuJing R Foot*
- **Translate** the foot about **0.05m** up along the **Z axis** to place it above the ground.

 Again, a key is automatically set.

3 **Play back the results**

Edit the animation curves

To refine the in-between motion of the feet, you can use the animation curves to view and change the tangent options for the feet.

1 **View the curves in the Curve Editor**

You will edit the animation curves produced by the keys in the Track View Curve Editor.

- Turn on the **In Place Mode** feature to make the animation loop in place.
- Select the two feet.
- **RMB** and choose **Curve Editor...**.
- On the **Track View** lower toolbar named **Track Selection**, click the **Filter Animated Tracks Toggle** icon.

- Select **View** → **Zoom Horizontal Extents**.

- Select **View** → **Zoom Value Extents**.

Each curve represents the local rotation value of each bone of the leg through the time span. The pattern of the animation curves you have created should look as follows.

The animation curves from the bones of the legs

Note: *The dashed lines represent parts of the curve that are driven by the planted key.*

2 Edit the curve tangents on the feet

The curve tangent type should be changed so that the steps cycle smoothly. The default tangent type is *Custom*. It includes Bezier handles to change the curve. You will change some of the key tangent to smooth.

- Select all the keys from frame **4** to frame **30**.

- From the Track View toolbar, click on the **Set Tangents to Smooth** button.

The Key Tangents: Track View toolbar

The visual difference between custom and smooth tangents in the Track View is subtle but the walk cycle animation looks better during playback.

3 **Save your work**
- **Save** your scene as My15-animtech_02.max.

Animate the arm swing

The character needs some motion in his arms. To do this, you will animate the translation of the arm bones to create an animation that can be cycled.

1 **Set keys for the start position**

- Make sure you are always in Auto Key mode.

- Go to frame **0**.

- **Rotate** the *Left UpperArm* by about **70** degrees on its Local **Y** axis and by about **30** degrees on its Local **Z** axis.

- **Rotate** the *Right UpperArm* by about **–70** degrees on its Local **Y** axis, about **–15** degrees on its Local **Z** axis, and about **–25** degrees on its Local **X** axis.

- **Choose Page Down** to move down the hierarchy of the arm.

- **Rotate** the *Right ForeArm* about **–25** degrees on its Local **Z** axis.

The starting position of the arms

2 Set keys for the opposite position

Now the arms are opposite to the feet, as in a normal walk. The only thing you have to do is to copy this arm pose and paste it in the opposite way on the next step to make the swinging motion work with the feet.

- Select both of the arms bone objects from the clavicle to the hand.
- Copy the posture of the two arms.
- Go to frame **20**.
- Click on the **Paste Posture Opposite** button to create the opposite posture of the arms.
- Go to frame **40**.
- Click on the **Paste Posture** button to create the starting posture of the arms.

Animate the head

To add some secondary motion, you will also set keyframes on the rotation of the head.

- Go to frame **0**.
- Select the *head* bone and **rotate** it around the **X axis** by about −**5** degrees.

 This has the head and hips moving in opposite directions, with the head always facing close to straight forward.

- Go to frame **40** and set a key on the head to get the same head orientation.
- Go to frame **20**.
- **Rotate** it around the **X axis** by about **10** degrees.

Note: *You can continue refining your walk cycle by creating new poses between keyframes or by changing the tangent of each individual key using the Track View Curve Editor.*

Create an animation clip file

The animation is finished, but since you will be working with the Motion Mixer later in this book, you will now create a clip file by exporting your walk cycle for later use.

1 Export the clip

- Select any bone from the biped.
- In the **Biped** rollout, click on the **Save File** button.

 This will bring up the Save As dialog for the biped animation file.

The Save As biped animation dialog

- Go to the *sceneassets/animations* folder of *project4*.
- Enter *MyLiuJingWalkCycle* in the file name field.

Note: *You can include the animation of the eyes or any other objects in the clip file with the Save MAX Objects options. Every object linked to the biped will be included in that list and will be part of the animation clip file.*

- Click on the **Save** button to export your animation into a clip file.

Now you can import this clip into another scene. You will do so later in this book.

Project 04

2 Save your work

- **Save** your scene as *My15-animtech_03.max.*

Conclusion

Congratulations, you have completed a walk cycle! You learned how to prepare a model for animation, and then you animated the character using some of the main biped animation tools. You produced a perfect cycle and exported it to a clip file.

In the next lesson you will create a new animation that will blend at the end of the walk cycle you have just created. This animation will not loop, so you will be able to be creative with the animation of the character.

Lesson 16
More Animation

You can now practice animation skills from a more artistic point of view. In this lesson, you will animate LuiJing opening a door from the building you created in the first project. This time, rather than approaching animation from a mathematical standpoint, you will have to establish key poses based on artistic knowledge to generate the animation.

In this lesson, you will learn the following:

- How to use reference objects;
- How to load an animation clip;
- How to establish key poses;
- How to refine in-betweens;
- How to preview an animation;
- How to fix the timing of your animation.

References

When you first animated LiuJing, you were doing the animation in an empty scene. You will now create an animation referencing the building created in the first project. Referencing the building scene using XRef Objects rather than importing it will make your scene file smaller, since it will not actually contain the building assets. This also gives you the opportunity to modify the building scene later in the process; it will then be automatically updated in all the other scenes referencing it.

> **Note:** *If you're doing design visualization you can use File Linking of DWG files for functionality similar to the XRef Objects workflow presented here.*

1 **Scene file**

• **Open** the scene file *15-animtech_03.max* from the last lesson.

2 **Load a reference**

• From the main menu, select **File → XRef Objects….**

The XRef Objects dialog

- Click on the **Create XRef Record from File...** button in the Xrefs Objects toolbar.

- In the browser window, select the *16-animart_building.max* scene from the *scene* folder and click the **Open** button to load the scene.

 A browser dialog will appear with all available objects that can be merged as a reference.

- Click on the **All** button to include all the objects from the building scene and click on the **OK** button to implement your selection. You'll have to wait a short while now.

- Click the File Name to populate the lower window.

The building scene loaded as a reference

The building is now loaded as a reference into your scene.

Lesson 16: More Animation

The building loaded into the scene

- Change the Perspective viewport to **Wireframe** shading mode and use the **Arc-Rotate** tool to explore the surroundings.

3 **Load the walk cycle**

You will now load the walk cycle from the previous lesson. Your new animation will start with the last pose of your walk cycle animation.

Note: *By using the last pose of the walk cycle as the starting pose of your new animation, you will make the two animations much easier to combine.*

- Select any part of the biped.

- In the **Biped** rollout, click on the **Load File** button.

- Select the file named *LiuJingWalkCycle.bip* from the *sceneassets/animations* folder.

- Click on **Open** to load the animation clip file.

 A Duplicate Material Name dialog will appear because the eyes object included in the clip file will be replaced in your scene; from there, you can decide whether to keep the material from the clip file in your scene. You can also rename the merged material but in any case, the eye material has not been changed and both versions of it are the same.

- Click on **Use Scene Material**, which will then import the walk cycle animation.

4 Reposition the character

Because the sidewalk was created a little higher than the world grid, your character has his feet in the ground.

- Go to the beginning of the animation at frame **0**.
- Select the center of mass of the biped.
- In the **Biped** rollout, click on the **Move All Mode** button. This button is on the second row of icons, on the right-hand side.

 A gizmo will appear around the center of mass with a dialog box to control the offset.

- Use the X, Y, Z Position and Z Rotation values in the dialog box to move the character on the sidewalk near the door.

 You can enter the same values as in the following image to reposition the character.

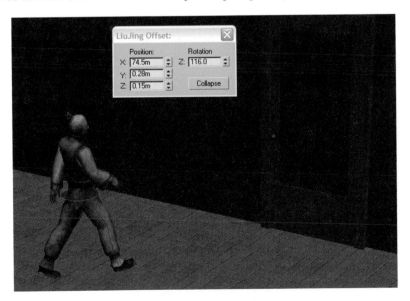

The fighter after being repositioned

- Click again on the **Move All Mode** button to exit that mode.

Lesson 16: More Animation

Prepare the scene

There are a few other changes to bring to the referenced scene before beginning the animation.

1 Hide objects

Because there is a lot of geometry that you will not use during the animation process, you will optimize your scene to make the animation process easier and quicker. You will keep only the objects that will be animated or will be used as references.

- In the XRef Objects dialog select all of the objects that will not be used in the animation process, such as the foliage, windows, floor, doors, and railings.

- In the **Selection Sets** toolbar, located to the right of the Snap tool icon in the main toolbar, enter the name **Animation Optimize** in the selection set name drop-down list and press **Enter** to create a new selection set.

The Selection Sets toolbar

By entering a name in the drop-down list, you create a new selection set that will remember all the selections you've made for that set. You will be able to hide them and unhide them more easily by including them in a selection set.

- Once your selection is created, use the **Hide Selection** function from the Quad Menu to hide every object in the selection set.

The scene is now simplified, giving you more viewport and better performance to work on your animation.

Note: *To unhide the objects included in the selection set, simply click on the selection set name from the drop-down list. A dialog will appear, asking if you want the objects to be unhidden. Click Yes to unhide the objects.*

2 Freeze the reference objects

To make sure you do not select the reference objects during the animation process, you will freeze the remaining objects from the scene (except for the main door, called *Building Animated Door*).

- Select the remaining objects, such as the skydome, sidewalk, ground, building first floor and the door frame.

- In the **Object Properties** dialog, disable the **Show Frozen in Gray** option.

- In the Interactivity Group turn on **Freeze**.

The only selectable objects now are the biped objects and the door.

3 Import the door controller

Because the door is a reference object, you cannot key its transformation, but you will need to animate the opening of the door. The only way to access keyframing on a referenced object is to merge the object into your scene.

- Return to the **XRef Objects** dialog.
- If necessary, click on the *16-animart_building.max* scene file.

 All of the objects and controllers included in that scene are now listed.

- Scroll down until you reach the *Building Animated Door.*

> **Tip:** *It should be located at the end of the list.*

- **RMB** on the object name and select **Merge in Scene**.
- Click **Yes** to confirm that you want to merge the selected objects into the scene.

 The door object with its controller is now merged into your scene and you have access to its transformations to animate the door.

4 Save your work

- **Save** this scene as *My16-AnimArt_01.max* in the current project's *scene* directory.

Animate the new clip

Now that your scene is properly set up, you will animate LiuJing opening the door and entering the building. He will begin at frame 40 and finish around frame 150 in the same starting pose of the walk cycle. Once this is done, you will save the new sequence as a clip file. To create this animation, you will use a pose-to-pose approach. Once you have blocked out the animation, you will refine it to correct the timing and make it more realistic.

> **Tip:** *In order to complete this lesson correctly, you must absolutely stand up and try the motion you are about to create in the real world. Doing so is part of the animator's job; without it you cannot properly reflect the motion and timing in your animation software.*

1 Set the time range

- Set the **Start Time** to **0**.
- Set the **End Time** to **150**.

2 Keyframe the first pose

- Enable the **Auto Key** button if it's off.
- Go to frame **55**.
- **Rotate** the biped object to get a starting position in which the character is standing next to the door and holding the doorknob in his hand.

The first pose

Tip: *Use the planted key to make sure the feet stay on the floor while you are moving the center of mass.*

3 Set keys for the second pose

- Go to frame **75**.
- **Create** a new pose of LiuJing opening the door.
- **Animate** the door rotation with the same timing as the hand pulling on the doorknob.

Note: *It's possible to animate the rotation of the door XRef object because you merged its controller into your scene. If you pick any other XRef object, you will not be able to animate its rotation or translation.*

The second pose

4 **Set keys for the first step**

- Go to frame **100**.

- Create the character's first step (his third pose overall), as he enters the building to look as follows:

The third pose

Note: *From there, you can optionally start to close the door slowly behind him, as if it were a spring door that closes by itself.*

5 **Set keys for the second step**

- Go to frame **115**.

- **Pose** the character's second step inside the building as follows:

The fourth pose

6 **Set keys for the final pose**

- Go to frame **0**

- **Copy** the starting pose of the walk cycle.

- Go to frame **150**.

- **Paste** the copied pose.

 By finishing your animation with this pose, you will be able to make LiuJing continue walking inside the building using the Motion Mixer in a later lesson.

The last pose of the animation pasted from the first pose of the walk cycle

7 **Adjust the animation**

- **Scroll** the timeline and **adjust** the poses to make the motion between them more fluid.

- Make sure you brought everything along when you moved the character.

- **Play back** the animation.

8 **Make a preview of your animation**

When you make a preview, 3ds Max software generates the animation by grabbing the image directly from the active viewport.

- Frame the scene in the Perspective viewport to see it in its entirety.

- From the main menu, select **Animation** → **Make Preview…**.

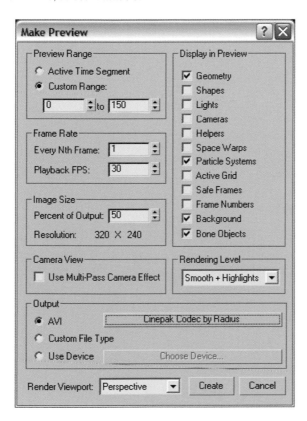

The Make Preview dialog

The Make Preview dialog lets you control the types of objects you want to be seen in the preview. It will then create an AVI file or custom file type preview of the animation in the current viewport. When the preview is complete, 3ds Max will open the preview _scene.avi file, located in the previews folder of your current project folder.

Note: *If you don't want the preview to be played automatically upon completion, choose* **Customize** → **Preferences**. *Select the* **General** *panel and in the* **UI Display** *group, turn off* **Autoplay Preview File**.

- Hide the **Bone Objects** category from the **Display in Preview** option.
- Click on the option box next to the AVI option and select a video compression algorithm from the drop-down list.

Note: *The list will include the codecs that are installed on your machine. Some basic codecs integrated with the Windows operating system, such as the Cinepak codec, can be quite good for an animation preview.*

- Click on the **Create** button to create the preview.

Tip: *Do not open any other windows that would cover the viewport while rendering a preview. Anything covering the viewport will be rendered into the AVI file.*

9 Animation refinement

Once you have seen the preview and animation at its real speed, you can concentrate on correcting the motion and timing.

- **Note** areas that appear to be too fast or too slow in the playback.
- To move a pose to a different frame, click on a keyframe in the Time Slider.
- **Press+drag** the keyframes closer to another one to change poses faster, or move them away from each other to change the pose more slowly.

Note: *You might have to redo your playblast and perform some trial and error before finding the perfect animation speed. This is part of any usual animation task.*

Project 04

Create a clip file

The animation is finished, so you will now create another clip file.

1 Export the clip

Because the first 40 frames were part of the walk cycle loaded as a visual reference, you will only save the portion of the animation created in this lesson.

- Click on the **Save File** button from the **Biped** rollout.

- Give your new clip the name *LiuJingOpenDoor.bip*.

- Click on the **Save Segment at Current Position and Rotation** button

 This will activate the time segment options.

- Set the **From** value to **40.**

- Set the **To** value to the last frame of your animation.

- Disable the option **A Keyframe per Frame**.

 If you keep this option on, a keyframe will be created on every bone at every frame of the animation, making the clip file unnecessarily complex.

- Click the **Save** button to create the clip file.

2 Save your work

- **Save** this scene as *My16-AnimArt_02.max*.

Conclusion

You have now completed an animation that required artistic judgment. As you can see, a lot of practice is required to achieve good animation in an efficient manner, and you might have to correct rigging problems as you work.

In the next lesson you will learn to import and edit motion capture as another method to animate your biped.

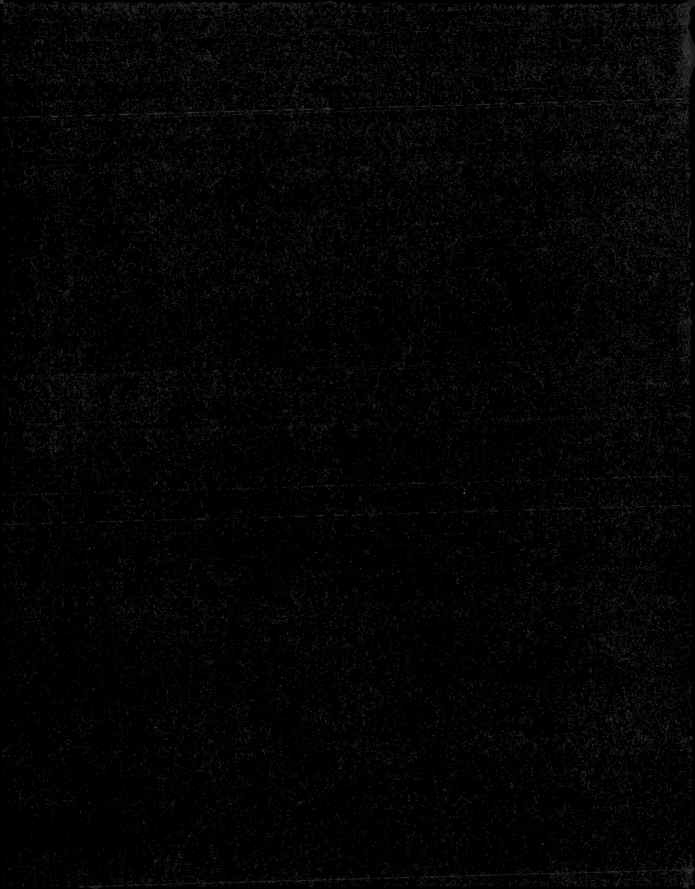

Lesson 17
Motion Capture

So far, you have animated using keyframed animation. Another way to create animation is to use motion capture animation. Rather than animating the biped frame by frame, you will import motion capture data onto the LuiJing character's biped. There will be some refinement to do in order to finalize the animation, but you will achieve a realistic look much faster.

In this lesson, you will learn the following:

- How to load a motion capture animation;
- About the functionality of the Buffer tool;
- How to apply key reduction on motion capture animation;
- How to use the biped layer system.

Working with motion capture data

Motion capture is the practice of getting motion data from live actors performing various actions. The motion data is captured via sensors placed at the actors' joints and extremities. Autodesk® 3ds Max® software does not perform motion capture, but it accepts motion capture data in the most commonly used formats (BVH and CSM). This data can be imported to the biped and used as is, or combined with other motions with the Motion Mixer (which you will explore in the next lesson). When motion capture data is imported to 3ds Max, it can be filtered to create fewer keyframes.

Motion capture data can be loaded onto the biped bones using either of two methods. To load motion capture onto your character, do one of the following:

- If your motion capture is in BIP or STP format you can click the **Load File** button from the Biped rollout, then browse to a folder of motions and select the motion capture file.

 This will load the motion capture data onto your character with the default options.

 OR

- If your motion capture is in BVH, CSM or BIP format you can load the motion capture file by clicking the **Load** button on the **Motion Capture** rollout.

 This will display a browser window to select the motion capture file and then a settings window for precise control over conversion parameters, which you'll explore next.

The Load Motion Capture File button

The motion Capture Buffer Tools buttons

The Motion Capture rollout

1 **Scene file**

- **Open** the scene from the earlier animation lesson called *15-animtech_01.max*.

2 **Load a motion capture**

- Select the *center of mass* biped object.

- Click the **Load Motion Capture File** button from the **Motion Capture** rollout.

- Select the motion capture file called *SampleTornadoKick.bip* from the animation folder and click the **Open** button.

The main
Conversion
options list

Motion Capture Conversion Parameters

Motion Capture File: C:\Temp\3ds Max\Cstudio\Motions\MoCap\Bip\CartWheel.bip

Footstep Extraction: None: Freeform

Conversion: No Key Reduction

Up Vector: X Y Z

Scale Factor: 1.0

Footstep Extraction

Extraction Tolerance: 0.07

Sliding Distance: 25.0

Sliding Angle: 0.0

☐ Only Extract Footsteps Within Tolerance

Tolerance: 0.5

From Z Level: 0.0

☐ Flatten Footsteps to Z = 0

Load Frames

Start: 0 ☐ Loop: 0

End: 0

Talent Definition

Figure Structure: _____ Browse... ☐ Use

Pose Adjustment: _____ Browse... ☐ Use

Load Parameters Save Parameters OK Cancel

Key Reduction Settings

	Tolerance	Minimum Key Spacing	Filter
Set all:	0.0	3	☐
Body Horizontal:	1.0	3	☑
Body Vertical:	1.0	4	☑
Body Rotation:	1.0	3	☑
Pelvis:	6.0	3	☑
Spine:	6.0	3	☑
Head and Neck:	6.0	3	☑
Left Arm:	6.0	3	☑
Right Arm:	6.0	3	☑
Left Leg:	6.0	3	☑
RightLeg:	6.0	3	☑
Tail:	6.0	3	☑

Limb Orientation

Knee:	Elbow:	Foot:	Hand:
○ angle	○ angle	● angle	● angle
● point	● point	○ auto	○ auto
○ auto	○ auto		

The Motion Capture Conversion Parameters dialog

Tip: *The default filter settings work well in most cases.*

- From the **Conversion** option drop-down list, select **Load Buffer Only**.
- Click **OK** to load the motion capture animation into the buffer.

 *By specifying **Load Buffer Only**, you instruct 3ds Max to load the motion file into the motion capture buffer without altering the biped animation.*

3 Paste motion capture animation from buffer

At this time, the motion capture animation is simply stored in a buffer. That is why there are no keyframes on the LuiJing character. This buffered motion data is independent of the biped motion in your scene, and it can be adjusted in various ways using the Buffer tool buttons.

- Click on the **Show Buffer** button from the **Motion Capture** rollout to reveal a red visual representation of the motion capture animation in the viewport.

The Show Buffer red visual representation

Note: *You can also view the trajectory of the buffer motion by using the* **Show Buffer Trajectory** *button.*

- Click the **Play** button to see the red stick figure cycle through the motion capture file.
- Select all the upper body bones from the pelvis to the head, including the arms.

- Click the **Paste From Buffer** button to paste the buffer bone posture to the bones of your character, LuiJing.

 This way, you can copy postures or complete poses from a motion capture file into your current animation.

LuiJing's upper body posture pasted from the buffer

4 Load motion capture animation

To load the motion capture animation directly onto the character, you can use the **Load Motion Capture File** button and choose a conversion mode other than **Load Buffer Only**. You can also use **Convert from Buffer** to try alternative filter settings quickly; this saves you from having to browse for the same file and reload it.

- With the buffer loaded with the *SampleTornadoKick* animation, click on the **Convert from Buffer** button to transfer the animation from the buffer onto the LuiJing character.

- Use the **No Key Reduction** conversion mode and click the **OK** button.

The animation loaded using the Convert from Buffer feature

Note: *The animation has now been applied to the character, so you no longer need the Show Buffer feature.*

5 **Adjust the animation**

- **Play back** *the animation.*

 After the kick, when the character holds its final pose, notice how the character's hands are shaking. You can fix that using the key reduction feature. Because the animation is always stored in the buffer, you can reconvert the animation without loading it.

- Click on the **Convert from Buffer** button to return to the **Conversion** parameters.

- Change the conversion mode to **Use Key Reduction**.

- Click on the **Filter** option box twice at the end of the **Set all** row in the **Key Reduction Settings**.

 This will remove the filter from every part of the biped.

- Click on the **Filter** option box of the *Left Arm* and *Right Arm* categories.
- Change the **Minimum Key Spacing** value for both hands to **6**.
- Click the **OK** button to reload the animation from the buffer with the key reduction settings.
- **Play back** the animation and notice how the animation of the hands is now smoother.

 By using the key reduction feature, you have smoothed the final animation. This is one technique used to modify a motion capture animation. Alternatively, you can import a motion capture file with no key reduction and add a layer to it. This is an easy way to make changes to a file that contains keys at every frame.

Editing with layers

Motion capture data typically needs some adjustment before it fits your biped or animation perfectly. Controls on the Biped Layers rollout allow you to add layers of animation above the original biped animation. This is a powerful way of making global changes to your character animation. With layers, you can easily adjust raw motion capture data, which contains keys at every frame; but you can also use the layer system on manually keyframed animation.

You will now use layers over the tornado kick to modify the animation.

1 **Create a new layer**

- Go to frame **0.**
- Click on the *Right Hand* biped object.
- **Expand** the Layers rollout of the biped from the **Motion** command panel.

- On the Layers rollout, click the **Create Layer** button.
- **Rename** this layer *Hand Pose.*

The main tools of the Layers rollout

2 Edit the hands

When you add a new animation layer, the layer is set on every bone of the biped, not just the bone(s) you selected before applying the layer. A red outline of the biped, like the one displayed with the Show Buffer feature, is now placed at the same position as the bones of the biped. These red bones represent the original base animation layer. The keys you've previously set also disappear from the timeline. They are still there, but the timeline only displays the keys of the new layer.

- Turn on **Auto Key**.

- **Rotate** the fingers of the hand into a fist.

 A new key has been created at frame 0. Notice the original position represented by the red finger bones.

The new hand pose

- **Play back** the animation.

 *The right hand is now closed during the entire animation because you've only created a new pose at frame **0**.*

- Select the key you have just made on frame **0** by clicking on it.

- **Click+drag** the key to frame **60**.

 This is where you will start to return to the previous hand pose.

- Go to frame **85.**
- Click on the **Snap Set Key** button to create a new pose from the base layer.
- **Play back** the animation.

 *The layer will maintain the fist hand pose until frame **60** and blend to the original hand pose through frame **85**. If you look at the Curve Editor, you will see the blend curve between the two poses.*

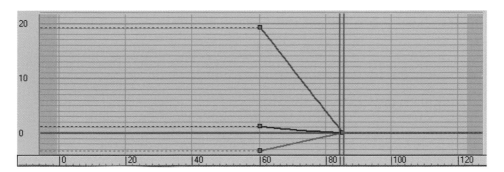

The curves blending the two poses

Note: *You can also use the **Copy/Paste** rollout when working with layers.*

- **Copy** the *Right Hand* pose on frame **60.**
- Go to frame **15** and use the **Paste posture opposite** button to paste the same posture on the left hand.
- Go to frame **0** and use the **Snap Set Key** button to create a pose of the original position.
- **Play back** the animation to see the fighter close his left hand from frame **0** to frame **15.**

3 Reposition the hand

If you want to reposition the hand during the animation, it will not be possible using layer 1 because there are already keys on it. To do so, you will have to add a second layer to reposition the hands.

- **Create** a new layer and name it *Hand Reposition.*
- Go to frame **0.**
- **Move** the *Right Hand* away from the body to avoid interpenetration.

Note: *You can also rotate the forearm to move the elbow away from the body.*

- Go to frame **75.**
- **Click** on the **Snap Set Key** to return to the original hand position from the base layer.

 The hand will blend between the two poses from frame **0** *to frame* **75**.

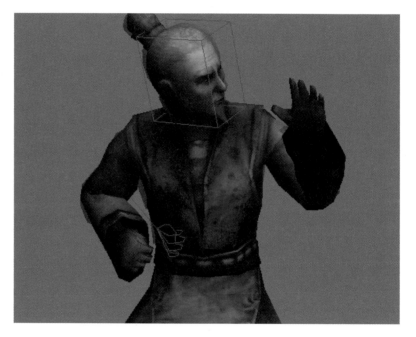

The hands' new position away from the body

Note: *You can navigate through the base layer and the first layer by using the Layer Navigation Tools button.*

4 Make the fighter jump higher

To modify other parts of the body, you can continue editing the animation on any layers created so far, but it is better to add a new animation layer in order to localize your modifications on separate layers. You can then make each layer active or inactive using the **Active** option box next to the layer's name.

- **Create** a new layer and **rename** it *Higher Jump.*

- Select the *center of mass*.
- Go to frame **55,** where the fighter is in the air.
- Make sure you are always in Auto Key mode.
- **Move** the *center of mass* **0.3m** up to make the jump higher.

The jump after being moved higher

- Go to frame **50**, where the character starts jumping.
- Click on the **Snap Set Key** button to copy the pose from the base layer.
- Go to frame **60**, where the character lands.
- Click on the **Snap Set Key** button to copy the pose from the base layer.
- **Play back** the animation.

Note: *There is a scene of the final animation with the three animation layers in the support files called 17-motionCapture_01.max.*

> **Tip:** *Animation layers are not limited to motion capture animation. You could modify any animation on any objects using layers.*

Export a clip file

You will now export the animation to a clip file.

1 Save your scene

You should save your scene before exporting a clip file because the animation layers will need to be collapsed to save the final animation. You should always keep a copy of your scene with its separate animation layers.

- **Save** this scene to *17-motionCapture_01.max*.

2 Export the clip

You will now collapse the layers to create the final animation.

- Make sure you are in the last layer, called *Jump Higher*.
- Click the **Collapse** button.

 This will collapse the Jump Higher layer into the next layer.

- Click the **Collapse** button again to collapse the *Hand Reposition* layer into the next layer.
- Click the **Collapse** button again to collapse the entire animation into a single layered animation.
- Click the **Save File** button from the **Biped** rollout.
- Give your new clip a name, such as *FinalTornadoKick.bip*.
- Click the **Save** button to create the clip file.

 The new animation file is now saved on disk and can be reused at will on any other biped character.

> **Note:** *New to 3ds Max 2008 is the ability to load and save individual biped layers as BIP files. Before you collapse the animation, you can save the layer using the Save Layer icon, and reload the layer at a later time using the Load Layer icon. These new icons appear at the very top of the Biped Layers rollout.*

Conclusion

You have now edited a motion capture animation using the basic motion capture tools provided by the biped. You learned the advantages of working with the buffer. You also learned how to apply key reduction on a motion capture animation and finally, you learned how to use the layer system to modify an animation.

In the next lesson, you will use the Motion Mixer Editor to combine multiple clips together and create a new animated sequence.

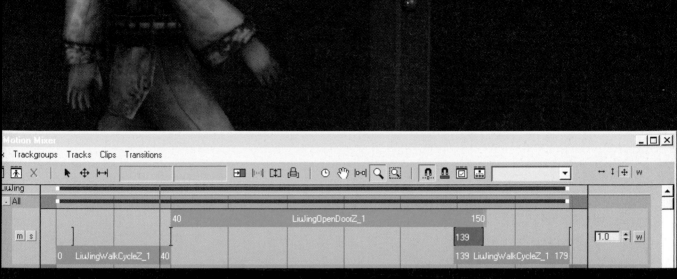

Lesson 18
Motion Mixer

In this lesson, you will use the Motion Mixer to create a new animation based on the two motion files you have created earlier in this project. The Motion Mixer lets you create a transition between different animations. You will start by practicing on mixing the tornado kick to familiarize yourself with the Motion Mixer and then move on to mix your walk cycle with the open door animation.

In this lesson, you will learn the following:

- About the Motion Mixer utilities;
- The various ways to open the Motion Mixer window;
- How to create a transition track;
- How to load clip into the mixer;

Understanding the Motion Mixer

The Motion Mixer allows you to combine motion data (in files called clips) for biped and non-biped objects. For any biped object, you can add multiple tracks to the mixer, each holding a separate series of motion clips. With the Motion Mixer, you can:

- Transition or fade between motions;
- Move motions in time;
- Trim a motion so only part of it is used;
- Vary the speed of a motion over time;
- Use animation from selected biped body parts within a motion clip;
- Keep planted feet from sliding during foot-based transitions.

You can also use the Motion Mixer to animate some body parts with one set of clips, and other body parts with other motions. For example, suppose you have two clips, one where the biped runs with its arms pumping by its sides, and another where the biped stands and cheers with its arms in the air. You can mix the leg and hip motions from the running motion with the arms from the cheering motion to make an animation of a biped cheering as he runs across a finish line.

Mixing the tornado kick animation

1 **Scene file**
 - **Open** the scene called *15-animtech_01.max*. This is the original fighter file, without any animation.

2 **Opening the Motion Mixer**
 There are several ways to open the Motion Mixer panel.

 - To access the Motion Mixer from the main menu, select a biped, and then select **Graph Editors** → **Motion Mixer…** from the main menu.

 OR

 - To access the Motion Mixer from the Motion panel, select a biped and open the **Motion** panel. On the **Biped Apps** rollout, click the **Mixer** button.

 OR

 - To display the Motion Mixer in a viewport, activate the viewport in which you want to display the Motion Mixer. **RMB** the viewport label, and choose **Views** → **Extended** → **Motion Mixer** from the pop-up menu.

Note: *When the Motion Mixer is displayed in a viewport, its menu bar is not accessible. However, you can access each menu by right-clicking the corresponding element in the Mixer.*

The Motion Mixer user interface

When the Motion Mixer window opens, the biped is automatically displayed in the Mixer. It has a default trackgroup labeled *All*, where you will start laying out your tracks, motion clips, and transitions. The label *All* indicates that motions placed on tracks will apply to the entire biped, rather than specific body parts.

Tip: *The Motion Mixer window can be resized for better viewing of what's added to the tracks.*

3 The Mixer button

To see the resulting animation of your mix, turn on the **Mixer Mode**. When Mixer Mode is on, the biped performs the motions in the Motion Mixer.

- Select a biped object.
- In the Motion panel, expand the **Biped** rollout.

The Mixer Mode button

- Click the **Mixer Mode** button to activate the Mixer Mode.

4 Add clips to the Mixer

Trackgroups are populated by tracks, in the form of layer tracks or transition tracks. On each track, you add clips and transitions. The final output is called a mix.

- Click in the track on the *All* trackgroup to highlight it. Click in the blank area to the left of the two buttons marked "m" and "s".

 The track turns a lighter gray when selected.

- **RMB** on the selected track and choose **Convert to Transition Track**.

The transition track after being converted

- **RMB** on the transition track and choose **New Clips** → **From Files**.

 *The **Open** dialog will appear.*

- Select the clip called *FinalTornadoKick.bip* that you edited in the previous lesson.

- Click the **Open** button to load the clip into the transition track.

 Because the clip is longer that the actual timeline of 100 frames, you should zoom out the timeline of the Motion Mixer window to get an overview of your clip. You can also set your timeline range to match the total number of frames of your mix. Theses tools are on the main toolbar of the Motion Mixer window.

The Set Range button ⟶ ⟵ The Zoom Extents button

The Motion Mixer navigation toolbar

- **RMB** a blank area of the transition track, and choose **New Clips** → **From Reservoir**.

 The Reservoir serves as a storage facility for motion clips that you use with the Motion Mixer. All clips that you load directly into the Motion Mixer are available in the Reservoir.

- Choose the file *FinalTornadoKick.bip* and click **OK** to load the clip again in the transition track.

 The second clip is added to the track, and a transition is automatically added between the two clips. The transition is shown with a darker version of the clip color, and spans the transition time between the two clips.

- Click again on the **Zoom Extents** button so you can see the entire mix in the display.

- Click again on the **Set Range** button to set the length of the animation to the number of frames needed for the mix.

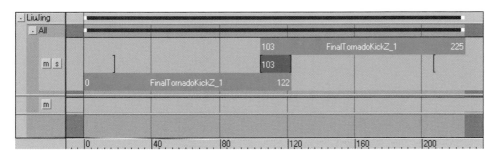

The two-clip mix with its transition

You have just created a basic mix consisting of two clips and a transition.

5 Play the mix

- **Play back** your animation.

 The character is now doing two tornado kicks one after the other.

Note: *In the Motion Mixer window, you will see the progress of the animation driven by a purple vertical bar.*

6 See the transition

You can see how the actual transition is made between the two clips.

- **RMB** on the transition clip (that's the clip between the two FinalTornadoKickZ_1 clips) and select **Edit...** from the menu.

 A new window will appear with all the parameters available for editing the transition between the two clips. You also can change the animation playback speed using the Playback options at the bottom of the window.

Lesson 18: Motion Mixer

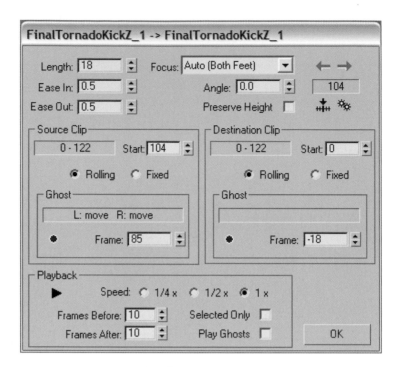

The Edit Transition window

Note: *You can leave this window open as you work in the Motion Mixer. You can also change any value during the playback to see the result in real time. You have to use the Playback button from within the transition editor to see the slow playback.*

With the Edit windows activated, a ghosted biped of each animation clip is displayed over the biped in the viewport. Each clip's ghost image has a different color. If the current time is during the transition, you will see the two ghosts at the same time, and you'll see how your character makes the transition between the two clips.

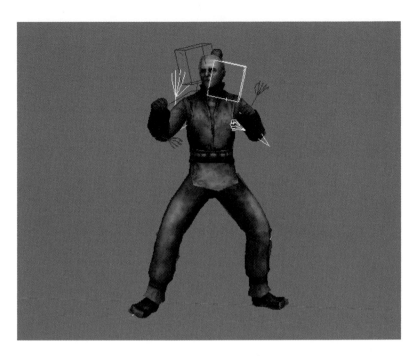

The two ghosted bipeds

7 Save your scene

A scene with the actual mix called *My18-motionMixer_01.max* is available in the support files.

Create the final animation

Now that you are familiar with the Motion Mixer, you will use it to finalize the animation you created during the previous lesson. You will start with the walk cycle, mix it with the animation of LiuJing opening the door, and finally continue the walk cycle animation to make him walk inside the building.

1 Scene file

• **Open** the scene you made from the previous lesson where LiuJing walks to the door, opens it, and enters the building.

> **Note:** *You can also start with the scene provided with the support file called 16-animart_02.max.*

2 Offset the starting pose

You will need to move the character to the same position as the starting pose of the walk cycle.

- Click on the **Mixer Mode** button to activate the Mixer mode.

 At this time, you don't have any animation loaded into the Motion Mixer. That explains why your character is suddenly relocated to the center of the world.

- Click on **Move all Mode** from the **Biped** rollout to bring up the LiuJing offset dialog.

 Notice that the offset values are all set to **0**.

- Click again on the **Mixer Mode** button to turn off the Mixer mode.

 You can now see the offset values that you used earlier to start the walk cycle.

- **Note** down these values.

- **Reactivate** the Mixer mode.

- **Enter** the offset value for each position and for the rotation.

Tip: *You can copy and paste their values if you like.*

The new mix you are about to create will start at the same position to make sure the character opens the door in the same position.

3 Load your clips

- Open the Motion Mixer window.

- Convert the layer track into a transition track.

- **Load** the *LiuJingWalkCycle* clip file into the transition track.

 The clip holding the walk cycle motion is added to the track.

- **Load** the *LiuJingOpenDoor* clip file in the transition track.

 A transition is created automatically between the two first clips. Because you start the open door animation with the last frame of the walk cycle, you don't need a transition between these two clips.

- **Press+drag** the *LiuJingOpenDoor* clip until the starting frame of the clip is set at **40**.

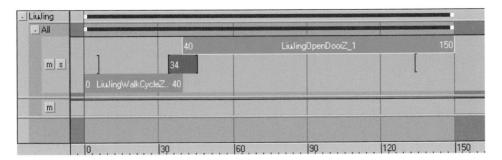

The LiuJingOpenDoor clip after being moved

- **Play back** the animation to see the result.

 The animation is about the same as the one on the biped in the scene but if you go to frame 55, where the character is holding the door knob, you will notice that the hand is not exactly on the knob. This is because the transition clip moves the center of mass during the transition.

- Click the black handle on the left side of the transition clip and **drag** it to frame **40** to remove the transition.

- Do the same thing with the black handle on the right side of the transition clip and **move** it to frame **40** to finish removing the transition.

 Now the hand is directly on the door knob.

4 Copy the walk cycle

Because you have already loaded the walk cycle into the Motion Mixer, you can simply copy this clip to the end of your mix to make the fighter continue walking inside the building.

- Hold the **Shift** key and **press+drag** the walk cycle clip to the right side of the transition track until its starting frame is at **150**.

 At this time, the transition between the two clips is not smooth. You will optimize the transition to get a better result.

- **RMB** on the transition clip and choose **Optimize**.

 *The **Transition Optimization** dialog will appear.*

The Transition Optimization dialog

Lesson 18: Motion Mixer

- Leave the options as they are and click **OK** to let the Optimize tool search for a new transition.

 The new walk cycle clip will move to a new position and the transition clip will also change to new values set automatically by the tool.

- Click on the **Set Range** button to make the timeline match the number of frames of your mix.

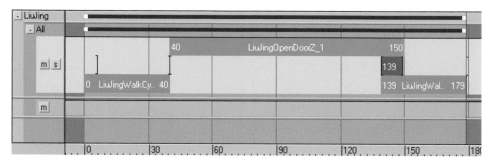

The new transition between clips

5 Compute a final clip

The mix you have just created is only visible while in the Mixer mode. If you exit the Mixer mode, you will lose your mix and all transitions. To import your mix onto the biped you have to compute a *mixdown*, a collapsed version of your mix. In general, a mixdown contains the same data as the raw mix, with one difference. During the process of computing a mixdown, any transitions involving planted feet are corrected to prevent the feet from sliding.

- Select the biped in the Motion Mixer by clicking the *LiuJing* biped name at the upper left of the trackgroup set.

- **RMB** on the *LiuJing* biped name and choose **Compute Mixdown**.

 A Mixdown Options dialog will appear, allowing you to change any options you would like. You can force a Keyframe For Every Frame if you are afraid of losing detail in your animation. There are default filters on to Enforce IK Constraints and Filter Hyper-Extended Legs. These filters are generally useful, but in extreme cases you should correct problems with over-extended legs manually in the individual clips.

 In this case, you will leave the default options.

- Click **OK** to start the mixdown.

 A progress bar at the bottom of the Mixer shows the progress of the mixdown. After a few moments, a new track called Mixdown is created as the last track in the biped's mix.

> **Note:** *You can turn the track on and off by clicking it. When the track is solid, the Mixdown track is on (active), and the biped performs the animation in the mixdown. When the track appears with hash marks, it is off (inactive), and the biped performs the animation in the raw mix.*

- **Scrub** the Time slider or **play** the animation to check the transitions. If they need correction, turn off the Mixdown track, correct the transitions, and compute the Mixdown again. **Repeat** until the entire animation is correct.

- Make sure the Mixdown track is active.

- **RMB** on the *LiuJing* biped name and choose **Copy Mixdown to Biped**.

- Turn off **Mixer Mode.**

 The mix from the Motion Mixer is visible on the biped in viewports even though the biped is no longer in Mixer mode. Now that the keys are visible on the timeline, you can refine the animation by moving existing keys or creating new keys and planting keys on the biped.

> **Note:** *Before you do a mixdown, you can save the mix by right-clicking the biped name and choosing Save Mix. You can also load a mix file using the same method.*

6 Save your scene

- **Save** your scene as *My18-motionMixer_02.max*.

Conclusion

You have created a new animation based on different animation clips. After mixing animation clips together, you learned the basics of Motion Mixer, from how to import a clip to how transitions work. Finally, you have computed a final animation back to the biped.

In the next project you will use this new animation to create your final scene. You will learn the fundamentals of lighting and how the camera works to create a final rendered scene.

Image courtesy of Uniform

Project 05

In this project, you will learn about the basics of animation with characters in Autodesk® 3ds Max® software. You will explore the main tools of the biped that will help you create animation for your character. You will also learn how to use the Animation Layer tool to modify your existing animations and how to mix them together.

Lesson 19
The Camera

The camera acts as a roving eye, telling a story as it travels throughout the scene. It gives the viewer a privileged position from which to watch the story unfold. As you plan your camera shots, try to focus on what holds your attention, what makes an image strong, and when a timed action should take place. Consider these options, keeping in mind that the human eye is drawn to specific things, such as movement, color differences, and weights of objects in a shot.

In this lesson, you will learn the following:

- How to create and manipulate cameras;
- How to frame a camera shot;
- How to work with camera parameters, such as lens size and aspect ratio;
- How to apply extreme camera angles to create dynamic shots;
- Understand the line of action and abide by its rules;
- How to animate camera motion using a path constraint.

Camera types

Autodesk® 3ds Max® software offers two different camera types to frame your shots: the target camera and the free camera.

The target camera has an associated object called a target, which acts as a focal point to the camera. By placing the target in a given spot or on a particular object, you ensure that the camera will always look at that object.

The target camera movement

A free camera does not have an associated target and can roam and look in any direction you want. In that respect, you orient the camera manually by rotation of the free camera object.

The free camera rotation

The camera type you use in a given situation depends largely on the action taking place and the shot you are trying to capture. You'll learn how to create, position, and animate both camera types as you learn the theory associated with camera shots.

Framing a camera shot

A basic set of conventions assigns names and guidelines to common types of shots, framing, and picture composition. The most basic shot types are the long shot, the medium shot, and the close-up. In some situations, you might use a more extreme camera shot to convey a particular feel for the story. For example, using an extreme close-up shot emphasizes emotions, such as fear or anger in a subject's eyes.

In a long shot, the subject takes up the full height of the frame.

LS (Long Shot)

A medium shot shows part of the subject in enough detail to give an overall impression.

MS (Medium Shot)

In a close-up, a feature or a part of the subject (hand or head, for example) takes up the whole frame.

CU (Close-up)

Finally, in an extreme close-up, the shot gets much closer and shows extreme detail.

ECU (Extreme Close-up)

The following diagram shows where to align the bottom of the frame in the commonly used framing techniques:

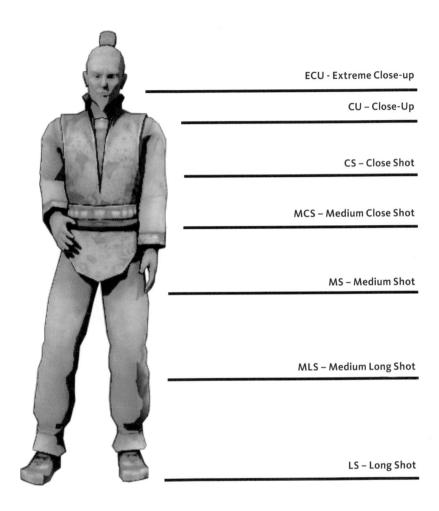

ECU - Extreme Close-up

CU – Close-Up

CS – Close Shot

MCS – Medium Close Shot

MS – Medium Shot

MLS – Medium Long Shot

LS – Long Shot

The commonly used framing techniques

Camera lenses

In addition to positioning the camera in XYZ coordinates, you can also make the view appear closer to, or farther from a subject by modifying the camera lens. The lens is your entry point into the world you create in your 3D scene. It's a tool you can use to define the relationship between characters or objects and their environment. Different lenses have different personalities. The camera lens (or focal length) is expressed in millimeters (mm).

A wide-angle lens (30mm or less) distorts the perspective by exaggerating the distance between foreground and background. The camera is closer to the action, which translates into greater "depth" in the shot. Interior architectural renderings almost always use a wide angle lens.

Wide-angle 28mm lens

A long or telephoto lens (200mm or higher) compresses the depth of the image. Subjects or elements that are close to the camera appear to lie at approximately the same distance as those that are farther from it. A long lens allows very little or no perspective distortion. In a long-lens shot, the camera is at a considerable distance from the action.

Telephoto 500mm lens

The field of view (FOV) is the "cone" of vision that the camera captures of the world around it. The field of view is inversely proportional to the camera's lens size.

The FOV on a long lens is narrower than on a wide lens

Lesson 19: The Camera

Camera aspect ratio

The camera aspect ratio defines the relationship between the width and the height of the frame. This is typically dictated by the project you are working on and its output medium. In real life, you usually set the camera aspect ratio by choosing the proper lens and hardware. In 3ds Max, you set the aspect ratio in the Rendering dialog.

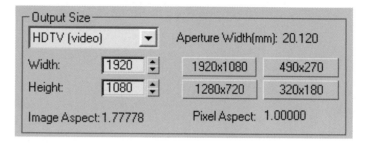

Setting the aspect ratio in the Output Size area of the Rendering dialog

If you are rendering an animation for standard TV or video, the camera aspect ratio will be set to 1.33:1 to accommodate the TV set. If you're rendering for HDTV, film, or sometimes for game cinematics, you may need to render in widescreen format (1.85:1) or anamorphic (2.35:1).

You include more information in the shot by using a wider frame. Not only do you capture more of the environment around the subject, but it also helps to establish a mood.

Unlike some other programs, 3ds Max has separate Image Aspect and Pixel Aspect ratios. You can define the proportions of the individual pixels (Pixel Aspect) independently from the output resolution proportions (Image Aspect). Macintosh systems expect square pixels (1.0); standard NTSC D-1 video, as another example, requires a pixel aspect ration of 0.900.

Video 1.33:1

Widescreen 1.85:1

Anamorphic 2.35:1

1 Show aspect ratio in the viewport

You can view the final aspect ratio of your camera directly in the viewport.

- In the shaded Camera viewport, right-click the Camera label in the top-left corner of the viewport and choose **Show Safe Frame**.

This ensures that the view displayed in the viewport is always of the proper proportions, even if you resize the viewport.

The safe frame of the camera in the active camera view

Note: *Using the Show Safe Frame option is important when framing a shot; it can help you optimize image composition.*

Camera angles

In addition to the camera-framing techniques discussed so far, you can adjust camera angles to create more dynamic camera shots. So far, you've mostly been using an eye-level camera angle. This provides a familiar feel, because it's how you normally observe the world around you.

You can also frame characters and subjects based on their personalities. For example, big and powerful people look more threatening from a low-angle shot, while weak and frail subjects yield a sense of apprehension when viewed from a high angle.

Eye-level angle

Low angle

High angle

Camera perspective

Cameras can be set to acquire various types of perspective shots, including one, two, and three-point perspectives. The names of these categories refer to the number of vanishing points in the perspective shot.

Three-point perspective

Any of these categories can be simulated to convey an emotion in a scene. For example, a one-point perspective can be used to simulate a long road that vanishes into the distance, creating a sense of loneliness and unknown.

One-point perspective

In design and visualization, architects and designers often rely on two-point perspectives to show off their work. A two-point perspective has two vanishing points, and all vertical lines run parallel to one another. Theoretically, two-point perspectives can only be achieved when both the camera and its target are located on the same horizontal plane.

Two-point perspective

A three-point perspective is most obvious when looking at a building from above. The building walls tend to recede into a vanishing point below the ground. A similar effect can be achieved when looking up at a tall building from street level, where the third vanishing point would be much higher than the building itself. When heavily exaggerated, this method can project a sense of fear, which can be useful when working with threatening characters or environments. Design visualizers can use the Camera Correction modifier to counteract perspective distortion. The traditional name in architectural photography for this is "keystoning."

The line of action

The line of action is an imaginary line used to preserve consistency in camera shots, screen direction, and space. It serves to eliminate confusion when multiple camera angles are used, related to reversal of left/right screen space and lighting.

In the simple example where two people face each other, the line of action is typically the line of sight between the two subjects. With that in mind, you can then determine a working space of 180 degrees in which you can design camera positioning.

In any given scene, make sure the cameras are positioned within the established semicircle so that the resulting shots are consistent with one another.

The moving camera

Moving (animating) a camera in a 3D application is a lot easier than it is on a real-world set. On a movie set, moving a camera to create a panning or a tracking shot involves using a number of technicians and some heavy equipment. When the shot requires the use of a crane, it's even harder. In 3D, these limitations simply do not exist. You can make the camera travel any way you want; even in ways that would be impossible in real life.

You can simulate a panning camera effect by rotating a free camera or moving the target of a target camera. A panning camera remains in place as it rotates to follow the action in the scene.

A panning camera

You can simulate a tracking camera effect by animating both the camera and its target. A tracking camera travels with the subject at a similar or different speed. It can also tilt and pan to follow the main action.

A tracking camera

You can create a push-pull effect with either a free or a target camera, by animating the camera's position. A push-pull effect happens when a camera travels toward or pulls away from the subject.

A push-pull effect

Lesson 19: The Camera

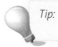

Note: *You can load the scene called 19-movingCamera_01.max from the support files to see the different types of camera movements.*

Create a camera move

You will now create a camera animation for your scene.

- Open the final scene from the previous lesson, called *My18-motionMixer_02.max*, showing the animation of the character you created with Motion Mixer. Or if you prefer, you can open the support file *19_makeCamera_01.max*.

- **RMB** the Perspective viewport to make it active. Frame your Perspective view to be what you want your initial camera shot to display.

- Press **Ctrl+c** to create a Camera from the Perspective viewport. The Perspective viewport is now labeled *Camera01*, and a target camera is created in the scene.

- **RMB** the *Top* view and zoom back so you can see the new camera that's been created. Zoom back so you can see both the target and the camera.

- **RMB** the Camera viewport to activate it. Notice that the viewport navigation controls change from the standard ones to a new set.

- **Press + Hold** on the Dolly Camera icon in the Viewport Navigation Controls. On the flyout that's displayed choose **Dolly Target**.

- **Press + Drag** in the Camera viewport while watching the Top viewport. Dolly the target back towards the camera, until the target is over the door that opens. Notice that dollying the target doesn't change what the Camera viewport displays.

- Turn on **AutoKey** by pressing **n** on the keyboard.

- Move the Time Slider to frame **80**.

- In the Top viewport move the camera up and to the left so the fighter is seen through the glass of the door, and the sky horizon is visible in the frame.

- Play the animation to observe the effect.

- Try out other animation ideas such as animating the target, or dollying the camera over time. Try to experiment and apply what you already know about keyframing to camera movement.

- **Save** this scene as *My19-movingCamera_02.max*.

Tip: *Activate the camera trajectory to get a better view of your camera movement. You can find this option in the properties dialog using the quad menu on the camera.*

Conclusion

In this lesson, you learned some basic principles of camera positioning, framing, and animation. You learned how to apply these principles to both target cameras and free cameras, in order to make a shot more interesting and more effective in a 3D scene.

In the next lesson you will learn the basics of lighting, so that you can light your 3D scene using the different types of lights that 3ds Max software provides.

Lesson 20
Basic Lighting

Lighting is an essential part of the visual process. Autodesk® 3ds Max® software offers a variety of ways to achieve proper lighting. In this lesson, you'll learn about the basics of creating primary light sources, and how you can improve the lighting of your scenes by adding secondary light sources to achieve a better range of tones in your final rendered palette.

In this lesson, you will learn the following:

- Understand ambient light and how to fake it;
- How to use the standard light types in 3ds Max;
- How to adjust shadow parameters and set different shadow types;
- How to use a three-point lighting approach to light a scene;
- How to use the Light Lister to manage multiple lights.

The ambient light

One of the common problems in 3D renderings is how to simulate ambient lighting. In the real world, ambient lighting is the indirect light that bounces off the surfaces of objects. It can therefore vary in intensity and in color as it picks up the colors of the surfaces it bounces off.

The easiest way to represent ambient lighting in a 3D scene is to fake it with secondary lights, or use one of the global engines provided in 3ds Max. To get better control over ambient lighting in your 3D scene, it's best to start in darkness. Most 3D applications provide an "ambient lighting" tool that usually translates into a uniform brightness, illuminating shadow areas in a flat and unrealistic way. Fortunately, this feature is turned off in 3ds Max, or more precisely set to a black color, forcing you, the user, to control ambient lighting on your own.

- From the **Rendering** menu, choose **Environment** or use the **8** hotkey to bring up the **Environment and Effects** dialog.

The ambient color swatch

The Environment panel showing the default black ambient color

- Choose **File → Set Project Folder to project5** if you haven't already done so.
- **Load** the scene called *20-Ambient_01.max* from the support files.

 The scene shows a cup set on a table top.

- With the *Perspective* viewport active, press the **F9** key to quickly render the scene.

 The main light illuminating this scene casts rays from right to left, making the left side of the cup extremely dark.

Render performed with a single light and a black Ambient light

- In the **Environment** panel, click the **Ambient** color swatch and set **value** to **128** to get a medium gray color.

- **Render** the Perspective viewport one more time.

 Notice how the whole scene is brighter, but in a flat, low-contrast way. You still cannot make out the details on the left side of the cup.

Render performed with a single light and a medium-gray ambient light

- Set the Ambient color swatch back to **0** to get full black again.

 Tip: *Right-click on the value spinner to set its value instantly to 0.*

- In the Front viewport, select the black light on the left side of the viewport called *Spot02*.
- In the Modify panel's **General Parameters** rollout, turn the selected light **On**.
- Activate the Perspective viewport and render the scene again.

Now that global illumination has been simulated by adding a secondary light, notice how the final render appears much more realistic than the previous tests. In classic photography, this second light is called a "fill" light.

Render performed with a main light and a secondary light, simulating ambient lighting

Light types

There are three categories of lights in 3ds Max: Standard, Photometric and Systems. Standard lights are simple to use and will be our main focus for this lesson. Photometric lights are more complex than standard lights, but they provide a more accurate model of real-world lighting.

Photometric lights are usually used in conjunction with the mental ray and radiosity (global illumination) engines. Lighting systems simulate sunlight based on location, time of day, and date. This makes them easier to set up than if you had to simulate sunlight using Standard or Photometric lights.

Using Standard lights

The Standard lights you use most often in 3ds Max are the omni, spot, and direct lights.

Omni light

The *omni* light simulates rays shining out from a single point in space. Rays are emitted uniformly in all directions. This is somewhat similar to a bare light bulb.

The omni light

Spot light

The *spot* light also simulates rays shining out from a single point but limits the illumination to a specific cone-shaped volume. This kind of control, which allows you to aim a light at a specific target, makes the spot a popular choice among lighting artists. When casting shadows, using spotlights will save memory, as compared to using shadow-casting omni lights.

The spot light

You have full control over the beam of light that defines the illumination cone. In fact, there are two cones that you can control: the hotspot (inner cone) and the falloff (outer cone). When the two values are close, the cone of light becomes very sharp and translates into a crisp pool of light in the scene. However, if you set a falloff value significantly higher than the hotspot value, you get a much softer-edged cone of light as the light intensity spreads from the inner to the outer cone.

Soft edge on right image with greater values between hotspot and falloff.

1 **Direct light**

A *direct* light has roughly the same workflow as a spot light but casts rays using a cylinder instead of a cone. The rays are therefore parallel, making the direct light suitable for simulating distant light sources, such as the sun. Because the direct light casts parallel rays, it does not matter how far you place it from the objects in the scene; the only thing that matters is the direction in which it's pointed.

The direct light

Much like a spot light, the direct light has hotspot and falloff values you can use to control the softness of its cylindrical beam.

2 Target light

When you create a *target* spot or direct light, you use the target object (in the form of a small square) to orient the spotlight. The spotlight itself will always point to (look at) that target. This makes the light very easy to position in the scene. In addition, by linking the target to an animated object in the scene, you can ensure that the spotlight will always follow the animated object.

3 Free light

When you create a *free* spot or direct light, you orient that light using the Rotate tool. For example, you would use a free light when simulating the headlights on a car. As you animate the car in the scene, the spotlights' orientation follows that of the car.

Color, intensity, and attenuation

The subtle use of color is a very powerful tool for reaching your audience's emotions. Color in 3ds Max can be used in a variety of ways: by applying materials to objects, by using backgrounds, or by controlling the light color, among others.

There's a direct connection between the colors derived from materials on objects and the color of the lights used in the scene. Scenes can become richer and more realistic if there's variety in the colors of the lights illuminating objects. Differences in color temperature, typically ranging from blue (cold) to red (warm), can add realism to your lighting.

Some light types, like Photometric lights, are automatically assigned a light color, intensity, and attenuation values based on their counterparts in real life. In this book, you'll deal mainly with Standard lights that you can customize any way you see fit, including tinting the light to the color of your choice.

The intensity of a light can also be adjusted in many ways, but it's important to remember that lighting a scene is an additive process. This means that if you have multiple lights in the scene, the sum of all light intensities make up the resulting illumination. Therefore, when you start adding multiple lights, you inevitably want to adjust their multiplier values so that the final scene is not overexposed.

Attenuation is the decrease of a light's intensity over distance. You can control this effect with Standard lights by specifying exact distances where attenuation begins and where it ends, or by using Decay values. Or you can also choose the (unrealistic) solution of not attenuating a light at all, in which case its distance to an object in the scene becomes irrelevant.

With a Standard light selected, Color, Intensity, and Attenuation can be set in the Modify panel under the appropriately named Intensity/Color/Attenuation rollout.

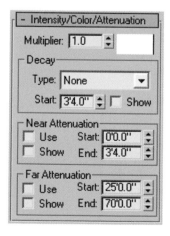

The Intensity/Color/Attenuation rollout for any Standard light

The importance of shadows

You see shadows every day, but you seldom stop to consider how vital they are in helping to establish the spatial relationships that surround us.

CG shadows differ greatly from those in the real world, however, and creating believable shadows in a 3D environment requires skill and the ability to analyze shadow form, color, density and general quality.

Arguably, the most important visual cues that shadows provide are perception of depth and positioning between objects in an environment.

The difference between an object without shadow and an object with shadow

The character on the left appears to be floating in space. The one on the right is more grounded because of its shadow.

Various shadow types are available in 3ds Max but all are based on either of two algorithms: shadow maps and ray-traced shadows. There are considerable differences between the two types, and the choice will ultimately dictate rendering quality and speed.

Shadow maps

The shadow map method uses a bitmap that the renderer generates before final rendering. The process is completely transparent and does not store any information on the hard drive. The bitmap is then projected from the direction of the light. Shadow maps can be fast to calculate and can produce soft-edged shadows. On the downside, they are not very accurate and do not take objects' transparency or translucency into account.

Lesson 20: Basic Lighting

Tip: *Adjust the Shadow Density parameter in the Shadow Parameters rollout to get shadows that aren't so black and dark.*

A shadow map produces soft edges.

Note: *The shadowing is uniform and does not recognize the transparency of the glass.*

Ray-traced shadows

Ray-traced shadows are generated by tracing the path of rays from a light source. They are more accurate than shadow maps but always produce hard-edged shadows. Because ray-traced shadows are calculated without a map, you do not have to adjust resolution as you do for shadow-mapped shadows, making them easier to set up. Ray-traced shadows take transparency and translucency into account, and can even be used to generate shadows for wireframe objects.

Ray-traced shadows have hard edges

Note: *With ray-traced shadowing, the transparency of the glass is taken into account.*

More shadow types

There are other shadow types that you can use in 3ds Max. Advanced ray-traced shadows are similar to ray-traced shadows but provide better antialiasing control and can generate soft-edged shadows. Area shadows simulate shadows cast by a light that has a surface or volume, as opposed to a point. Shadows of this type tend to become more blurred with distance.

An area shadow blurred with distance

Lighting techniques

When lighting in CG, your ultimate goal is to create a mood that projects an emotional connection with your audience. Many lighting techniques are available in CG, but it doesn't matter which one you adopt as long as you achieve your goal. Of course, if you are doing design visualization you are trying to accurately display realistic lighting in your design, which will also contribute to the emotional acceptance of your work.

Before you start creating lights in your 3D environment, take a moment to consider what you are trying to achieve and how to place light sources to achieve it. Think of color, shadow, contrast; look at the world around you and think of how you can achieve similar results.

If you have no experience with lighting, you can follow some basic guidelines established in cinematography, such as three-point lighting.

Three-point lighting

As its name implies, the technique of three-point lighting uses three lights with very specific functions:

1 **Key light**

The key light is the main or dominant light in the scene. It is often the only one that casts shadows and is used as the primary light source in the scene.

2 **Fill light**

The fill light functions primarily to control shadow density. Controlling the density of the key light's shadows is often insufficient for the desired effect. The fill light helps to remedy that problem by softening the effect of shadows in the scene. At the same time, it acts as a bounce light, simulating global illumination. Typically, the fill light is less intense than the key light.

3 **Back light (or Rim light)**

The back light's sole purpose is to separate the subject from the background, giving the scene greater depth. It works by illuminating the back of an object or character so that the silhouette is easier to see.

Working with three-point lighting

You will now set a three-point lighting setup on your character.

- **Open** the scene file *20-3pointLight_01.max*.

- With the *Camera* viewport active, press the **F9** hotkey to render the scene.

 The scene shows the rendering of your character using the 3ds Max default lighting. The general mood is far from interesting, so you will use the three-point lighting technique to make the scene more appealing. There are no shadow-casting lights in the scene at present.

The character rendered with default lighting

- On the **Create** panel, click the **Lights** button.
- Click **Target Spot** from the Object Type rollout.
- In the *Front* viewport, **click+drag** from the top-left corner to the fighter.

Note: *If you played with the hotspot and falloff earlier, adjust these values so the light resembles the one in this screenshot that follows:*

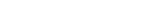

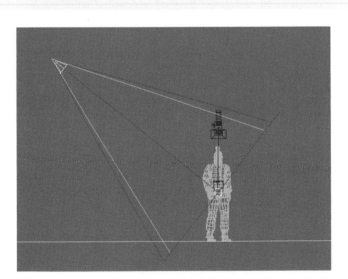

The main spot light from the front view

- In the *Top* viewport, **move** the spot light and position it in the bottom-left corner of the viewport. This will be the key or main light.

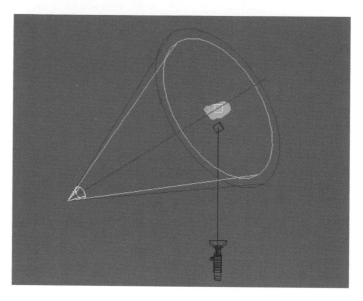

The main spot light from the front view

- **Rename** the spotlight to *Main_Light.*
- Go to the **Modify** panel on the **General Parameters** rollout.
- In the Shadows group turn on **Shadows** and leave the type set to **Shadow Map**.
- On the **Spotlight Parameters** rollout, set **Hotspot** to **30** and **Falloff** to **100** to create a nice falloff effect.
- On the **Shadow Parameters** rollout, set **Density** to **0.7**.

 This prevents the shadows from being completely black.

- On the **Shadow Map Parameters** rollout, set **Size** to **2000, Bias** to **0.1** and **Sample Range** to **6**.

 Increasing these values ensures that the shadow edges are soft and of better quality than the default settings allow. This creates a large bitmap resolution for the shadow map. The bias setting ensures that the shadow will remain close to the object, and not show a gap between the object and the shadow.

- In the *Front* viewport, create a second light by dragging it from the center-right of the viewport to the fighter. This will be the fill light.

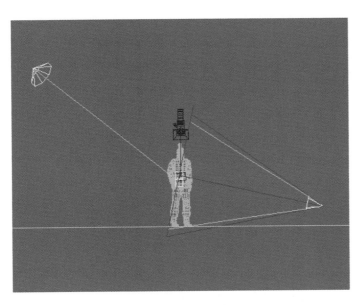

The fill spot light from the front view

- **Adjust** the position of the new spotlight in the Top viewport so that it's directed at the fighter from roughly the opposite direction as the main light, as shown here:

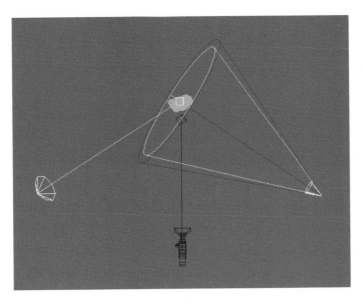

The fill spot light from the top view

- **Rename** the second light to *Fill_Light*.
- On the **Intensity/Color/Attenuation** rollout, set the **Multiplier** value to **0.4**.

 This makes the fill light less intense than the main light.
- In the **Far Attenuation** group, turn on **Use**.

 This causes the light intensity to fall off with distance, based on Start/End distances you specify.
- Adjust the **Start/End Attenuation** values so that the light attenuates from the front of the fighter to his back.

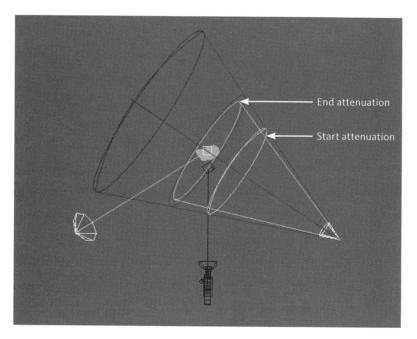

The fill light start and end attenuation

- **Create** one more spotlight in the *Front* viewport, dragging from the top-center of the viewport to the fighter. This will be the back light.

Project 05

The back spot light from the front view

- In the Top viewport, move the new spotlight so that it's directed at the fighter from the "northeast" direction.

The spot light from the top view

Lesson 20: Basic Lighting

- **Rename** the light to *Backlight*.
- On the **Intensity/Color/Attenuation** rollout, set the **Multiplier** value to **0.6**.
- In the **Far Attenuation** group, turn on **Use**.
- Adjust the **Start/End Attenuation** values so that the light attenuates from the fighter's head to his knees.

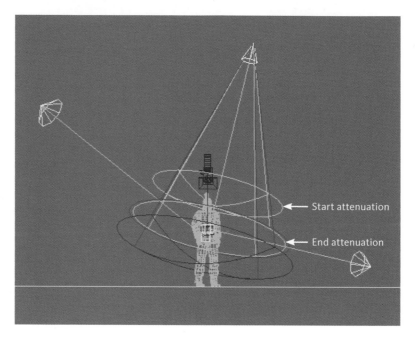

The back light start and end attenuation

- **Render** the *Camera* viewport.

Rendered scene with three-point lighting

Note: *Compare this rendering to the first test render you created early in this exercise to see how three-point lighting changes the look of your final render.*

Light Lister

Light Lister is a dialog that lets you control a number of features for each light. It is a very useful tool for managing multiple lights in your scene. You can easily change light parameters, such as Multiplier values and shadow types, turn lights or shadows off and on, and so on.

Using the Light Lister

You will use the Light Lister to analyze how the three-point lighting has affected your scene and how using different lighting combinations will affect the final rendering.

• From the **Tools** menu, choose **Light Lister**.

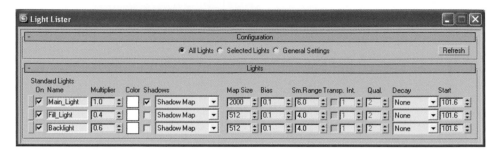

The Light Lister with the three lights from the three-point light setup

• On the Light Lister dialog, turn off **Fill_Light** and **Backlight**.

• **Render** the *Camera* viewport.

With only the key light lighting the scene, the right side of the fighter is hidden in black.

• Turn on and off different combinations and render to see the results.

The fighter lit with the main light only

Note: *You can also see the shadows in the viewport.*

- **RMB** on the main light and choose **viewport Lighting and Shading**→ **viewport Shading**→ **Best**.

- Then turn on **viewport Lighting and Shading** → **Enable viewport Shadows Selected**.

- Move the Main light's position and watch the shadows update in the *Camera01* viewport.

Conclusion

In this lesson, you learned how to use standard lights in 3ds Max. You have learned about light types, shadows, and the importance of ambient lighting and how to fake it in 3D. You learned basic lighting techniques, such as three-point lighting, and how to use the Light Lister to analyze your scene and make subtle changes to your lighting parameters. Proper CG lighting is not learned overnight, but takes time and practice. You have experimented with some basic principles and will take this knowledge to the next level in the following lesson, where you'll learn about global illumination and how to use it in 3ds Max.

In the next project you will learn more advanced lighting techniques using the mental ray renderer to light a scene. mental ray is a general-purpose renderer that can generate physically correct simulations of lighting effects.

Lesson 21
mental ray

In this lesson, you will be learning about a renderer called mental ray®. mental ray is an alternative to the traditional scanline renderer that you've been using generally in this book. mental ray is different in many ways but mostly, it's a general-purpose renderer that can generate physically correct simulations of lighting effects, including ray-traced reflections and refractions, caustics, and global illumination. You can use it to create realistic images faster and more easily than trying to simulate a lighting environment "by hand."

In this lesson, you will learn the following:

- How to switch the renderer from scanline to mental ray;
- How to identify where changes occur in the Material Editor and the Render dialog;
- How to enable Final Gather to improve rendering;
- How to use the mental ray daylight system.

Bouncing light

If you've ever wondered how you can see under your desk even though there are no light sources underneath, the answer is simple: Light bounces off the surfaces it hits. Some light bounces are more important than others, depending on the nature of the surface.

The color of light depends upon its source. White light is composed of all the possible colors that exist. A ray of white light changes color if it encounters an obstacle and it collects some of the color information from that obstacle. If it hits a white object, the same ray is reflected. If it hits an object of a different color, then the reflected light will take on the properties of that color and tint the next surface it encounters. For example, if a white light bounces off a bright blue fabric that's close to a white wall, the light rays bouncing off the fabric have a blue tint that can affect the perceived color of the wall.

A light ray that strikes a smooth surface

A light ray that strikes an uneven surface can break up into multiple rays. Perfect light reflection is possible only if the reflecting object is absolutely smooth. In reality, most surfaces have imperfections and a light ray does not usually reflect in any one direction. Some of it is reflected off at odd angles from the surface it hits. This in turn reduces the intensity of the reflected ray even more.

A light ray that strikes a bumpy surface

3ds Max contains three global illumination (GI) engines: Light Tracer, Radiosity, and the one built into the mental ray renderer. In this lesson, you will work exclusively with the mental ray renderer.

mental ray

mental ray gives you new controls over lighting and materials and lets you determine how images are rendered. With mental ray, you can also create render effects that are not possible with the default scanline renderer.

To use mental ray, you must first assign it as the renderer from the Common tab of the Render Scene dialog, as you did in lesson 3 when texturing the building. When the mental ray renderer is selected, the Render Elements tab is replaced by the Indirect Illumination tab, which gives you access to options such as Final Gather, Global Illumination, and Caustics.

The Indirect Illumination tab

Lesson 21: mental ray

In the Material/Map Browser, more material and map types become available when mental ray is assigned as the rendering engine. The mental ray-specific materials are identified with a yellow sphere.

More Map types are also available with the mental ray renderer; they're identified by a yellow parallelogram.

The mental ray materials

The mental ray maps

Lighting

Lighting techniques with mental ray depend largely on what type of scene you're trying to render. Exterior scenes usually need only a Daylight system to yield a convincing look. An interior scene requires more work, and usually involves the use of "man-made" lights. New to 3ds max 2008 is the sky portal light, meant for use in Interiors that are illuminated by light coming through exterior windows. There are many powerful advanced features available through mental ray. For this introductory lesson on mental ray, an exterior scene will be used.

The Daylight system

The mental ray Daylight system is a combination of the Sun and Sky effects, both of which are physically accurate. You can set a world location, a date, and a time of day, and the Daylight system will influence the scene with the adequate color and energy. Note that there is a standard Daylight system as well, for when you are using the scanline renderer.

- **Open** your scene from Lesson 19 with the moving camera, called *19-movingCamera_02.max.*

- In the main toolbar, use the **Selection Set** drop-down list to select the selection set named *Animation Optimize.*

 This will unhide all of the objects from your scene, which you hid during the animation process.

- Zoom back the top viewport so the entire building is visible

- Make sure mental ray is assigned as the production renderer.

- On the menu bar, go to **Create** → **Systems** → **Daylight**.

- A Daylight Object Creation dialog appears recommending that you use the mr Photographic Exposure Control. Click **Yes** and continue.

- In the top viewport, click the center of the building and drag to create the radius of a compass rose (the radius is for display purposes only), and then release the mouse button, move the mouse again to set the orbital scale of the sun light over the compass rose, and click to finish.

 You can set the orbital scale at any distance you find convenient, since directional lights produce parallel illumination regardless of where their icon is located.

- After creating the daylight system, use the Control Parameters rollout to customize the actual location of your scene using the Get Location button. You can also change the North direction of your scene to match the real-world orientation.

The daylight control parameters rollout

Lesson 21: mental ray

- Go to the **Modify** panel and expand the **Daylight Parameters** rollout.

The daylight parameters

- Use the **Sunlight** drop-down list to select **mr Sun.**

For best results, the Daylight system should always be used with the mr Physical Sky environment map. This type of background uses a procedural gradient map to simulate a sky dome, and its values are automatically calculated based on the status of the Daylight system.

- Use the **Skylight** drop-down list to select **mr Sky.**

 A message dialog will appear, asking if you want to add an mr Physical Sky environment map.

The mr Sky warning

- Click **Yes** to create an mr Physical Sky environment map. This automatically adds a map into the Environment Map channel. Press **8** on the keyboard to open the Environment and Effects dialog to confirm that the mr Physical Sky has been created.

The mr Physical Sky map applied by the Daylight system in the environment

The *mr Physical Sky* map is responsible for the visual representation of the sun disk and the sky. This will show up in the camera shot, and in reflections and refractions. Because you are using the mr Physical Sky environment map, you will not need the Skydome object used to simulate a physical sky.

- **Hide** the Skydome object from your scene.
- Make the *cameraFinal* view the active viewport.
- Press **F9** to render your first frame.

The fighter rendered with the Daylight system

The net effect of the Daylight system is a dramatic increase in the realism of the lighting and materials in the scene, but the fighter still has dark areas. To correct this, you will use Final Gather.

> **Note:** *Depending on how you set your north direction, geographic location, time and date, your rendering maybe dramatically different from the preceding screenshot. Don't worry, this is fine.*

- **Save** your scene as *My21-daylighSystem_01.max*.

Final Gather

Final Gather is a way to calculate bouncing light in the scene, and it provides the effect of a global illumination solution. It is very useful in exterior scenes, where it improves the calculation of indirect illumination.

- On the **Render Scene** dialog, on the **Indirect Illumination** tab, turn on **Enable Final Gather** in the **Basic** group on the Final Gather rollout .

The Final Gather rollout

When you enable Final Gather, your render times will increase, but the quality of the images will improve. The shadows will be lit by the ambient light in the Daylight system. Final Gather has preset values that you can use to control quality and rendering time. Start with the Draft preset and build your way up. You will find that the lower presets are adequate for most situations.

- Change the Final Gather preset to Draft using the drop-down list.
- Render your scene.

With Final Gather activated, the light now bounces on the wall to light the fighter.

The scene rendered with Final Gather option

The image will appear dark; you can make adjustments now to correct that.

Now that you have set up the Daylight system, you can start testing some of the parameters to get different results.

- Select the **Daylight** object again.
- Expand the mr Skylight parameters rollout.

The mr Sky Parameters rollout

- Change the **Multiplier** value to **5**.
- Change the **Red/Blue Tint** value to **0.5**.
- Render your scene.

The same render with changed parameters

- Select the **Compass** and rotate it to change the **North** direction; then render again.
- **Save** your scene as My*21-daylighSystem_02.max*.

Conclusion

In this lesson, you were introduced to the mental ray rendering engine. You learned how to use it at a basic level, and although you did not get into the advanced features and refinements, you were able to produce realistic renderings with the help of the Daylight system. Mostly, you have learned how to create convincing renderings of exterior scenes quickly and effortlessly.

In the next and final lesson, you will learn to set up your project so that it is ready to render.

Lesson 22
Rendering

Rendering is typically the final stage of the 3D process. It is certainly the last thing you do when you want to show the final product to a client. The final product can be an architectural rendering, the latest design for a game box, a simple web-based animation, or even a feature film. The final rendering takes into account all the other aspects of the production pipeline, including modeling, texturing, rigging, lighting, and animating.

In this lesson, you will learn the following:

- How to set up your scene and save your renderings;
- How to use various 3D effects;
- How to use rendering tools efficiently;
- How to use the RAM Player.

Rendering in 3ds Max

By default, Autodesk® 3ds Max® software uses a scanline renderer to render the scene. The Material Editor also uses the scanline renderer to display materials and maps. As its name implies, the scanline renderer renders the scene as a series of horizontal lines. Other options are available to you; mental ray (discussed in Lesson 21) is an advanced renderer that comes with 3ds Max, or you can also use other plug-ins or third-party renderers that you have installed.

Rendering creates a 2D image or animation based on your 3D scene. It paints the scene's geometry using the lighting you have set up, the materials you have applied, and environment settings such as background and atmosphere.

The Render Scene dialog

You set the parameters for rendering in the Render Scene dialog. The keyboard shortcut to open this dialog is **F10**. You can also click the Render Scene button on the main toolbar. The command is found on the menu bar by choosing **Rendering → Render**.

The Render Scene dialog

The Render Scene dialog has multiple rollouts, accessed from tabs at the top of the dialog. The number of rollouts and their names depend on the active renderer.

The Common panel

The Render Scene dialog's Common panel contains controls that apply to all renderers. The Common panel contains four rollouts. The Common Parameters rollout sets parameters common to all renderers. Here you set the resolution of your output and the time segment for your rendering, as well as turn on other various options.

Lesson 22: Rendering

Common Parameters

Time Output
- ● Single Every Nth Frame: [1] ⬍
- ○ Active Time Segment: 0 To 100
- ○ Range: [0] ⬍ To [100] ⬍
 - File Number Base: [0] ⬍
- ○ Frames [1,3,5-12]

Output Size
- Custom ▾ Aperture Width(mm): [36.0] ⬍
- Width: [640] ⬍ [320x240] [720x486]
- Height: [480] ⬍ [640x480] [800x600]
- Image Aspect: [1.333] ⬍ 🔒 Pixel Aspect: [1.0] ⬍ 🔒

Options
- ☑ Atmospherics ☐ Render Hidden Geometry
- ☑ Effects ☐ Area Lights/Shadows as Points
- ☑ Displacement ☐ Force 2-Sided
- ☐ Video Color Check ☐ Super Black
- ☐ Render to Fields

Advanced Lighting
- ☑ Use Advanced Lighting
- ☐ Compute Advanced Lighting when Required

Bitmap Proxies
- Bitmap Proxies Disabled [Setup...]

Render Output
- ☐ Save File [Files...]
- []
- ☐ Put Image File List(s) in Output Path(s) [Create Now]
 - ● Autodesk ME Image Sequence File (.imsq)
 - ○ Legacy 3ds max Image File List (.ifl)
- ☐ Use Device [] [Devices...]
- ☑ Rendered Frame Window ☐ Net Render
- ☐ Skip Existing Images

The Common Parameters rollout

Time Output

The Time Output group lets you specify which frames to render and whether to generate an animation (such as an AVI file), sequential single-frame output, or a combination of different frames that are not sequential.

Output Size

The Output Size drop-down list lets you choose from a number of standard film and video resolutions and aspect ratios.

The standard film and video Output Size presets

Choose one of these formats, or use the Custom choice to specify your own settings.

The output size set to 35mm anamorphic (2.35:1)

A custom output size (640x800)

Render Output

Another important part of the Common parameters rollout is the Render Output group. This is where you can save the output files to disk when you're done.

Click the Files button to specify the output filename and image type. You're prompted for a file name and a file type for output.

The Render Output File dialog

Note: *When you set a project as you did during each lesson, the default render output folder will be in the \renderoutput folder within your project.*

If you render a single frame, you can also save your images by clicking the **Save Bitmap** button on the toolbar of the rendered frame window.

The rendered frame window

If you attempt to render a sequence of frames, you first need to specify the base file name and image format or you will be prompted by a warning:

The warning displayed if you have not specified an output file

File type

When you render a scene, you can output a still image or an animation. You can output to most of the known formats, such as JPG, TGA, TIF, and many others. Movie file types include AVI and QuickTime®. Be sure to choose a format; the default is set to All Formats. Make the choice in the **Save as Type** field.

The available render output file types

Some of the formats support various options. If output options are available, they appear in a separate dialog after you click the **Save** button.

RAM Player

The RAM Player is a useful tool that lets you load a sequence of frames into memory and play it back at a specific frame rate. You can also save an image sequence in AVI or MOV format from the RAM Player using the Save command.

> **Note:** *It can take some time for the RAM Player to save the animation. It might look like your computer is frozen and not responding, but that is usually not the case; it's actually saving the animation to disk.*

The RAM Player also serves as a useful comparison tool. You can load images or sequence of images into the two different channels and compare scene setups, lighting, materials, and other aspects of your work.

1 Using the RAM Player

• From the **Rendering** menu, choose **RAM Player**.

The RAM Player interface

• On the RAM Player toolbar, click the first button, called **Open Channel A**.

• Browse to the *project5/renderoutput* folder in the support files and open the image file called *FinalGather_SettingOne.bmp*.

Once you click on the Open button, a configuration dialog will appear.

The RAM Player Configuration dialog

- Click **OK** to accept the default RAM Player Configuration setup.

 Now that the first image is loaded, you will load the second image into channel B.

- On the RAM Player toolbar, click the **Open Channel B** button.

- Load the Image file *FinalGather_SettingTwo.bmp*.

- Click **OK** to accept the default configuration.

 As you can see, half of each image appears in the player window.

The two images shown in the RAM Player

- Click in the window and drag horizontally in both directions to compare the two images.
- Click the **A** or **B** button on the toolbar to toggle display of the images.
- Use the **Horizontal/Vertical Split Screen** button next to the **A** and **B** buttons to compare images from top to bottom.

 When you close the RAM Player, a new dialog will appear, telling you that all the files you have loaded will be unloaded from the RAM Player. Click **Yes** *to quit the RAM Player utility.*

Note: *The Ram Player is often used to load in a sequence of still image files and then output them to a movie file format. Consult the 3ds Max tutorials formore information on how to do this.*

Rendering effects

Rendering effects let you interactively add post-production effects without having to render the scene every time you want to view the results. With the Effects panel of the Environment and Effects dialog, you can add various effects and view them prior to the final rendering of an image or animation.

As you adjust an effect's parameters, the rendered frame window is automatically updated with the final output image of the scene geometry and the applied effects. You can also choose to update the effect preview manually.

1 Creating render effect

- Open the file *21-daylighSystem_02.max*.
- From the **Rendering** menu, choose **Effects**.

 The Environment and Effects dialog is displayed.

The Environment and Effects dialog

- Activate the **Interactive** feature using the check box option.

 *This will render your scene on the current frame. With the interactive feature activated, you don't have to re-render the complete scene to see the effects on your scene. If you want to see the effect from another frame, use the **Update Scene** button to render the scene again.*

- Click the **Add** button.

- Choose **Color Balance** and click **OK**.

 The Color Balance Parameters rollout will be added under the Effects rollout.

The Color Balance Parameters rollout

- Change the color value to give a new feeling to the scene.

 Each time you change a value, the color is updated in your preview render. You have exaggerated the effect so it's clearly visible in the following illustration.

The Color Balance effect – Original Right, Interactive update Left

- Click the **Add** button again.
- Choose **Film Grain** and click **OK**.

 A film grain effect is added to your render over the color balance you have just made. You have toned down the color balance in the next illustration and added an additional Brightness effect to lighten the final output.

The film grain effect

Note: *You can add as many effects as you want using the Add button. They will all be processed and displayed in your render preview one over the other in the processing order of the stack modifier. You can change the order using the Move Up and Move Down buttons next to the Effects list.*

- **Save** your scene as My*22-addEffects_01.max*. If you had problems you can compare your work to the support file *22-addingEffects_02.max*, which is located in the support files.

Now that you have learned how to prepare your scene for final rendering and what the render output options are, you can render your final shot as an image sequence or as a movie.

Conclusion

In this final lesson of *Learning* 3*ds Max* 2008 | *Foundation*, you learned how to set up rendering output, use the RAM Player to preview your work and compare different images, and use environment effects to make the scene more interesting.

Index

A

B

C

Notes

Notes

Revolutionary Visual Computing Solutions
The definition of performance. The standard for quality.

As a DCC professional, your workflow demands graphics solutions that keep up with your abilities. With NVIDIA Quadro® graphics solutions at your side, you can accelerate your projects all the way through the end of production.

NVIDIA Quadro, coupled with the NVIDIA® MAXtreme performance driver for Autodesk 3ds Max software, allows users to achieve dramatic performance improvements enabling you to deliver cutting-edge creations. Quadro is fully certified for leading DCC professional applications, including Maya and 3ds Max.

For more information on NVIDIA solutions, please visit **www.nvidia.com**

THE MAGAZINE FOR 3D ARTISTS

If you're serious about 3D, you need 3D World. Each issue of this high-quality magazine comes packed with news, inspiration and practical advice for leading software packages, including 3ds Max, Maya, LightWave 3D, Cinema 4D and XSI

View the latest subscription offers online at:
www.myfavouritemagazines.co.uk

Tutorials & Tips

Artists' Showcase

Downloads

Community Network

A free subscription lets you discover many ways to
develop your skills—and it puts you in touch with the
exciting Autodesk® 3D animation community.

www.the-area.com

AUTODESK®
3DS MAX®

AUTODESK®
MAYA®

AUTODESK®
MOTIONBUILDER™